BIRDS

An Artist's View

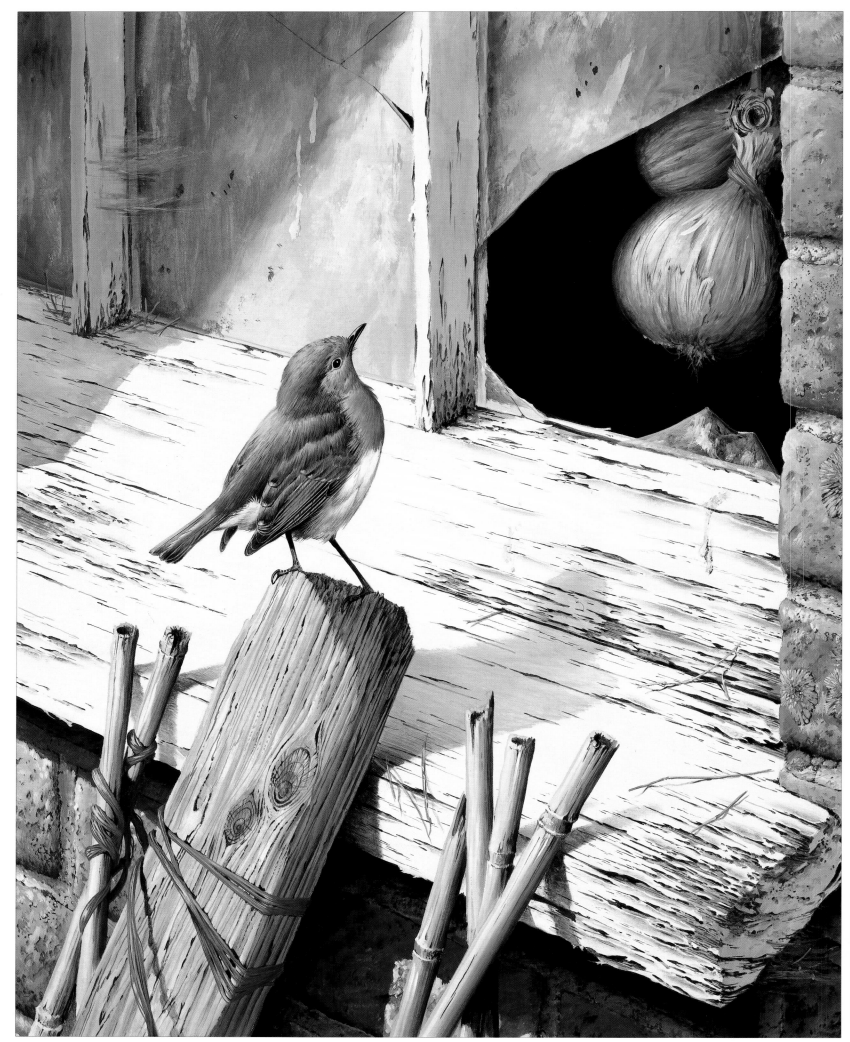

'WINDOW SHOPPING', ROBIN, 19 x 14.5IN. (48.2 x 36.8CM), GOUACHE

BIRDS
An Artist's View

SELECTED PAINTINGS BY
TERANCE JAMES BOND

TEXT BY
ROB HUME

FOREWORD BY
BILL ODDIE

COURAGE
BOOKS

AN IMPRINT OF RUNNING PRESS
PHILADELPHIA · LONDON

First published in the United States in 1998 by Courage Books

Printed in Singapore

9 8 7 6 5 4 3 2 1

Digit on the right indicates the number of this printing

Library of Congress Cataloging-in-Publication Number 97-77967

ISBN 0-7624-0376-4

Editors: Elizabeth Radford and Fiona Trent
Designer: Ian Youngs
DTP Manager: Keith Bambury
Design Liason: Victoria Furbisher
Editorial Director: Pippa Rubenstein

This book may be ordered directly from the publisher.
But try your bookstore first!

Published by Courage Books, an imprint of
Running Press Book Publishers
125 South Twenty-second Street
Philadelphia, Pennsylvania 19103-4399

CONTENTS

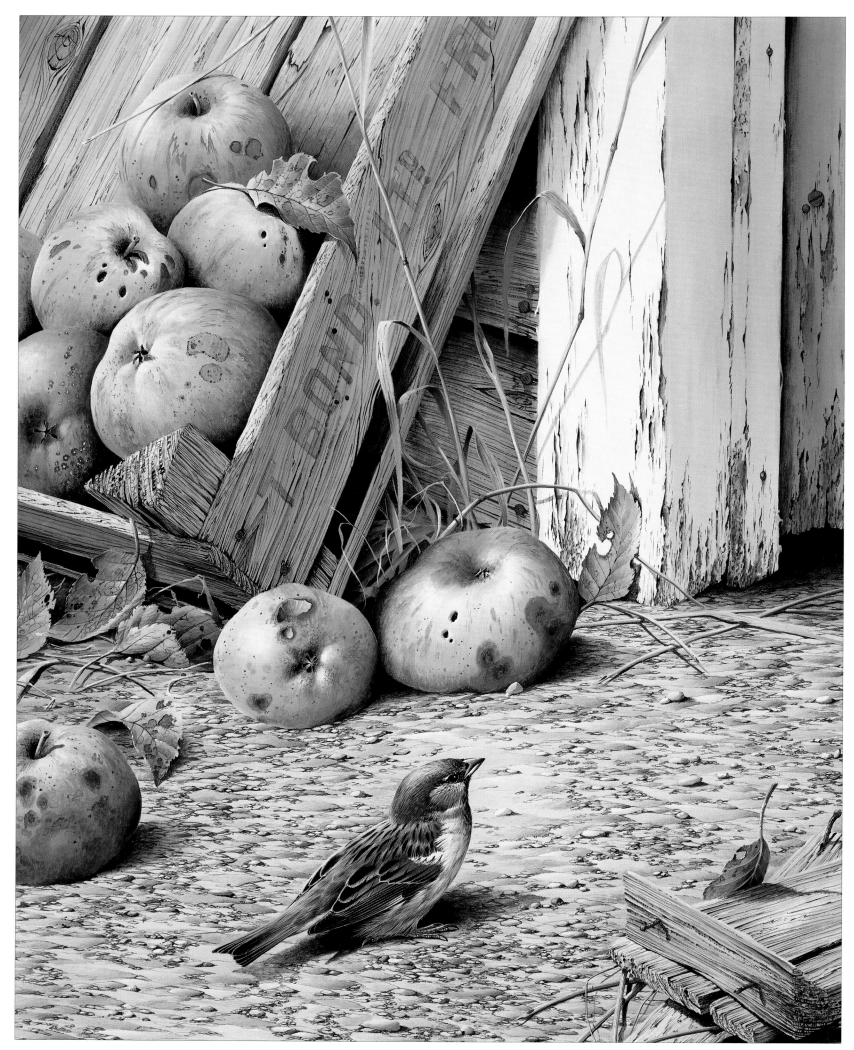

HOUSE SPARROW, 20 X 16IN. (50.8 X 40.6CM), GOUACHE

FOREWORD

Time was – and not so long ago – when bird artists were not necessarily birdwatchers. The evidence was often hanging on living room walls. For example my father's, which was festooned with several portraits of waterfowl and waders that delighted him, but infuriated me. 'Yes, I agree the sunset looks lovely, and it is a very nice windmill, BUT,' I'd protest, 'the gadwall's speculum is the wrong colour and those oystercatchers look more like flying penguins!'

To put it bluntly, the birds themselves were often inaccurate and to a pedantic young birder (as I was then), this was unforgivable. I am now a pedantic middle-aged birder and it would still be unforgivable, but it does not happen so much nowadays.

If I had to sum up the one advance in bird art over the past twenty years it would have to be the meticulous attention that is now paid to feather detail and 'jizz'. The birds depicted really do look like the birds they are meant to be. But surely there is a danger here? Surely a bird is a bird and therefore an accurate painting will be no more dynamic than a well-exposed photograph? Not so, since the other miracle of current bird art is that individual styles are probably more diverse than they have ever been. Give a gaggle of bird artists the same species to paint and no two will look the same. All brilliant, all different, and yet all accurate. The fact that bird art is so prolific is, to my mind, a tribute not only to the artists but also to the birds. Just as painters have celebrated the human body, so too may they explore and capture the infinite variety of birds.

In Birds: An Artist's View you can marvel at the work of an undisputed master, T. J. Bond. Bond's immediately recognizable style is evident not only in his birds – always a bit spiky and dishevelled – but even more so in his backgrounds. The contexts are as important as the species. These are very much complete paintings, and clearly Bond is not only a fine artist and birdwatcher, he is also a complete naturalist. It is a pity that my father is no longer around to appreciate him. But you are. Look, read, and enjoy.

Bill Oddie

INTRODUCTION

If, like me, you are one of those people who always reads the introduction to a book after reading everything else, then perhaps one characteristic of my paintings will have become apparent: the exotic does not generally appeal. Given the choice, I would rather paint a subject that is, to most people, rather down-to-earth, even mundane.

During my painting career, now in its twenty-third year, I have had the good fortune, as a direct result of the decision to become an artist, to have travelled to various parts of the world and met enthusiastic, and sometimes famous, people. Presented with the opportunity and the talent to become integrated with such a distinctive lifestyle, many people would probably find it peculiar that I should want to sit in my studio in deepest Suffolk and go on and on painting sparrows! After all this time, however, it is unlikely that my outlook towards the subject matter will change; this preoccupation with the vin ordinaire of the ornithological world will no doubt continue.

My fascination for things natural and commonplace is a legacy, presumably, of my experience as a teenager, when I spent a great deal of time wandering around my parents' farm. As my interest in wildlife became more intense, the more I learned. In particular, it was the visual impact of the countryside that prompted me to paint rural subjects.

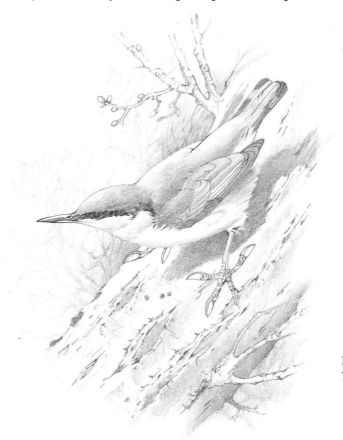

NUTHATCH,
7 x 9IN. (17.8 x 22.9CM), PENCIL

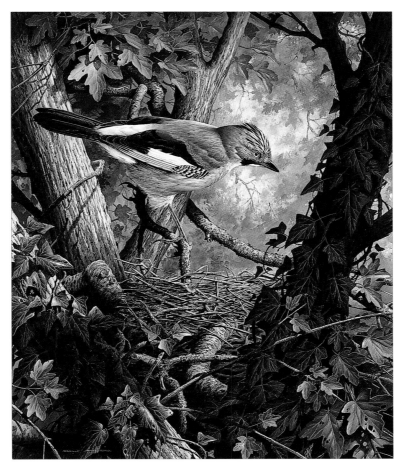

JAY, 23 x 17IN. (58.4 x 43.2CM), GOUACHE

First attempts at translating my love for my surroundings into pictures took the form of detailed landscapes, usually of buildings and trees around the farm and the neighbouring countryside. Before too long, however, I invariably found myself more interested in certain components of the landscape, and would concentrate on perhaps a corner of a building, or the section of a tree, usually to the detriment of the rest of the painting.

It was but a short step from this stage to the conclusion that I would have to paint things life-size in order to obtain the realism with which I had now become intrigued, or possibly even obsessed. This devotion to the authenticity of my subject, along with the desire to reproduce it actual size, is almost a form of self-inflicted punishment! Some of the works included in this book have taken literally weeks to paint, and at times I have to admit to bouts of frustration and boredom, when a large work does not seem to 'come together'.

Trees figure extensively in many of the paintings and, for me, birds and things arboreal are inseparable. Again, this is presumably the result of many happy hours spent in the Suffolk woodland surrounding my home – woodland, alas, that is no longer as extensive as it was in those days. During the last twenty years Dutch elm disease, along with two major storms, have drastically rearranged the scenery in my native East Anglia, and the feeling of helplessness and gloom brought about by the loss of a particular tree is an experience I know well. The

large painting of the kestrel in this book (pages 44–53) was prompted by just such an event. Large and ancient trees are literally a dying race – whatever the species – and mature trees and woodland, along with the infinitely varied associated wildlife, must be cherished and protected. In my own small area of land I have endeavoured to put something back into the environment and my immediate landscape, by planting hundreds of trees. It is extremely satisfying to see them grow and become fine specimens, almost old friends and characters in their own right. They, in turn, provide me with ideal subjects to draw and paint, and so the circle is completed.

One of these days (or years) I should like to fulfil the challenge of producing a collection of works that all revolve around, or are associated with, one particular species of tree, just to see how many original ideas I can come up with. This book includes several pictures containing pine trees and some with birch; both are striking in form and colour, and have their particular uses in the creation of a balanced composition.

Fortunately, sources of inspiration are something that I am not short of: the opposite is probably nearer the mark. In fact, I know that I have ideas for paintings flying around in my imagination that will never be transferred to paper. This is the wonderful thing about the natural world, and walking around my few acres here in Suffolk, I notice the character and appearance of each object change constantly with the light, the weather, and the angle from which it is viewed. It requires a particular sort of patience and self-discipline to continue a painting (even if I am already three weeks into it) when there seems to be no end in sight and I am crying out for a change, when so many new ideas present themselves on any morning walk. No, it is not ideas I am short of, only time. The speed at which the years have flown by became apparent when selecting the list of images for this book. Paintings that seem to have left the studio only a short while ago, reveal themselves as having been painted up to ten years previously. I was always told that time flies when you are enjoying yourself, and continuous enjoyment is something that painting has brought me for the last two decades. This personal selection will, I hope, share some of that enjoyment with others, whilst at the same time representing faithfully this particular 'Artist's View'.

Terance James Bond 1993

OLD FIREWOOD, PRELIMINARY LAYOUT (FOR FUTURE SONG THRUSH PAINTING), 16 X 12IN. (40.6 X 30.5CM), PENCIL

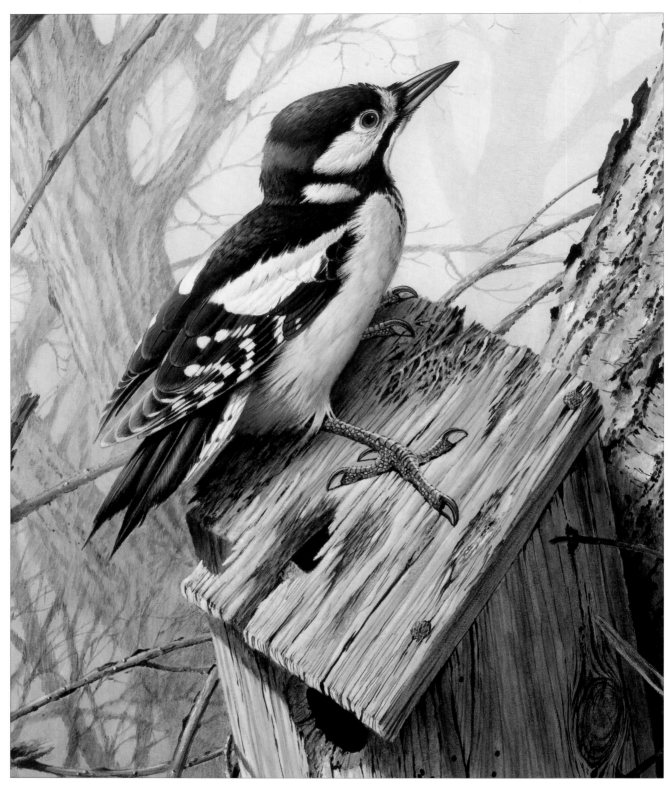

GREAT SPOTTED WOODPECKER, DETAIL (SEE PAGE 21)

A PERSONAL
SELECTION

All the works in this section of the book have been chosen for a variety of reasons; however, it is a combination of certain characteristics that make these paintings special to me. The technical process of producing the work went without problems and the end result transpired exactly as envisaged. These paintings also contain some of my favourite species, which in their various ways rekindle a particular emotion or memory.

ROBIN

Erithacus rubecula

This is the oldest of all the paintings included here. Robins are popular with my clients, and over the last twenty-odd years I have painted a good many. Despite this, it is, in fact, a difficult bird to paint correctly, and there are features that are depressingly hard to get right. This picture has, I feel, succeeded in achieving a certain degree of 'robin-ness' and still gives me satisfaction.

No one can deny the irresistible appeal of the robin. Universally liked, easy to see in practically any British garden, the robin is still little understood by most casual bird lovers.

So often, people fondly believe that they have fed the same, tame robin in the garden for years and years and years. Usually, they will have been host to a whole series of robins, all just as cheeky, just as opportunistic, and just as likely to take advantage of anything we can give them. Since all robins look identical, the change from one to another is not noticed and, in any case, matters little.

Nevertheless, there is a lot more to robins than their ardent admirers may think. They are, for one thing, extraordinarily aggressive birds: bold, maybe; confident, yes; pert and bright-eyed, of course. But they are nasty pieces of work, too!

Many robins are killed in territorial disputes with other robins. Even in winter they hold territories: indeed, females do so then, as well as the typically dominant males. Only in times of real stress, such as the annual late summer moult and in very hard winter weather, do they relinquish their territorial rights. Then, against all the odds, two or three or more robins may call a truce and feed together at a bird-table, as if realizing that interminable bickering and fighting will do none of them any good, and that disputes will mean only losers, not winners. It is better that they ignore each other and eat.

There is, however, much more to it than this. Some males may have two territories at the same time, holding a winter territory where they feed, but still clinging to the summer one where they will breed again the following year. Very occasionally, male and female will maintain their pair bond through the winter, although as a rule they go their separate ways and keep territories separately. Adults in moult after breeding may temporarily lose their territories to young birds or other adults, but usually they come back, all spick and span and very fit after a change of feathers, and take back what is rightfully theirs.

Even migrant robins, which move great distances to milder winter quarters, will return year after year to the same winter territory. This is one of the features of an individual bird's life that only ringing can reveal, and which seems to be much more common than was once believed possible. It is remarkable that summer visitors to Europe return year after year to the very same spot, such as swallows to the same shed, and chiffchaffs to the same tree, but more so that robins, among others, should spend the winter in the same place, year in year out, after long migratory flights.

Robins in Great Britain and Ireland are mostly resident: that is, they do not go far from home all year. But some do migrate, heading south-south-west at least as far as southern Spain and Portugal. Robins in France, Iberia, Italy and south-east Europe tend to remain where they are, but those breeding in Scandinavia and Europe, from Germany eastwards into central Asia, are all migratory, leaving the bitter cold of a continental winter far behind. A few go to north Africa: the majority spend the winter in south and west Europe. Where some remain behind in border areas, most move to urban districts, which are markedly warmer, and have the advantage of more food left around, or deliberately put out, by humans.

'WINTER BRAMBLES', ROBIN, 17 X 12IN. (43.2 X 30.5CM), GOUACHE ▷

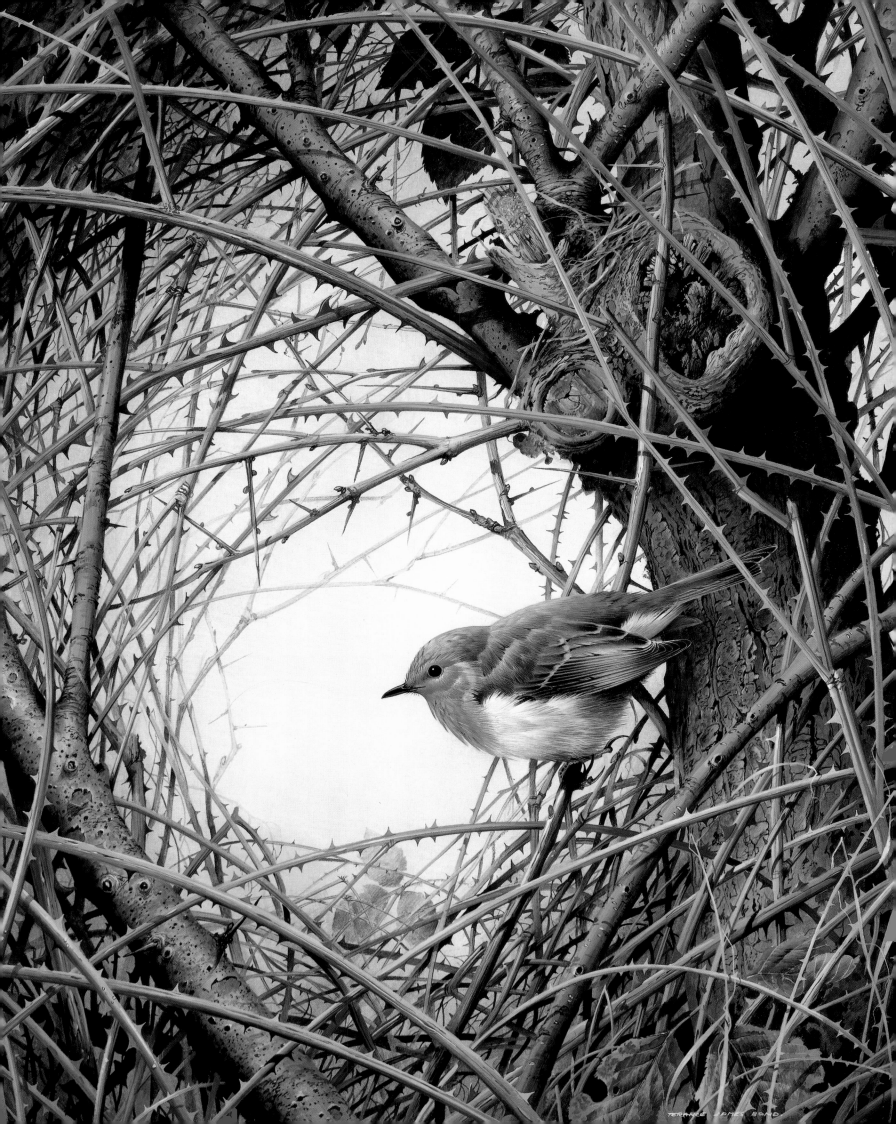

HOUSE SPARROW
Passer domesticus

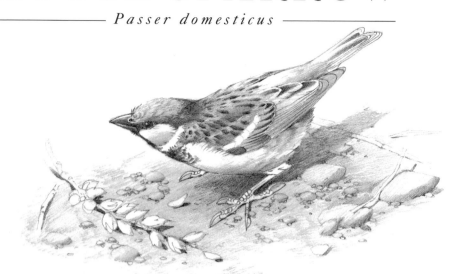

HOUSE SPARROW, 6 X 8IN. (15.2 X 20.3CM), PENCIL

House sparrows follow man wherever he goes. Even in the Egyptian desert, the thinnest chain of remote guardposts has created its own hangers-on, as sparrows have found huts and temporary buildings with a few crumbs and scraps to exploit.

There is, it must be said, a world of difference between a typical Cockney sparrow, besmudged with soot, dulled by the grim fall-out of city life, and the clean, bright spark that lives in a country village somewhere in the middle of England. A spring, male house sparrow, untouched by fumes and pollution, is certainly a colourful character.

There is always something to be said for sparrows. As often as not, in places where they are common and tame, there are few other birds about. To have sparrows is better than having nothing at all. Anyway, they are a cheery lot: always chirruping, often squabbling, frequently showing off. They live beside man and exploit his food and his buildings, and even feed on insects splattered on the front of his cars. And yet, other than in some city parks where they perch confidently on any hand that offers them food, they are never quite tame. Walk out into a garden and the first bird to fly off is likely to be the sparrow. He does not trust you, and prefers to keep his independence. But he will go only as far as the nearest roof. Put out some bread, go back indoors, and the sparrows will be back before you have time to sit down. They deserve to be forgiven their bad manners and the damage they do to yellow crocuses and sweet peas.

It is well known that I cannot resist the challenge of painting something so commonplace that it would normally be overlooked as a subject for a picture. This decorator's paint-kettle caught my attention one weekend. It lay unused in my workshop while the painters were away, and I immediately saw the potential for yet another sparrow painting!

In particular, it was the build-up of brush wipes and paint drips on the side of the kettle, suggesting years of use, that really caught my eye. The contrast between the brilliant white paint and the coloured brush handles was also appealing. To a degree, they echoed the colours in the sparrow's plumage: it required nothing else to finish the composition.

'THE DECORATOR', HOUSE SPARROW, 20 X 16IN. (50.8 X 40.6CM), ACRYLIC ▷

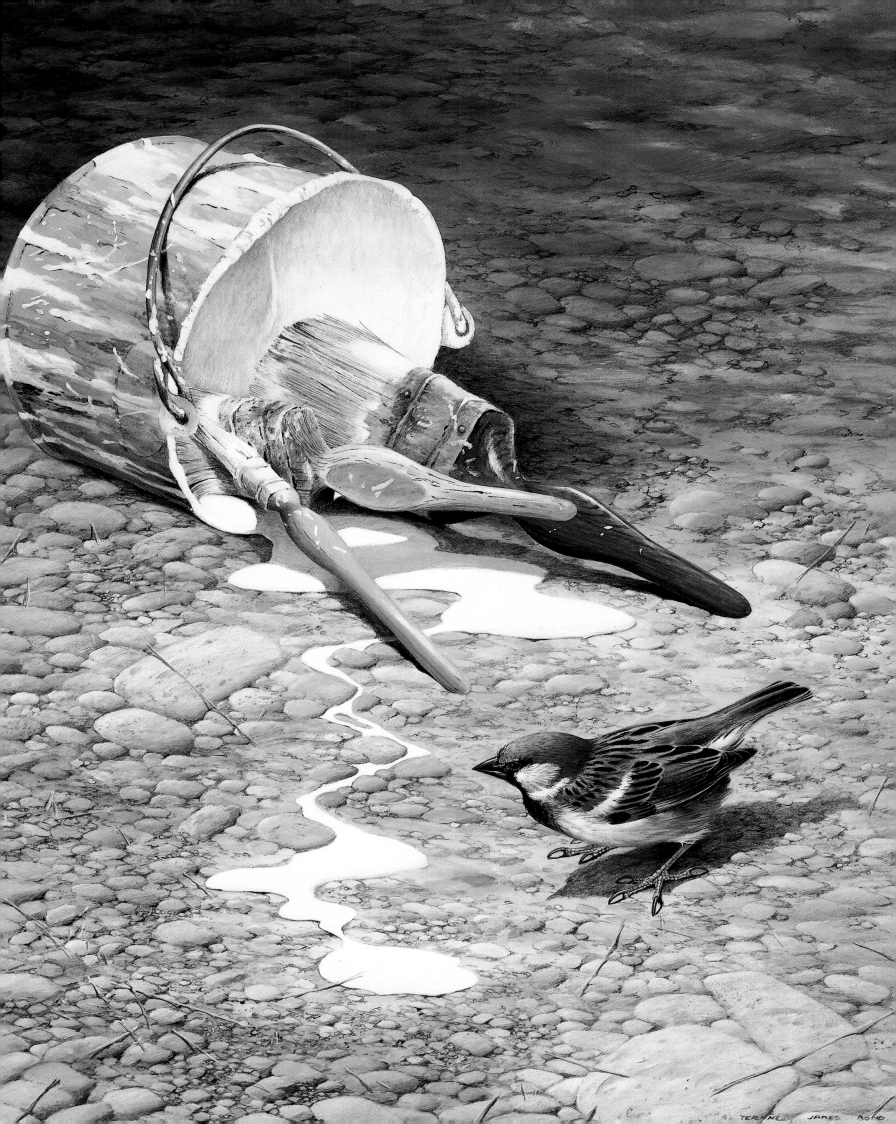

FIELDFARE

Turdus pilaris

In Great Britain, this is a bird of autumn and winter, a sign of hard weather as it fills the fields and hedgerows after the swallows and martins have left for warm, sunny Africa. In autumn, great numbers move south and west from the Continent, and the east coast of Great Britain in October is often the scene of enormous, overnight arrivals. They swarm in the orange-berried sea buckthorn and flow from roadside hedges, where hawthorn berries are abundant, in front of passing cars or cyclists. As they go, swooping low from the hedge before picking up speed, they show their distinctive broad, pale-grey rumps and black tails. The lanes are full of deep, quick, chuckling 'chak chak chak' notes, which have a peculiarly pleasant, comforting quality.

The winter flocks, having stripped all the berries from the hedgerows, and taken their fill from the fallen apples in our orchards, roam the fields, frequently mixing with redwings, starlings, blackbirds and lapwings. In midwinter many are to be found in Wales and the West Country, with much of eastern England having been vacated. If birds in the east are caught out by a sudden fall in temperature, or a deep fall of snow, great flights of them pass over all day long, seeking milder conditions and open ground to the west. Such hard-weather movements, often involving skylarks, redwings, starlings and lapwings, are dramatic and entrancing.

Fieldfares are handsome birds, and by spring have an even richer, more strongly patterned plumage. Spring flocks, which may linger through April in great numbers, move back east before leaving for the Continent. They are noisy, energetic and colourful. Although likely to make for the nearest tall tree at the least disturbance, they usually sit out in the open and allow a good view.

These flocks may be several hundred strong, and few sights are more attractive than a gathering of fieldfares systematically working the surface of a ploughed field or a well-grazed meadow. They spread out, all facing one way, hopping across the ground in springy bounds, seeking worms and grubs in the rich earth.

There are strong similarities between this painting and the song thrush on the white-painted fence (page 25). Dominated as the bird is by the strong, graphic shape of the hawthorn tree, the subject remains in control of the composition.

Fieldfares are birds for which I have a great affection. They evoke memories of teenage years spent on my parents' farm in Suffolk, and they herald the departure of one season and the onset of another. Harvest over and a return to school imminent, I would walk around the stubble, under hawthorn hedges filled with the commotion of fieldfares and redwings squabbling with blackbirds for the ripest berries. Fieldfares, choosing to spend the winter with us – I secretly admire that in a way – are able to hold their own, and even better the aggression of the blackbirds. But they have a gentler side to their nature, too. My solitary bird in the picture shows that resigned yet confident attitude. Imagine, if you can, a still, cold, damp, grey 'never to get properly light' sort of day in January. Most of the hedgerow food has been exhausted. The fieldfare is sitting next to what may be the only berry left on the tree: try and get it, Mr Blackbird, if you dare!

In summer, fieldfares form simple monogamous pairs, but the partnership is strictly for one season and in the following year the same pairings are exceptional. Some pairs are isolated nesters but most nest in loose colonies, often numbering forty to fifty pairs. Bramblings, redwings and chaffinches are particularly associated with fieldfares, and even aggressive shrikes will nest confidently and amicably within the colony's bounds.

'JANUARY', FIELDFARE, 20 X 16IN. (50.8 X 40.6CM), ACRYLIC ▷

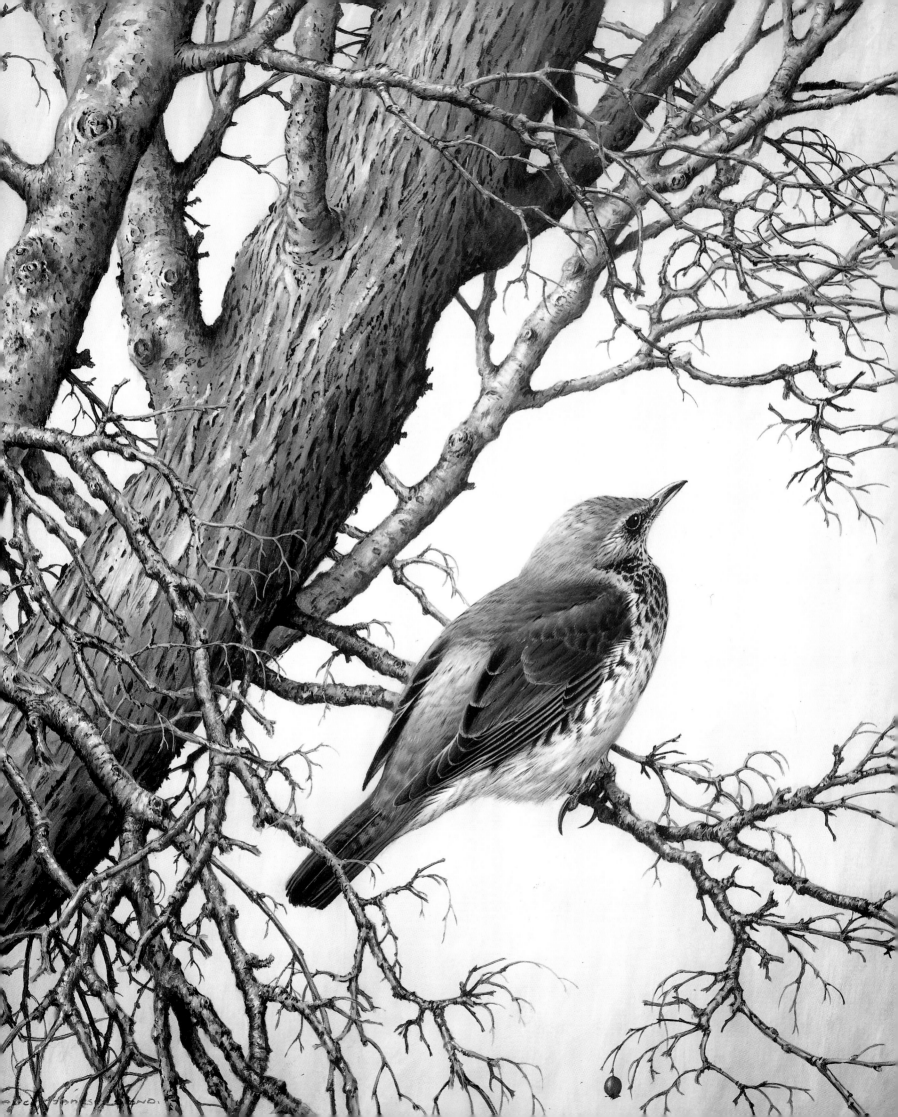

GREAT SPOTTED WOODPECKER
Dendrocopus major

It is debatable whether the New World or the Old World woodpeckers are the more attractive. Woodpeckers are not everyone's instant choice when asked to name a 'beautiful bird', but the family does include some remarkably fine species. They have a curious shape and peculiar behaviour, marking them out from the general run of small birds, but their patterns and colours are designed to perfection. Red-bellied and golden-fronted, red-headed, pileated, ladder-backed and acorn woodpeckers, not to mention the flickers and sapsuckers, create some splendid pages in North American field guides. European books are adorned by green and grey-headed, black and three-toed, Syrian and middle spotted, white-backed and lesser spotted woodpeckers, all, in their own way, birds of particular beauty.

Of course, the book plates can do little but whet the appetite: the real things are infinitely better, as they fly from tree to tree, climb up and around trunks and branches, even hang upside-down from some of the smaller twigs. Woodpeckers are always busy, always alert and sharp-sighted, ready to fly on to a distant tree at the least disturbance. They do so with a distinctly undulating flight, progressing with bursts of wingbeats and long, curving swoops with wings tightly closed. At the last moment, the bird swoops upwards to land flat against an upright tree.

The great spotted is a middle-sized woodpecker, rather small by American standards, but typical of European woodpeckers. It is in the boldly pied group and, like most, has splashes of vivid red setting off the artistic design of black and white patches, bars and spots. As Terance shows in his fine painting, the 'white' parts actually have a whole range of colours, from spotless white to rich creamy-buff.

Great spotted woodpeckers come to the gardens of those fortunate enough to live within reach of a wood. They are especially attracted to lumps of suet or cheese, as well as the traditional peanut basket. Terance sees them every day from his window, as they swing from slender branches of birch and willow, as well as climb the solid trunks of oak and ash. As he says, they are not always on the thickest, oldest boles, as so often portrayed.

In Great Britain they are widespread in all kinds of mixed woodland and pine forest, but they are not found at all in Ireland. In Europe the great spotted is a common, widely distributed woodpecker, and its range extends right across Asia. While continental birds have to be separated from several other black-and-white woodpeckers, in Great Britain there is only one other species, the lesser spotted, and that is much smaller and altogether less dramatic. If ever there is room for confusion, which is unlikely, the large, white shoulder patches of the great spotted species will make it easily identifiable.

Leaving aside the fact that a little Payne's grey was included in the underpainting of the background of this picture, the work as a whole is executed in four colours. The repetitive range of pigments, including raw umber, Hooker's green, yellow oxide, and (usually) a dark grey, seem to form the basis of most of my tree trunks and it is intriguing how extensive a range can be achieved with such a restricted palette.

Low-key green and grey work well juxtaposed with bold colours on a main subject, and they do not come much bolder than the great spotted woodpecker. Predominantly only three colours make up the plumage, with the only concession to any bright hue being the brilliant red. It is the way that the colours are arranged that give the impression of such a striking bird.

GREAT SPOTTED WOODPECKER, 24 x 20IN. (61 x 50.8CM), ACRYLIC ▷

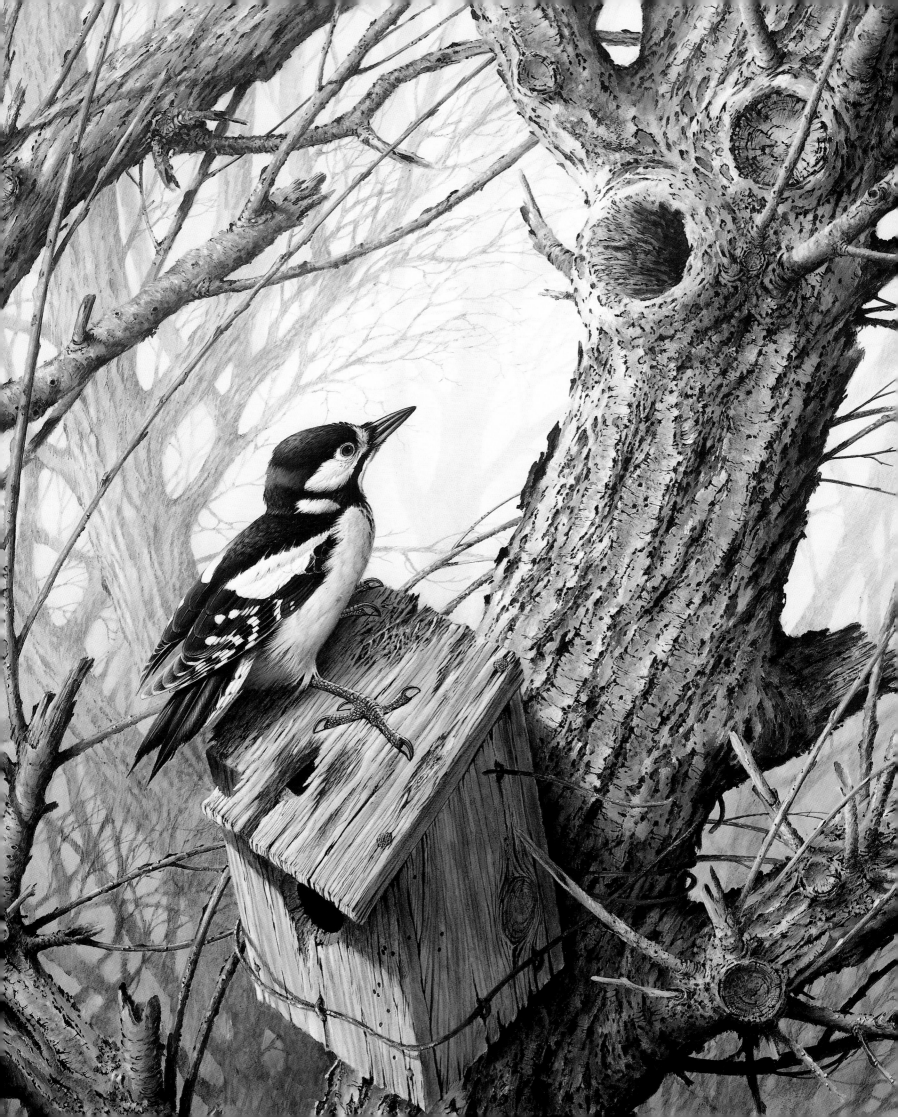

REDWING
Turdus iliacus

Noticeably smaller and slighter than a song thrush, the redwing is the smallest common thrush in Europe. Compared with the song thrush, it is darker and more contrasty, and has 'sharper' facial features, with a pale stripe over the eye, dark line through the eye and dark cheeks, and a pale line beneath the cheeks, all adding up to a 'stripey' face. The song thrush is much blander and plain-faced by comparison.

Redwings breed in northern Europe, from the south side of the Baltic across the whole of Norway and Sweden, Finland and Russia. A darker race nests in Iceland, and a small number breed in Scotland, although the recent colonization there has shown signs of faltering in recent years. In most of the United Kingdom, certainly, the redwing is a winter visitor.

Like fieldfares, with which they are often found, redwings arrive on the east coast in something of a rush in October and November, filling the hedges and soon stripping all the available berries. Then they have to move into the fields, joining other thrushes and starlings, feeding mostly on earthworms.

If the weather suddenly turns very cold, or if there is snow, redwings suffer more than most birds. If they can, they fly west; south-west England, South Wales and Ireland provide a milder refuge for great flocks of these rather delicate birds. Those that are caught out by the weather, however, may move into gardens, and can be found seeking food and shelter in all kinds of places, including city parks, central reservations on motorways, even suburban roundabouts. Spray and salt from roads may keep a little, grubby strip of grass clear of ice and snow and the poor, bedraggled birds huddle there for a while, but may face a bleak and very short future if conditions fail to improve.

Some enter gardens and may be saved by the food put out there. If there are old apples or cotoneaster berries, the redwings may thrive, but they are slow to take more artificial kinds of food. Each autumn, although they are a sign of winter to come, they are welcome arrivals, especially the first ones glimpsed in a hawthorn, or hiding away in a still-leafy apple tree. Their flight call is one of the most distinctive of all bird sounds. It is often heard on clear nights, in October and November, as redwings pass, unseen, overhead.

By the tail end of winter, most birds that feed on fruit and berries are running out of supplies. Invertebrates and worms are out of reach in hard frosty weather, and species like the redwing are then stretched to the limit. In some cases they are tested literally to the bitter end.

This painting shows a scene that is familiar to me every winter. As soon as the snow arrives I put out apples and fruit daily. Notwithstanding the aggressive resident blackbirds, the redwing is usually able to get enough to live on, and gets through the coldest night, but it is vital that food is available for it first thing in the morning.

In summer, redwings seek birch or mixed woodland, often with a mixture of spruce and pine, sometimes willow thickets close to remote peat bogs on the edge of more mountainous terrain. In Iceland they may nest on rockier ground, even among rocks where there is hardly a bush to be found.

A redwing in its territory eats mainly worms and insects, with far fewer berries than in winter. Unlike the fieldfare, redwings breed in isolation, although in some areas the density is such that a small, loose colony may be formed. The song has a distinctive rhythm, with lengthy phrases separated by gaps of three or four seconds. Each phrase consists of up to fifteen notes, with a fluty quality, descending or ascending the scale.

'WINDFALLS', REDWINGS, 24 X 20IN. (61 X 50.8CM), GOUACHE ▷

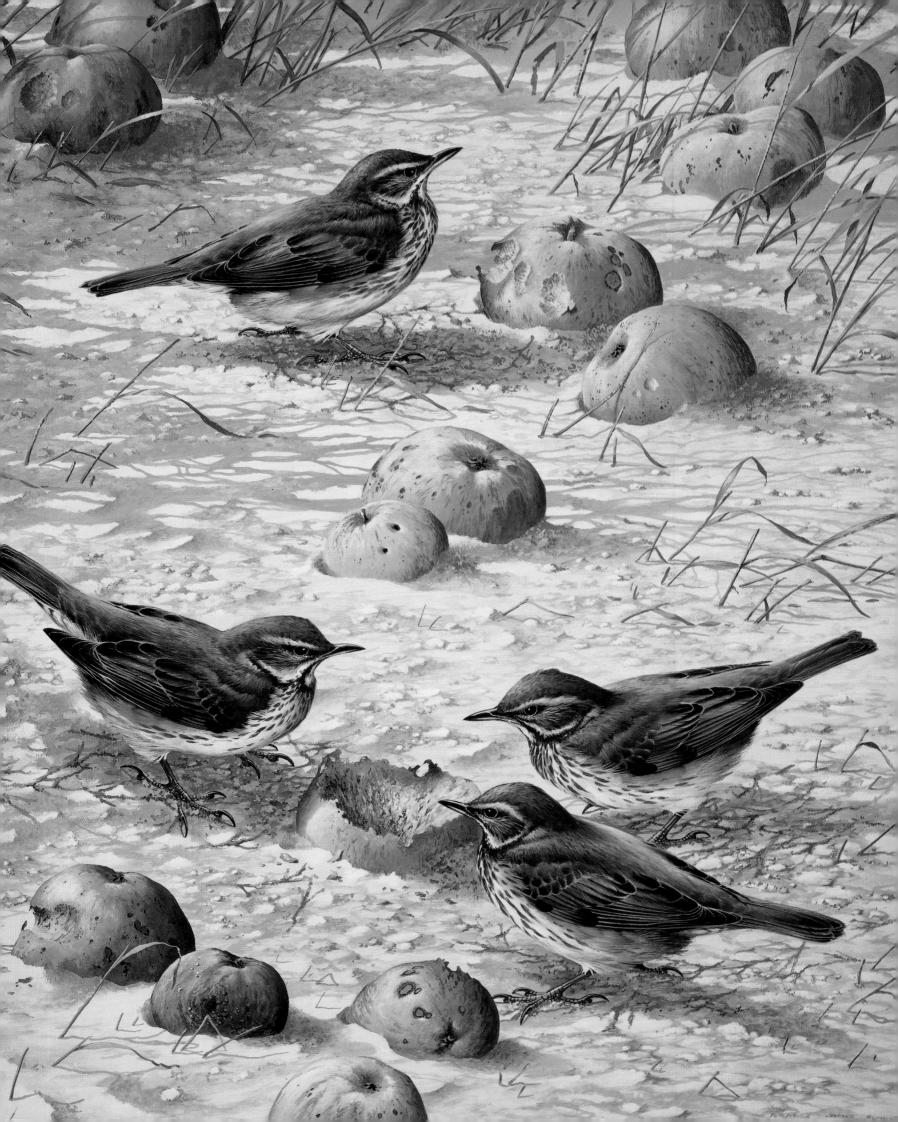

SONG THRUSH

Turdus philomelos

The clear, still air of a late winter evening, as the sun sets beyond tall conifers of a town park or the complex skyline of wooded gardens, chimneys and television aerials, is split by the purest, most passionate notes of any British bird-song. The song thrush, perhaps lacking the flowing melodies of the blackbird and the throbbing beauty of the nightingale, surpasses them both with the sheer quality of some its most bold, most powerful phrases. The finest notes are breathtakingly pure.

A popular image of the song thrush is the snail-eater, smashing hard shells of large snails against an 'anvil', maybe a stone, or simply the corner of a paved patio. The smacking, tapping noise of a thrush whacking a snail against such a surface is peculiarly distinctive. On the coast, song thrushes sometimes venture on to the seaweed-covered rocks to mete out the same punishment to the periwinkle population.

Snails form a relatively small part of the thrush's diet most of the year, but they do have a special significance. In studies made in suburban England, song thrushes fed almost entirely upon earthworms from December until March, unless heavy snow made them hard to capture, in which case the thrushes turned more to snails. Snails were a much more popular item in late summer, from July to September, perhaps reflecting the dryness of the soil and the difficulty of capturing worms. In June, caterpillars were the most frequent food; from September to November, the thrushes were berry-eaters.

All the thrushes from Denmark, Norway and Sweden eastwards, move south and west for the winter, many reaching north Africa and the Middle East, where they do not breed. The movements depend to some extent on the weather, but, unlike the rather random movements of redwings and fieldfares, the migrations of song thrushes seem much more fixed, and individual birds return time and again to the same place. Sadly, however, vast numbers do not survive their journeys, as they are among the most frequent victims of hunters in France, Spain and south-eastern Europe, and hundreds of thousands end up on restaurant tables, or in jars of pâté, in the Mediterranean region.

Suburban song thrushes nest in gardens and parks, often choosing a thick ornamental conifer (not much good for feeding birds, but often ideal for early nesting cover), the depths of a beech or privet hedge, or a thicket of ivy tangled around the base of a tree. The nest is much like a blackbird's, a thick, stout basin of woven grasses and leaves, but the inside is left as bare mud and dung. The eggs are amongst the most beautiful of bird's eggs: a simple, intense sky blue, dotted irregularly with inky-black specks.

This is a favourite painting of mine. It typifies my approach: minimal colour, lots of texture and plenty of detail. Busy and complicated paintings need very little colour: the shapes would be lost if the eye had too much to absorb. In a fairly monochromatic image, such as this, I like to include an object that seems to be in complete contrast to the general artistic order. In this picture it is the red nylon twine around the gatepost. If understated and properly placed it works as a foil to the primary colour scheme without being a focal point, rather like a suitable tie worn with a sober suit.

As a simple exercise, compare the contrasting results of this painting with the green woodpecker and silver birch on page 171. There is a painting with only three components: bird, grass and trees. But consider the almost overpowering effect that the colour range provides in such a simple structure.

SONG THRUSH, 24 x 20IN. (61 X 50.8CM), GOUACHE ▷

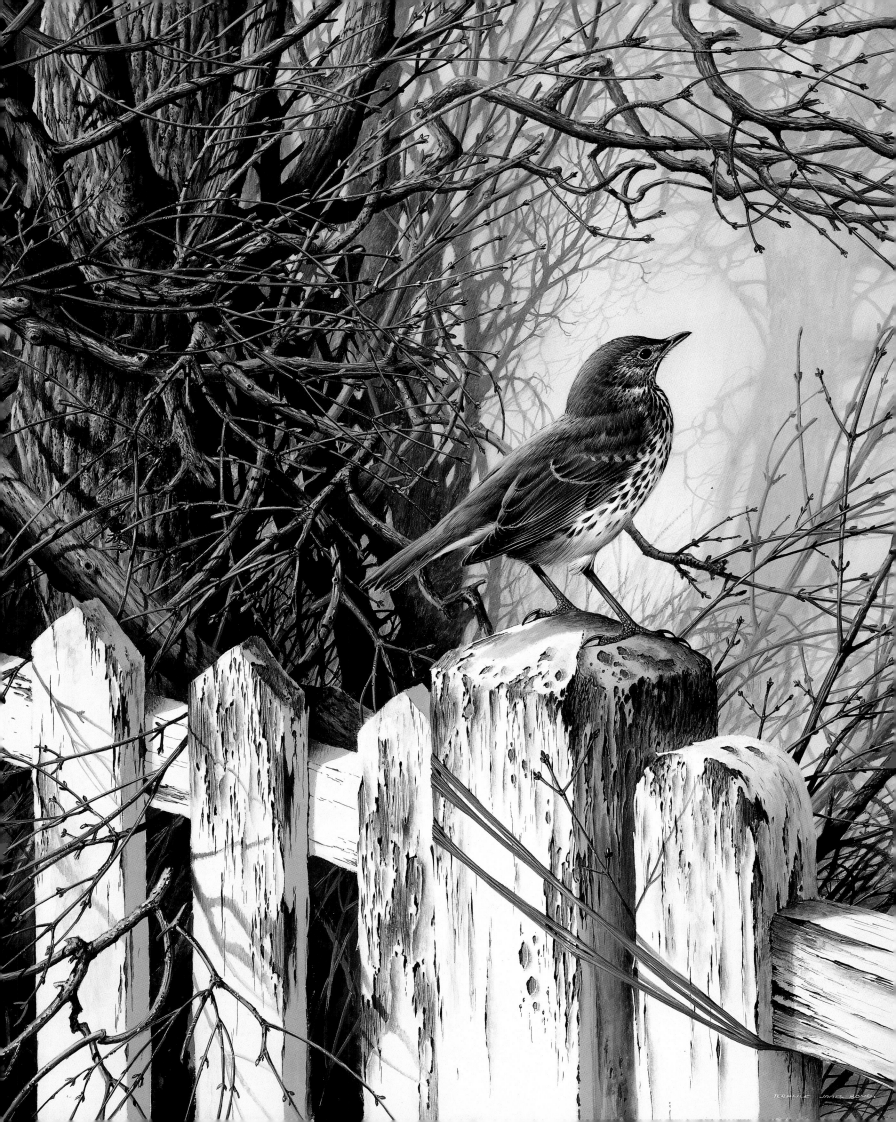

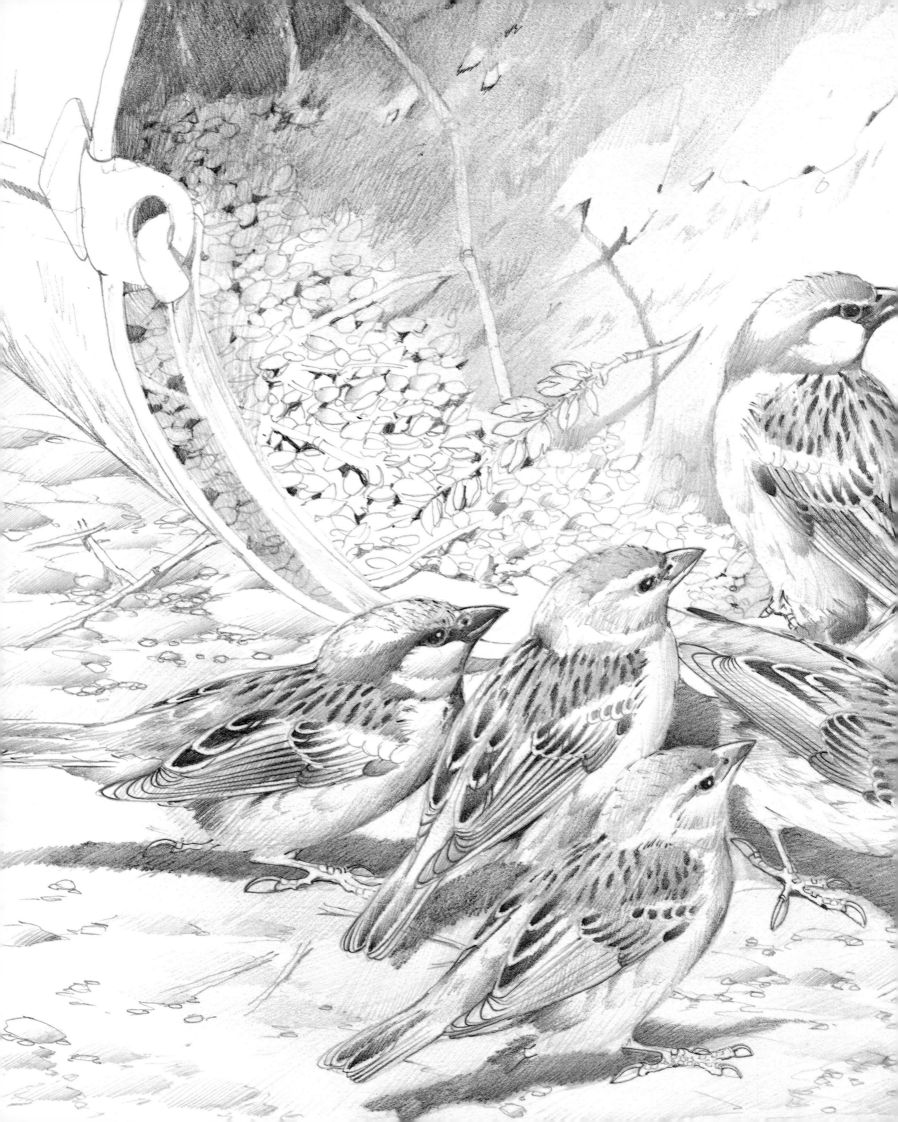

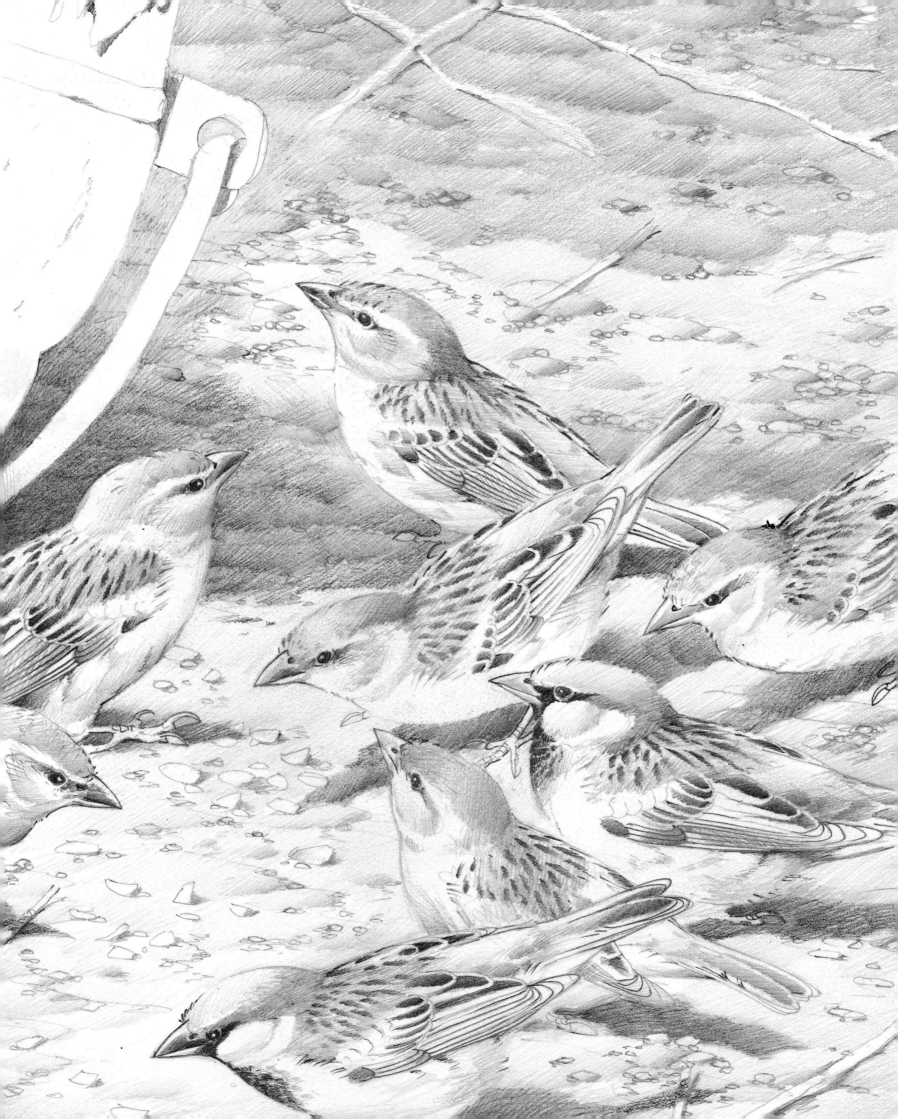

HOUSE SPARROW
Passer domesticus

In Great Britain, house sparrows are to be found practically everywhere. They are also now common and widely spread in much of the USA and in various other parts of the world, where they have been introduced either by accident or design.

The sparrows of the world – not including the American sparrows (a different group, more akin to Europe's buntings, but with the same English family name by mistake) – include some surprisingly striking and colourful birds. The Dead Sea sparrow, the chestnut sparrow of Africa and the Spanish sparrow really are attractive birds, sparrows or not. What, then, of the house sparrow? Seen through fresh eyes, in the clean countryside where its plumage is not soiled by fumes, it is a surprisingly handsome little bird. So familiar, it is inevitably overlooked: all the better, then, that it is so frequent a subject in Terance Bond's paintings.

No excuses are offered in defence of another house sparrow painting! This was intended to become the pièce de résistance of all my sparrow pictures. It was also an exercise in producing something almost monochromatic. We are back to my favourite scenario: lots of detail, lots of interest, but a limited range of colours. The only possible improvement for the next multiple sparrow painting is to increase the number to fifty. I'm thinking about it!

One might assume that all that there is to be known about the house sparrow, is known. In fact, it is a species that gives museum ornithologists, as well as field workers, plenty to chew over when they begin to look at its variation worldwide and attempt to put the varieties into some sort of logical, organized system. Fortunately, for most of us, a sparrow is a sparrow and that's the end of it, but it does illustrate that even the most 'ordinary' bird can be instructive, as well as difficult, in a more scientific way.

House sparrows have been divided into no fewer than twelve races, or subspecies, which themselves can be put into two main groups: six into a west Asian/European group and six into an Oriental group. Some would argue that at least one member of the latter group, the race found in India, should be treated as a different species altogether! It is, indeed, confusing but, essentially, even the more obscure races look more or less obviously like house sparrows, whether smaller or larger, richer or duller in colour, whiter-cheeked or greyer-cheeked, small-billed or large-billed, with a larger or smaller black bib.

Subspecies are separated geographically and have some characteristic that makes them different from others, but not so different that they cannot interbreed: species are not usually able to interbreed, or at least to produce fertile young. These subspecies might, one day, through hundreds of thousands of years of evolution, become distinct enough to merit full species status: evolution in action. Somehow one might imagine that the house sparrow itself would, if only it knew about all this, have a wry smile at the expense of the poor, confused ornithologist.

'THE OPPORTUNISTS', HOUSE SPARROWS, 30 x 24IN. (76.2 x 61CM), GOUACHE ▷
◁ HOUSE SPARROWS, 14 x 20IN. (35.6 x 50.8CM), PENCIL

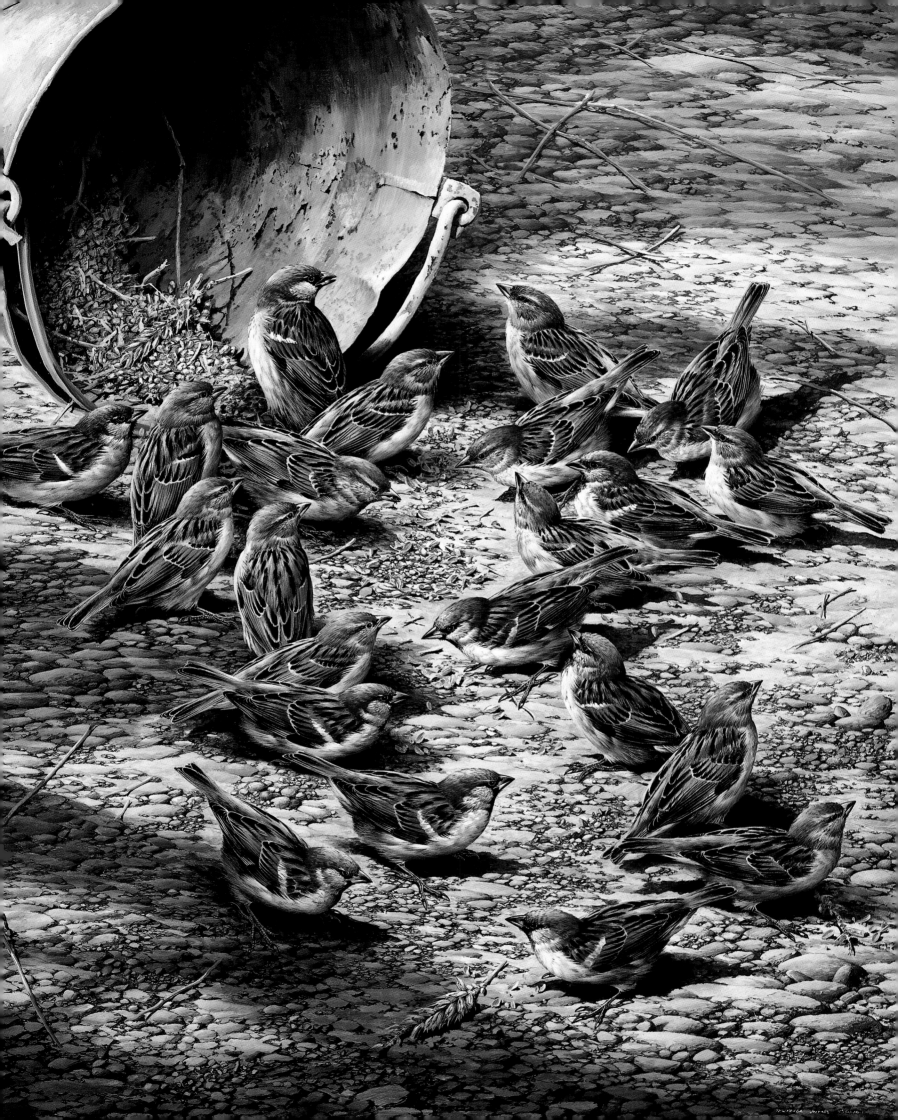

WREN

Troglodytes troglodytes

The wrens comprise some sixty species of American birds, with just one – known as 'winter wren' in North America, but simply 'wren' in Europe – found outside the New World.

The wren is one of the smallest of the family, about as long as a goldcrest or kinglet, but dumpier and weightier. Some island groups have their own race of wrens, mostly being larger, darker, or more clearly barred than average: the Faeroes, Iceland, St Kilda, the Outer Hebrides, Shetland, Fair Isle and other, larger regions have wrens of their own in this varied and widespread species.

It is largely a lowland bird in Europe, but does breed above the tree line in a few Alpine locations. It prefers rather moist conditions, and some of its island homes are truly wet and windswept – surprisingly bleak habitats for what is generally thought of as a woodland bird. In the north, it is a summer migrant, and in parts of eastern Europe it is a winter visitor, as it is over much of eastern North America. In western Europe, however, it is largely a year-round resident, but it is liable to suffer periodic catastrophic declines during severe winters.

In woods and gardens, as well as more open areas, it is a bird of low cover, foraging in upturned tree roots, under hedges and around buildings, along the bottoms of shrubberies and flowerbeds, through jungles of gorse and bracken, or in the dark, spidery crevices between rocks. It has a life of creeping, hopping and shuffling around in deep shade, using its thin, rather long bill to probe into unsavoury places where it might find a cluster of spider's eggs, a spider, or some kind of small beetle, or other unfortunate insect.

It uses similar places for nesting, as well as the undersides of bridges and holes in walls, where it can tuck in its peculiar, domed nest with an entrance in one side. These nests and sometimes wooden nestboxes are used in winter, when several wrens may huddle together for warmth. In exceptional cases, forty or even fifty or more will pack themselves into one box; it is however, quite possible that some of the first arrivals will suffocate at the bottom of such a tightly packed heap of birdlife.

Often a wren will give itself away by a rustling of dead leaves or movements in the undergrowth. Suddenly, out it pops, to perch momentarily in full view, as often as not with a few scolding notes, before it cocks and swings its tail, bobs its head and dives out of sight again. It may fly with a sudden flurry and whirring wingbeats across a track or clearing, scarcely slowing before it disappears into another thorny thicket. It is always irascible, excitable, and likely to burst into song, or a sequence of bad-tempered churrs and rattles.

Placing a tiny bird on a prominent perch is a favourite device of mine. It emphasizes the diminutive stature and the surprisingly long legs of the wren in comparison with something considerably more solid. This is one of what was intended to be a series of pictures showing wrens and nestboxes in combination. For some reason I progressed no farther than this one, which was number two.

Nestboxes, particularly with peeling paint and rusty nails, are subjects that I am always painting. The more dilapidated and fragile the construction, the more I like them. This whole painting pleased me so much that I was delighted when the publishers Mill Pond Press in Florida chose it as a Limited Edition Print.

The clean, bright colours, in a limited range, suit the mood of the picture perfectly. Despite the brilliant-yellow leaves screaming out for attention, there is little doubt as to the real point of interest in the composition.

WREN, 20 x 16IN. (50.8 x 40.6CM), GOUACHE ▷

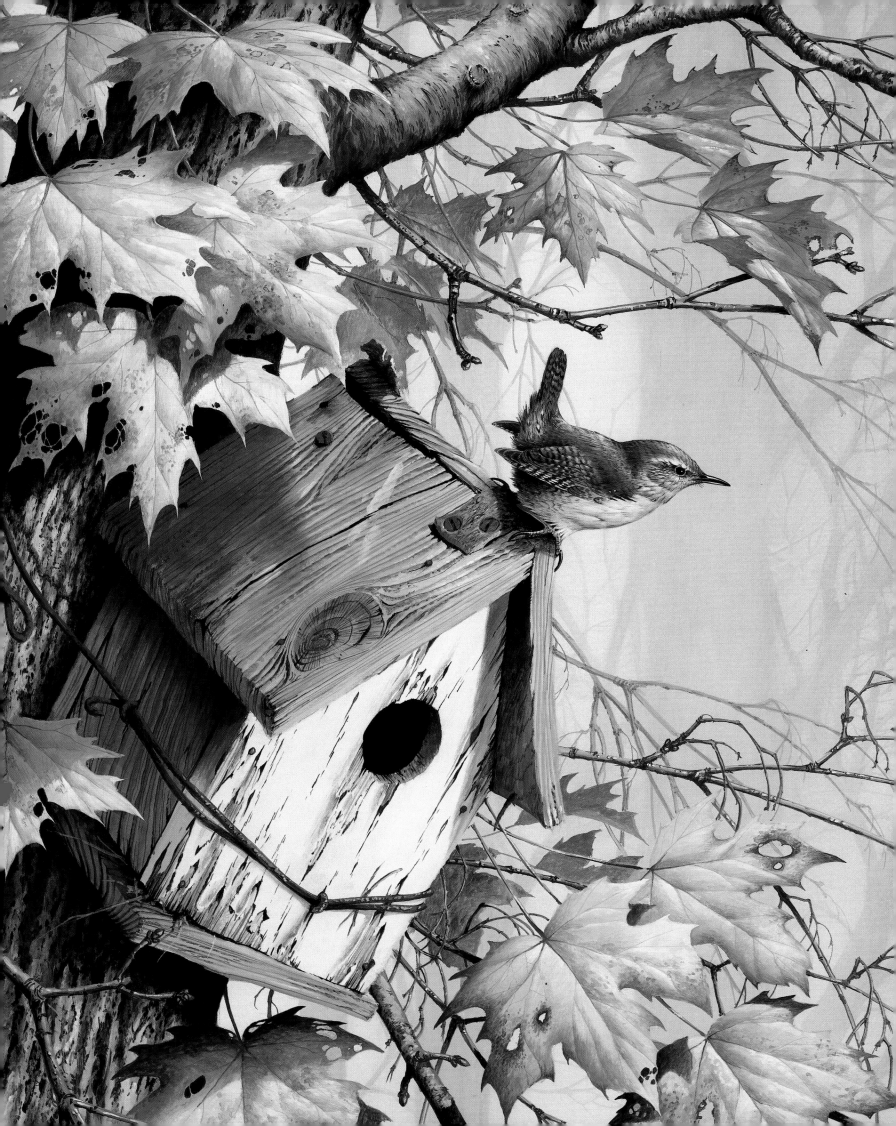

NUTHATCH
Sitta europaea

If there was ever a bird designed with the ornithological artist in mind, it has to be the nuthatch. Everything about this little bird is somehow perfect from a drawing and painting point of view. The colours and patterns are placed ideally to emphasize the anatomy. Even the black eyestripe runs symmetrically through the eyelines, neither above nor below, but neatly dividing the blue-grey top from the pale underside.

Of all birds, this one and the tree creeper are the most closely tied to trees. Like a woodpecker, the nuthatch occasionally comes to ground to pick up a nut, or it may resort to an old brick or stone wall, exploring the cobwebs and crevices for small spiders, insects and fallen seeds. Most of its life, though, is an arboreal one. Old deciduous trees are favourites, especially big beeches, limes and oaks, although it will also clamber about in big pines in more open coniferous forests. A few have discovered the delights and easy life of peanut baskets in gardens, and provide lucky people with endless entertainment from the kitchen window.

The nuthatch relies on its large, strong feet and sharp, curved claws to cling on to the bark, and it does so like a fly on a wall, and can go up, down or sideways with indifference. The nuthatch does not use its tail as a support in the way that a woodpecker habitually does.

Nuthatches have loud voices, with a series of boyish whistles and loud, ringing trills that echo through the woods in spring. They also tap loudly when hammering a nut or berry wedged into a crevice in the bark: a determined, regular tapping could equally emanate from a nuthatch, a woodpecker, or a great tit.

NUTHATCH, 16 x 12IN. (40.6 x 30.5CM), ACRYLIC

WHITE-BREASTED NUTHATCH
Sitta carolinensis

The nuthatch and the picture of the American white-breasted nuthatch are part of the same collection, and as far as I know, they still hang as a pair on the same wall. I cannot recall two paintings or species that complement each other as well as these.

The colour range used in the painting of the American bird was dictated, to a degree, by the bird itself. Its gentle, subtle, almost pastel shades demand that a similar range of hues be incorporated in the background, so as not to overwhelm the personality of this lovely bird. Displaying a more colourful and stronger plumage, the European nuthatch can hold its own in a composition of stronger colours and shapes.

More than once, in discussing the pictures in this book, Terance Bond sang the praises of the white-breasted nuthatch, which he clearly regards very highly. It is, indeed, a super little bird, one of four nuthatch species in North America. It is the largest of them, being about the size of the familiar European bird. It ranges over southern Canada and most of the USA, except for the mid-west plains and the higher ranges of the Rocky Mountains. Those found in the lower Rockies and the Great Basin have noticeably longer, more upswept bills than the norm.

White-breasted nuthatches prefer oaks and conifers in the west, and a wider variety of leafy trees in the east. A low, nasal call, just a short, single note, often draws attention to them up in the canopy.

WHITE-BREASTED NUTHATCH, 16 X 12IN. (40.6 X 30.5CM), ACRYLIC

WAXWING

Bombycilla garrulus

Waxwings are inveterate wanderers, going where their search for food takes them. As such, they are unpredictable. One year may see thousands all over western Europe and across Canada, the next almost none at all. They are among those birds that have irregular 'irruptions' depending on food supply and population levels. The correct combination of circumstances triggers mass migration.

Essentially what happens is that, in normal years, the waxwings and their preferred winter food of berries are more or less balanced. Then comes a particularly fine summer with plentiful food, principally mosquitoes, and the waxwings rear unusually large numbers of young. If, by chance, this should be followed by a really bad autumn, when there are no berries to be found for so many hungry mouths, the flocks have to get out and head south. It is in these winters, which follow no predictable pattern, that large flocks may arrive in Great Britain, even Ireland, and they are more easily found in North America.

The waxwing breeds in north-eastern Scandinavia, and in a relatively narrow band across northern Siberia, and from Hudson Bay westwards to Alaska. In North America, these north-western breeders tend to migrate east-south-east in autumn, wintering in southern Canada, east to Nova Scotia, but some move much further west, going south to California, Arizona, New Mexico and Texas.

In Europe and Asia, some groups are migratory, others resident, unless the weather or food situation forces a move. It is the birds from Sweden, Finland and western Russia that visit Great Britain. They tend to appear first in the north-east and then gradually, as the winter progresses, move southwards and, sometimes, farther west. As they go, they demolish local crops of hawthorn, rowan, cotoneaster and pyracantha berries and delight, too, in crab apples that are still on the trees. Their total list of foods is enormously varied, with anything from yew berries to mulberries, medlars to maple seeds, and flowers of jasmine to buds of willow likely to be tackled. They also require regular access to fresh water to drink.

When feeding like this, taking so many ornamental berries as well as natural foods, waxwings come into close contact with people sooner rather than later. They appear in gardens, town parks, orchards, and car parks surrounded by berried bushes, even in shopping centres. Planted roadsides and central reservations are typically full of berries, and many a birdwatcher has screeched to a halt in the nearest layby on seeing a crowd of waxwings right beside the highway.

I *have not seen a waxwing since 1988. In that year these glamorous birds visited Great Britain in large numbers. Painting waxwings is somewhat difficult and different from illustrating other birds. Their plumage is so silky and soft and there is really hardly a feather outline to be seen. The lovely, warm colouring is difficult to describe, too, but however you see it, the shades work well with red berries and autumn leaves.*

As they feed, waxwings communicate by calling to each other with high, shrill, rippling trills. A bout of calling may herald a sudden departure, or the arrival of extra birds to increase the flock. They typically perch upright and tug at a berry, sometimes leaning over to reach unexpected distances with their necks extended and whole body suddenly long and slim. Inactive waxwings tend to sink down, and are squat and dumpy. They also manage to reach out-of-the-way berries with all kinds of acrobatic actions, feeding almost with the agility and charm of small parrots.

WAXWINGS, 20 x 16IN. (50.8 x 40.6CM), ACRYLIC ▷

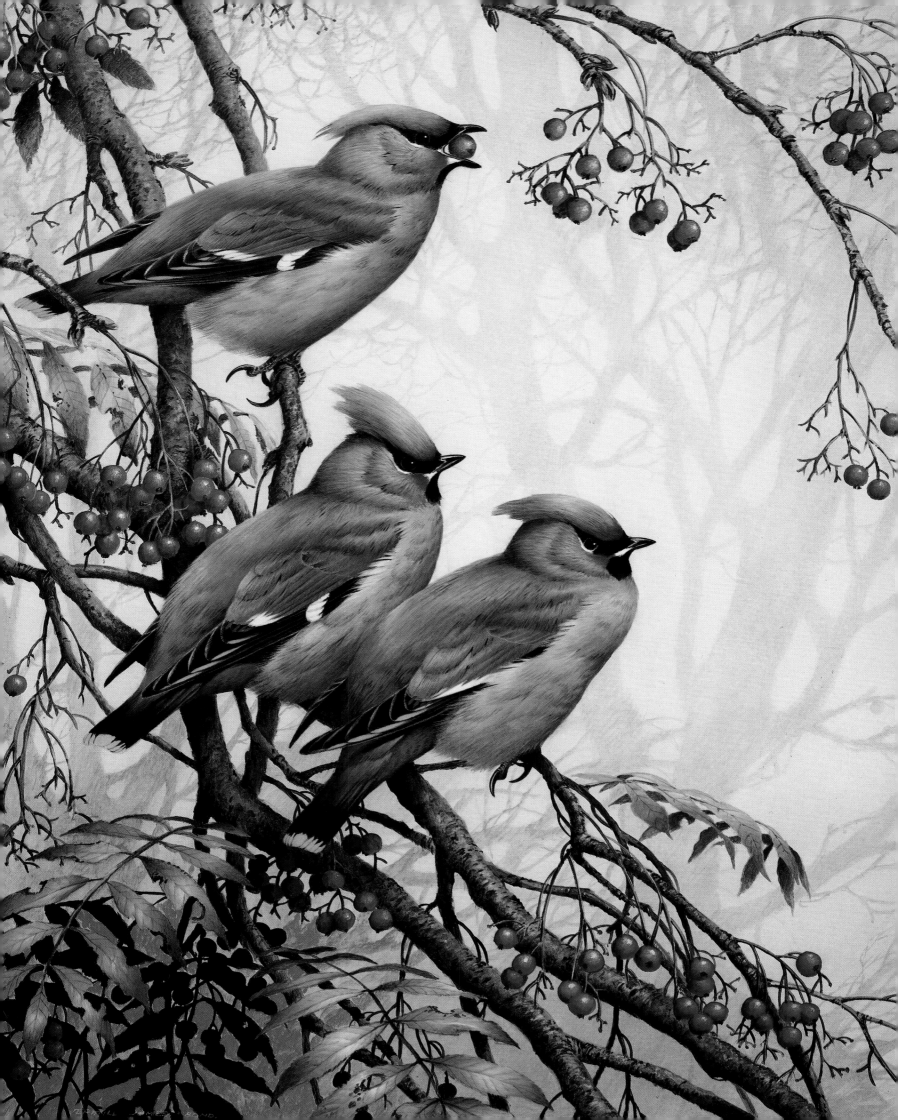

GREY WAGTAIL
Motacilla cinerea

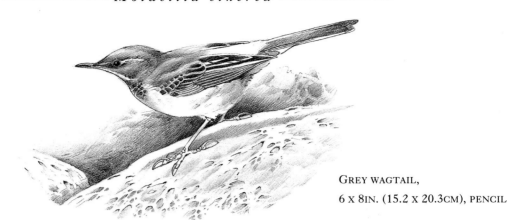

GREY WAGTAIL,
6 X 8IN. (15.2 X 20.3CM), PENCIL

In the wagtail family, a family full of elegance and delicacy, the grey wagtail is the most refined of all. It has the most slender rear body, the longest tail, and the most extravagant tail-bob of all the wagtails.

Unlike the yellow wagtail, the grey wagtail's upperparts are grey, and the male has a black bib in summer, as Terance shows in his painting. Nevertheless, the predominant colour is yellow in summer birds. In winter, juveniles and adults are dingy-buff beneath, but even these have a splash of vivid yellow beneath the tail. However, there should be no confusion in winter, since the yellow wagtails are in Africa.

That vivid chrome yellow is the main reason why many people wrongly identify this striking bird. One can see why, of course: it is odd, perhaps, that the bird has been named after the grey rather than the yellow in its colour scheme. The intense cadmium hue is not a pigment that I need to use very often: perhaps a little on the chest of a great titmouse, but not on much else. Grey wagtails are handsome birds with a satisfying combination of colour and pattern. No other colour was really necessary for this painting. I have emphasized the size and weight of the stones to balance the impact of that bright plumage, and evoke the bird's small size in proper perspective.

While all wagtails like water, the grey is most closely attached to running streams. It prefers rocky rivers, often tree-lined ones in hilly country, but also finds itself a home beside mill races and other artificial sites that break the flow of lowland streams and rivers. Together with the flow of clean, fresh water, it delights in the presence of slabs of rock and boulders, often with vertical cliffs outside the tightest bends of the stream. Failing that, however, concrete sluices and culverts will do, and in winter it will even forage around pools of rainwater that collect on flat roofs and undisturbed car parks, turning up in town centres far from any nesting area.

The nest may be used for more than one brood; sometimes even three broods may be reared in one nest during the course of a single summer. Usually second and third clutches of eggs are laid in fresh nests. The actual sites of nests seem to be traditional and used over many years. It seems that pairs are likely to be faithful to their territories from year to year.

Grey wagtails often catch flies in midair, showing a high degree of manoeuvrability, using the tail as a rudder in tight turns, and even vertical chases. This aerial flycatching is most obvious in summer, among riverside trees, when many insects are aloft. In winter, when the birds often move to bleaker, more open surroundings, deft picking of food from the ground is more frequent.

GREY WAGTAIL, 20 X 16IN. (50.8 X 40.6CM), ACRYLIC ▷

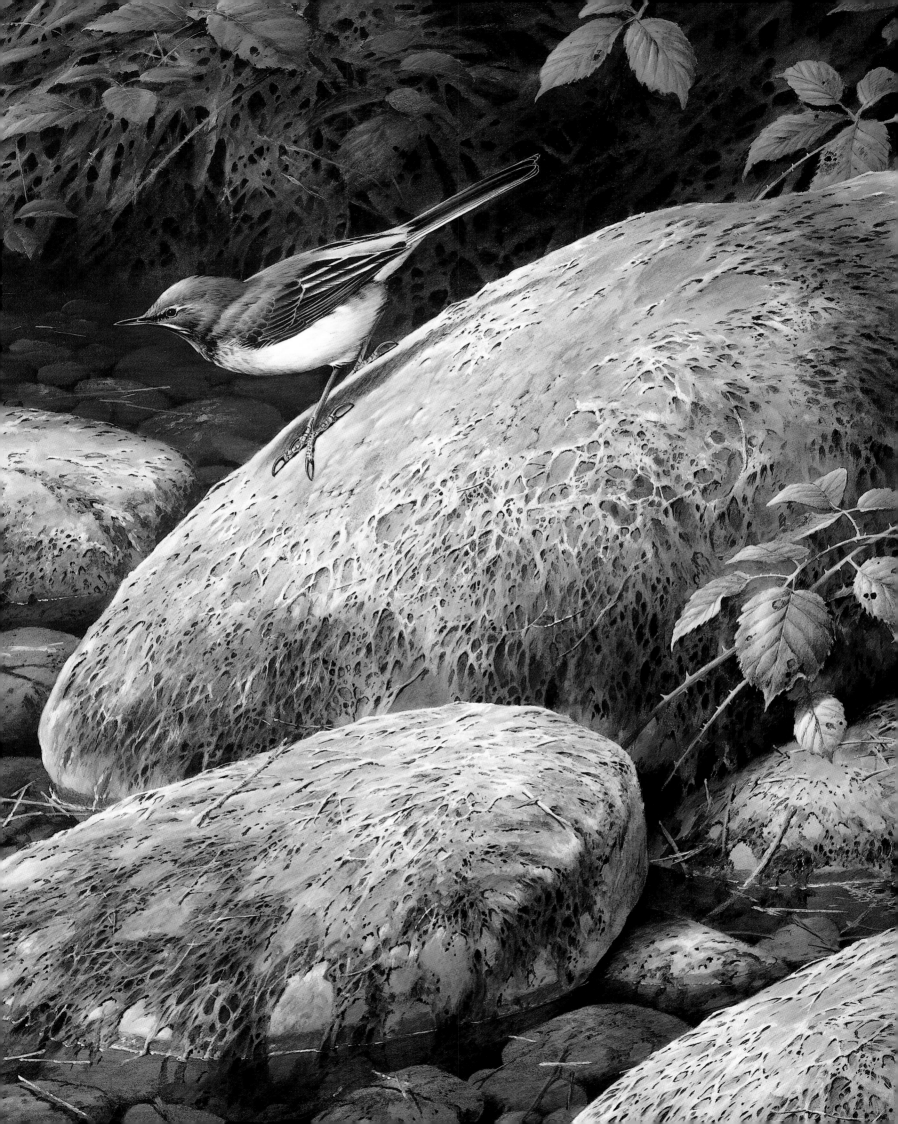

BLACKBIRD
Turdus merula

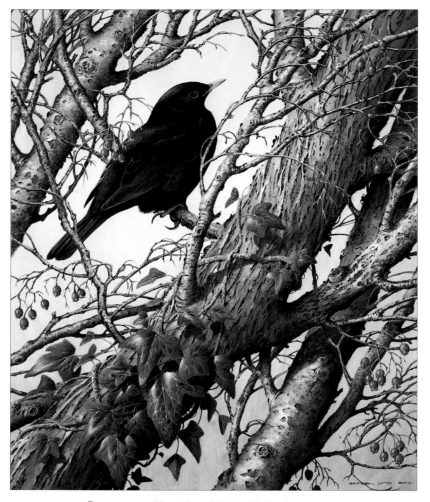

BLACKBIRD, 20 x 16IN. (50.8 x 40.6CM), ACRYLIC

The blackbird has adapted as well as any bird to the suburban environment. These two paintings show the bird in two distinct settings, one decidedly urbanized. Of the two, I think I prefer the hawthorn bush setting: then, I suppose I would do – my love of trees again!

Dark green and red are very complementary to the blackbird's plumage, and the red berries on the hawthorn lift the otherwise low key colours into a different spectrum. Interestingly, if the grey background were a little more blue, the painting would contain the three primary colours, red, blue and yellow.

Blackbirds are characterful birds. A typical action is a short flight from a lawn to a fence or the ridge of a roof. The wingbeats are quick bursts between short glides, and the broad, full tail is used as a rudder to assist easy passage through conifers and rose bushes. On landing, the head is raised, the tail cocked and half spread, before it slowly subsides. Even in silhouette, a blackbird is instantly recognized by this tail-cocking habit. This feature is part of the bird's 'jizz', that is, the combination of characteristics used to identify a species.

It is the rich, fluty song that is the chief glory of the blackbird, but its familiarity and bold, jaunty air make it a universal garden favourite. The male is instantly identifiable, being wholly black, except for its orange-yellow bill and a thin ring of yellow encircling the eye. Well-known to all, it is never relegated to the status of a nameless small bird or 'some sort of thrush'. Anyone can put a name to it, and so it is hard to ignore: its very identity lends it a particular appeal and popular recognition.

Adult males are all black, sheeny in fresh plumage, but fading to a matt black as the feathers wear. The feathers of the wingtips, particularly, have a browner, faded appearance when they are old. In flight, in fact, the blackbird catches the eye against a dark hedge because of its paler wingtips. They are noticeable even in the briefest of views of a bird escaping to the security of a shrubbery, or the depths of a holly bush.

Females, however, are quite different, being all dark brown except for the throat, which can be a dull white, with deep- or rufous-brown streaks and spots. The overall darkness, despite some spotting underneath, and the very dark legs is quite unlike any other garden thrush. Birds in fresh plumage in November look darkest and most rufous, with the spots most marked, but they become duller as the winter progresses.

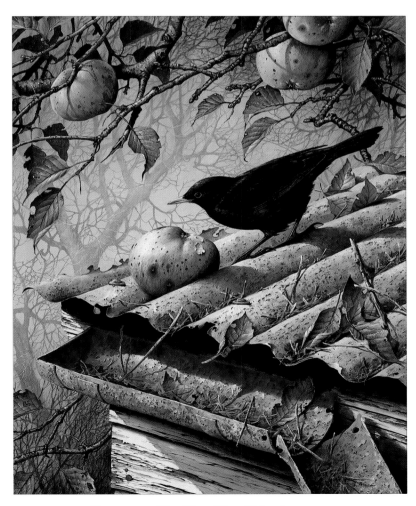

BLACKBIRD, 24 X 20IN. (61 X 50.8CM), GOUACHE

REED WARBLER & CUCKOO
— Acrocephalus scirpaceus & Cuculus canorus —

Reed warblers are plain but nonetheless attractive. Small brown birds they may be, but they are very different form other warbler groups. They are warm brown, even a little rusty on the rump, with a paler underside, almost white on the throat. The bill is relatively long, with a slightly 'spike-like' impression, while the tail is smoothly rounded at the tip.

The reed warbler's song has a distinctive grumpiness about it that gives it away. It is quite loud and harsh, but not always really grating: low and guttural, without much music in it. The pattern is characteristically repetitive, and includes regular changes of pitch: a high, sharp 'chik chik chik', then a low, churring 'gurr gurr gurr', a sweeter 'chirruc chirruc', and so on, in a regular, rhythmic flow, which is always pleasant, if not a great virtuoso performance. They sound all the better in a big reedbed at dawn, when dozens can be heard singing at once, spread out in a regular pattern of small territories.

Reed warblers build exceptionally neat nests, slung around several reed stems. The nest is soft and somewhat elastic, and has a deep cup that holds the eggs and chicks safely, even when the reeds are stirred by a good wind.

The cuckoo parasitizes reed warblers regularly. Along with the dunnock, the reed warbler is one of the favourite hosts of the cuckoo, which watches the warblers at dawn, waits until the female has laid and left the nest, then moves in. The cuckoo deftly removes an egg in its bill, then, by a remarkable feat of acrobatics, lays its own egg directly into the nest. The young cuckoo hatches quickly, and soon sets about turfing out all of the reed warbler eggs and chicks, until it is left alone in the nest. Not recognized for what it is, it is fed and cared for by the duped warblers until it becomes a grotesque, giant imposter, calling repeatedly to be fed.

Unlike its father, which calls 'cuckoo' with its bill virtually closed, the young cuckoo holds its mouth open wide when it begs for food, reinforcing its irresistible wheezing sound with the sight of a giant, brightly-coloured gape. All this proves too much for many adult birds that are 'programmed' to feed chicks: here is a 'super chick', with both call and mouth grossly exaggerated, so adult birds with food for their young are unable to resist feeding it. Not only do the poor reed warblers push caterpillars into the young cuckoo, but passing strangers may even do the same. It all helps to ensure that the cuckoo gets enough to eat. The truly remarkable thing about the young cuckoo is that it grows up with no help of any kind from its parents, or other cuckoos, without even a clue that its parent is not really a reed warbler. How then, after migrating to Africa and back without instruction or company from any of its kind, does it court and mate with another cuckoo, which is surely a complete stranger to it? Why does it not imagine it is a reed warbler?

While looking out of the window one day, feeling uncomfortably hot and disinclined to paint – the temperature was well into the high eighties – I noticed one of the neighbouring cats contemplating a corpse lying in my meadow. It was a young cuckoo, which had presumably fallen from its host's nest. Unable to fly, it had attracted the attention of puss, who did not seem to know what to do with it.

I found the bird to be overrun with large ticks that ran up my arms as I handled it! Whether the presence of these parasites in such numbers was responsible for the bird's plight or not, I don't know, but its hopeless condition was quite evident.

That unfortunate individual is now part of my reference collection, and was used to help me paint the picture shown here.

REED WARBLER AND YOUNG CUCKOO, 20 x 16IN. (50.8 x 40.6CM), GOUACHE ▷

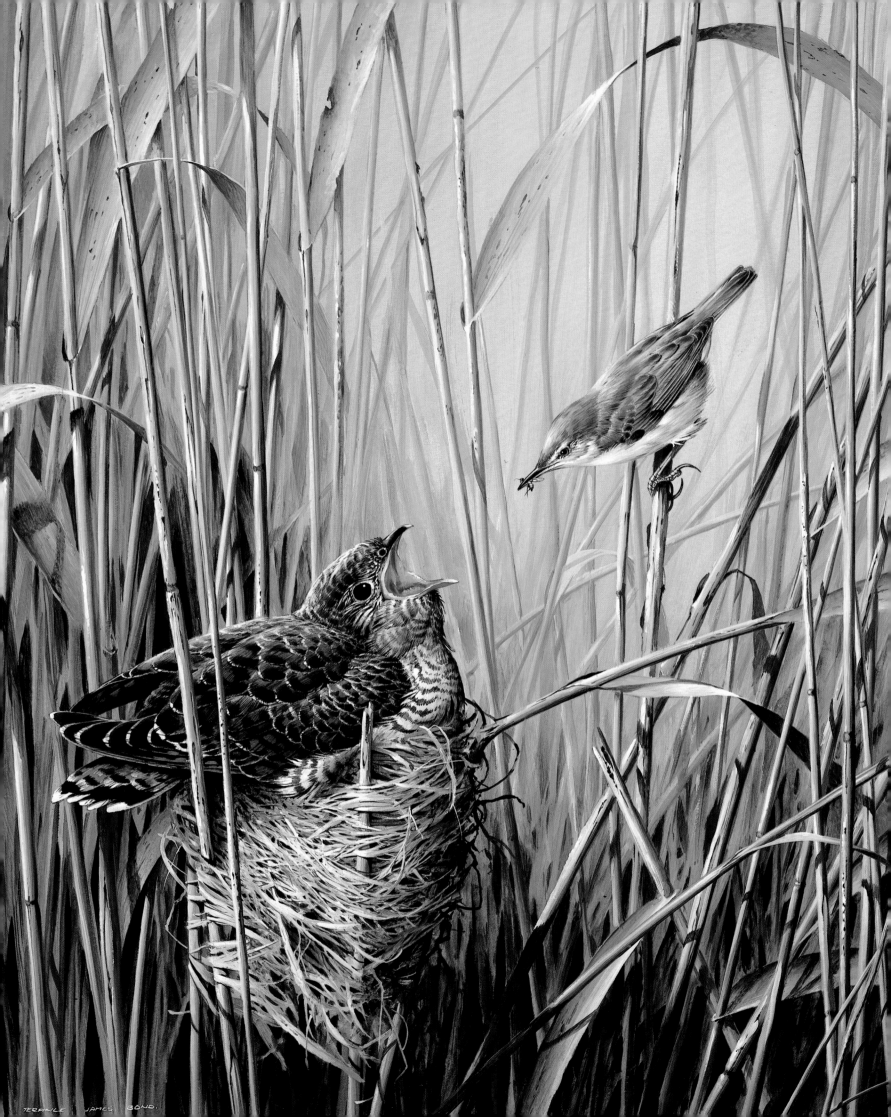

'After Harvest', wheat stubble, detail (see page 53)

THE IDEA
AND ITS
EVOLUTION

*C*lients visiting my studio often express an interest in the work in progress and are always, for some reason, keen to know what particular bird is being painted at that time. Occasionally a request is made to look at whatever is under the drawing-board cover, a favour that I generally refuse, simply on the basis that most incomplete works look a bit of a mess, and the inquisitive visitor is usually disappointed. Some are genuinely interested, however, in the stages that make up a large and complicated work. 'Where on earth do you start?' is a frequent remark when viewing a completed painting, so I hope that this chapter will give some idea as to how it all comes together.

KESTREL

Falco tinnunculus

Prior to undertaking any work on a painting, I tend to fiddle around with a few sketches and outlines on a cartridge pad in order to convince myself that the idea will really work. In this particular painting the composition was fairly basic. I knew, for instance, that the kestrel would be located at the top left-hand corner of the picture, and that the remainder of the work would consist, more or less, of stubble. This fairly loose and undetailed drawing was produced along with several other 'quickies' and it was the attitude of this particular falcon that appealed most.

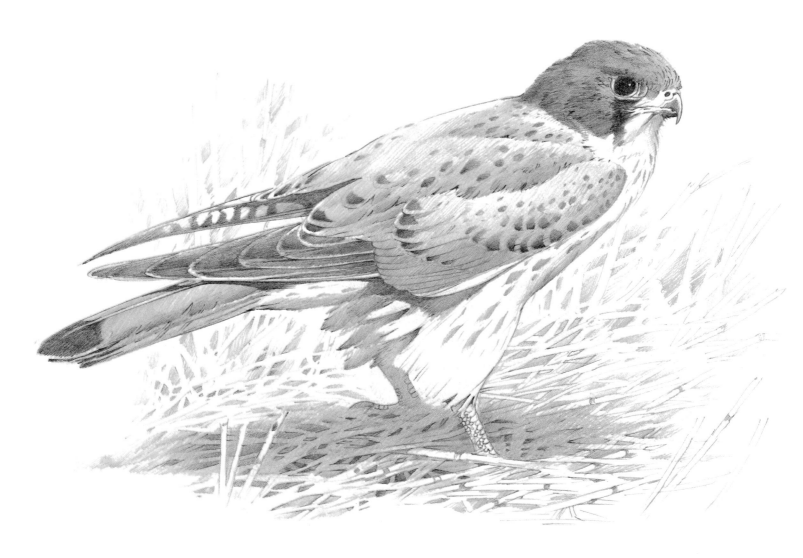

KESTREL, (PRELIMINARY DETAIL) PENCIL

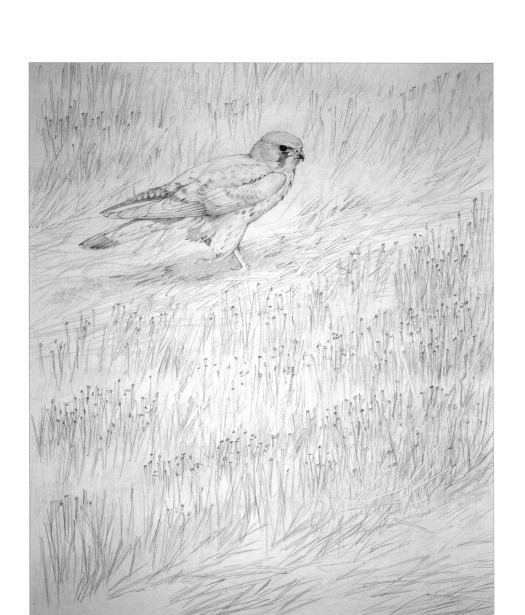

Stage two of the process is for the original preliminary drawings to be repeated, with possibly a few alterations, and then transferred to the board that will carry the completed picture. At this phase of the painting the subject was the first thing to be positioned and drawn in to any degree of detail. The remainder of the composition is then added, and the idea for the whole painting worked up in pencil to the stage where I think I have everything in its place. Detailing the stubble at this point would have been superfluous; for the moment, all that matters is that I know where each block or row is located in relation to the others.

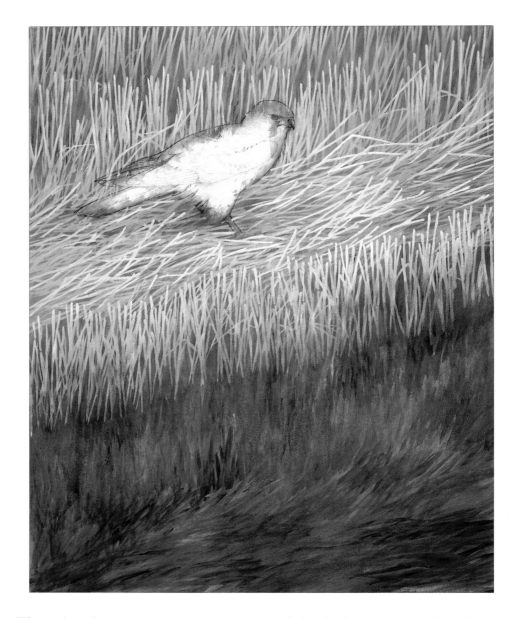

Three days later, the first paint is applied, in the form of a dark sepia and raw umber ground, the lighter areas of stubble represented at this stage by crude blocks of contrasting colour. By the time the work has reached the stage as shown in the top of this photograph, it would have received about six layers of paint or glaze; and a certain degree of redrawing to key pencil areas, notably the bird, will also have taken place.

At this point most of the brushwork has been undertaken with fairly large brushes, nothing too exotic: usually a flat sable/synthetic mixture ranging from a quarter of an inch to one inch (6–25mm) wide, sometimes used flat, sometimes on edge. The paint is applied quickly and not too heavily. The acrylics that I use tend to dry a little more slowly than most, so a degree of movement is achieved within the glaze.

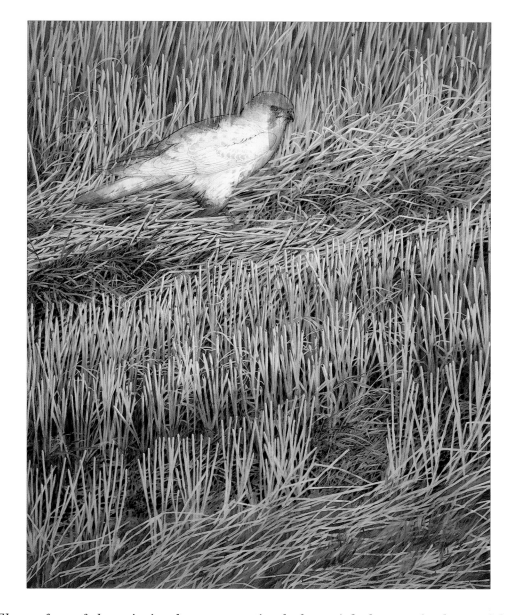

The surface of the painting has now received about eight layers of colour, with the exception of the bird. The semi-detailed drawing will be left unpainted until the end. The bottom of the picture has reached the stage shown at the top of the previous photograph, all the blocking-in and semi-detail being complete. Some of the more descriptive work has started behind the bird and, using smaller brushes, I have started to pick out individual pieces of straw. No real detail is there yet, but the shape and character of each stem is defined.

Cheaper sable brushes, size 3 to 5, are used to complete this stage, and this is where the time-consuming part begins. Having identified each stubble stalk I can start on the serious detailing, using pure sable water-colour pencils no larger than size 1 or 2. The next two weeks will be plain slog – picking out light and shade and all the details of the straw. It is very tedious!

Now some four weeks into the work, I start painting the kestrel. After repeatedly painting pieces of stubble and straw for the previous three weeks, it is a welcome relief to use some different colours, and paint a different shape.

At this point in the painting's evolution it will have become apparent that a few changes have been effected along the way. It may have been something to do with the fact that, after all that stubble, I really craved a diversion of some sort. I decided to break up the monotony by including a secondary element in the form of a small area of mayweed, a common plant of the cornfield edge. I also felt that the addition of a few areas of shadow would create a little more atmosphere within the composition. This places the bird in a particular location within the scenario. It has just descended from a hedgerow tree from which it had watched the stubble for suitable prey.

Whether I am unique in this respect I do not know, but I have always left the painting of the main subject as the final stage of the work. This can prove to be a rash decision if, after devoting considerable time to the background, the work is ruined because the bird, or birds, go completely wrong. One of the reasons I choose to leave the bird until last is, I suppose, to offer a kind of reward for working – for what seems forever – on a complex and repetitive background. This feeling of 'will I ever get it finished?' is typical of several paintings included in the book, not least the two works showing the common terns on the stones (pages 114 and 117); the piece of rope, or pool of water, is almost a sort of safety valve, something to divert the brain from the job in hand, and offer a day or two of recreation and a change of colour.

This also introduces another aspect of painting, particularly as a professional: it is not always either easy or relaxing. Many people paint as a hobby and will know that, when one is trying to achieve a particular effect or wishing to create a certain illusion on a piece of flat canvas or board, it is extremely frustrating if all does not go well. But to those who do not paint, it is all too easy to assume that it is a relaxing, simple, mindless task that clears the mind and eases the body, a nice pastime to relieve stress. Far from it!

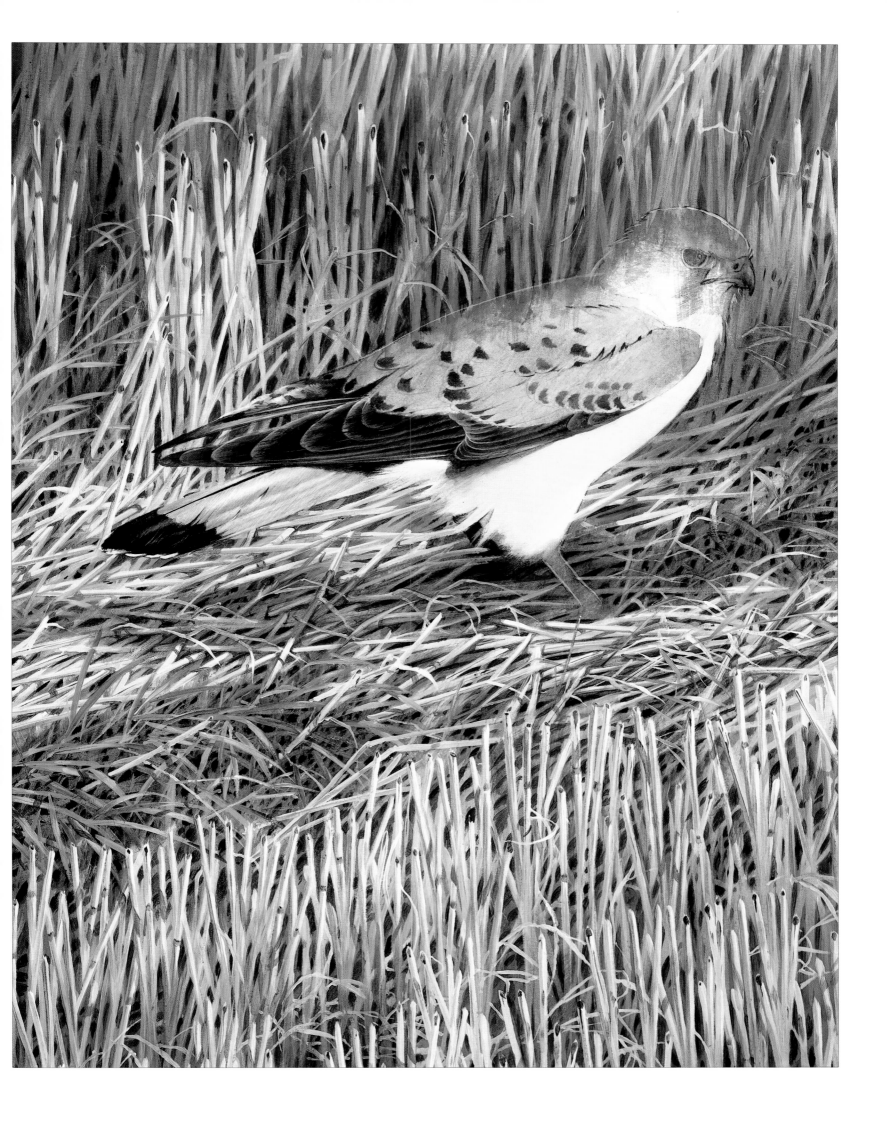

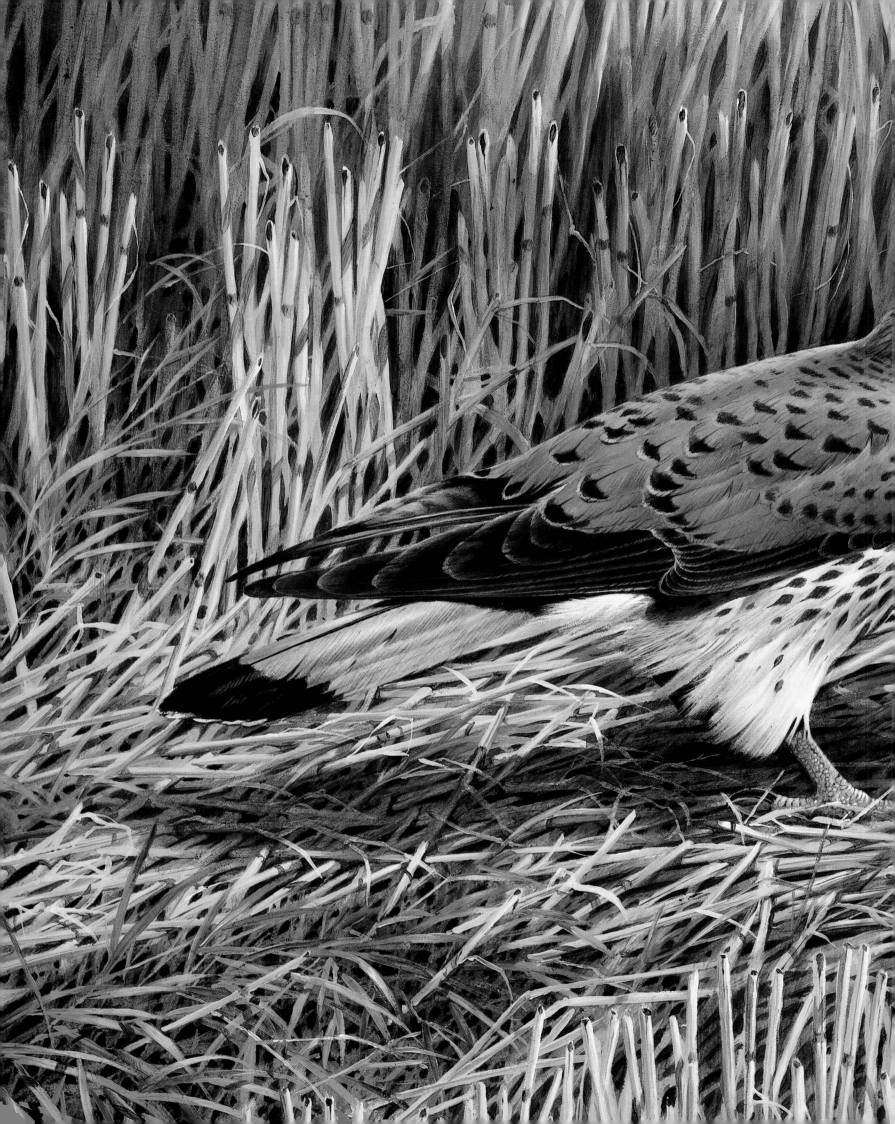

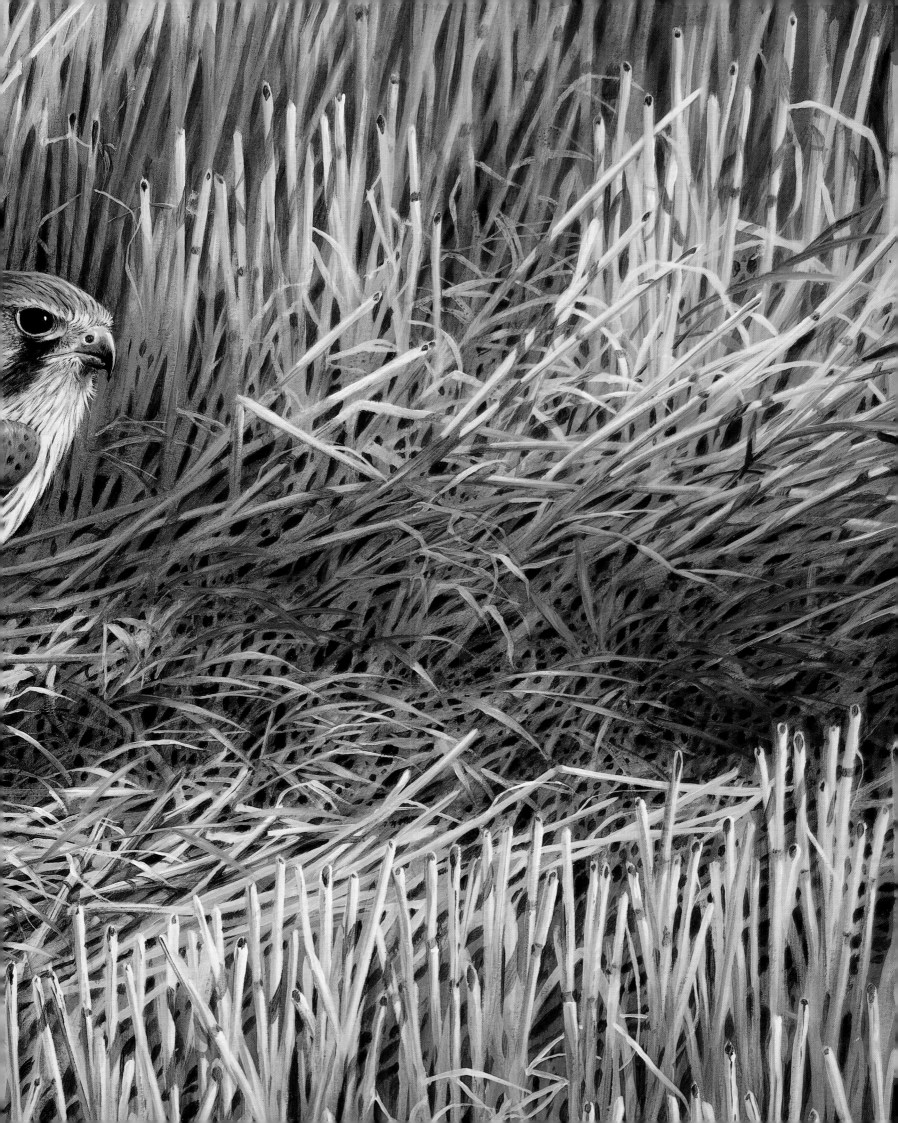

This habit of leaving the 'best bit' until the end is reflected to an extent in the painting of the bird itself for, without exception, I always start with the tail and work forwards, saving the head, and the eye in particular, to the end. I suspect that this method is quite the opposite to that of most bird artists. Each section of the bird is painted up in a series of glazes, and completed before going on to the next part. The tail shown here, for instance, was completely detailed before any other work was started on the wings. The shoulder and wing coverts have now received their equivalent of blocking-in, ready for their final detailing.

To a certain extent, I have left some of the stubble in the immediate vicinity of the bird to be completed later. Inevitably, there will be some stalks that overlap the bird, or need to be 'hidden' beneath and behind it, and this region requires a final painting, along with the detail of the bird itself.

Finally, when I am satisfied that the bird is finished, and looks as convincing as I can get it, I will spend a few days going over the whole work 'titivating', and working up (or down) areas that I feel require adjustment. The painting is then placed in a frame, and put away for a week or two so that I can forget about it. The frame itself is an important part of the final presentation, and the selection of frame and mount materials needs care. I always like to provide a finished piece of work whose quality of presentation complements the effort put in to the picture and, of course, attracts the approval of a potential buyer.

On viewing the painting again, after a period spent painting something else, I can usually tell if the composition requires any further embellishment or alteration. Perhaps you can now decide for yourself, and imagine what you might have done, had you been able to proceed with the development of the picture in the way that I have attempted to describe.

KESTREL, 30 x 24IN. (76.2 x 61CM), ACRYLIC ▷

◁ KESTREL, DETAIL (SEE PAGE 53)

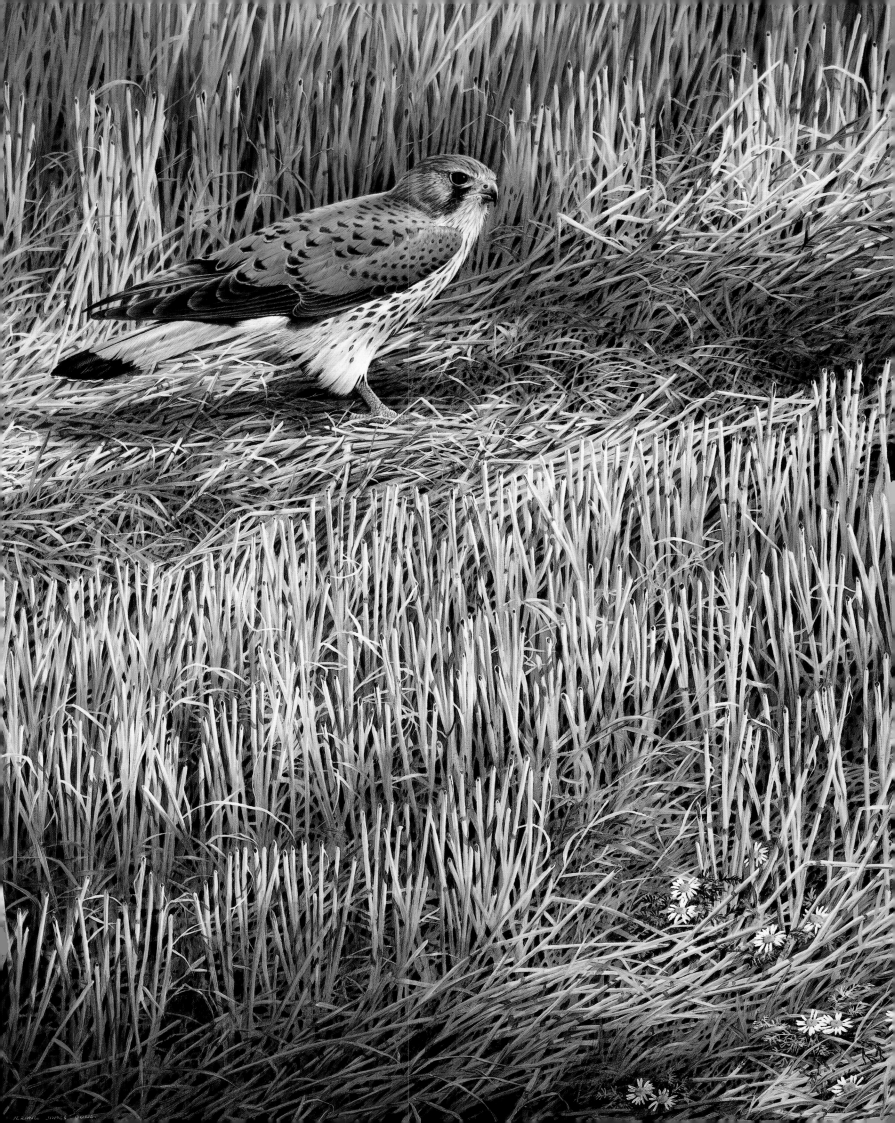

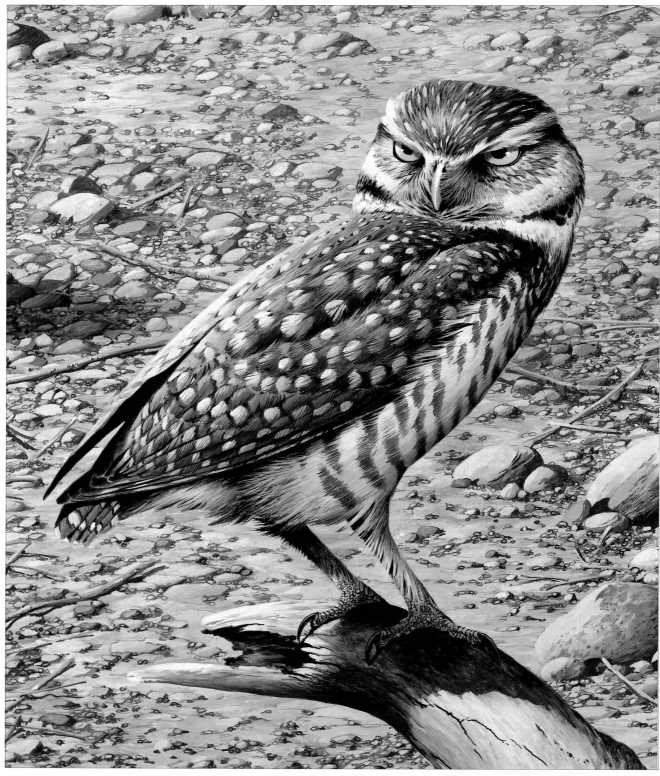

BURROWING OWL, DETAIL (SEE PAGE 59)

LARGE-SCALE PAINTINGS

This, *the most comprehensive section in the book, contains a collection of sixteen of my largest paintings, with several pages devoted to each picture. Large compositions are physically impossible to reproduce life-size in any publication, so the opportunity has been taken to include a few details of the background and of the birds themselves. Of the many questions asked about my paintings, one of the most frequent relates to the time taken to complete a picture, and, in the case of the largest works, the period involved can be anything up to ten weeks.*

BURROWING OWL
Speotyto cunicularia

A hole in the ground, in a western American plain, may contain many mysterious things. If a dry churring chatter, alarmingly similar to the sound of a rattlesnake, comes from within, it might be a snake – or it could just be a burrowing owl chick. Take your pick.

The owl is certainly the more endearing. It is a small species, quite like the little owl of Europe, but with longer legs, which suit it admirably for its life on the ground in open places. It often hunts by hovering over the ground and snatching up small creatures in its feet, again finding those long legs particularly useful. It has a rounded head, but quite a flat-browed, intense expression, with piercing yellow eyes. The white central streak and black-and-white 'V' shapes beneath the bill combine to enhance the strong facial pattern.

It is typically seen in colonies in prairie dog towns, and is also quite at home on airports, golf courses, and even in broad, grassy road cuttings. It does not much mind noise and general busy traffic, on the ground or in the air, but it does object to close attention from people on foot, and such disturbance is not easily tolerated. Since so many places are now pretty much disturbed, day in, day out, burrowing owls have lost ground in many places. Intensive agriculture, and, earlier this century, campaigns to eradicate prairie dogs, also told against the burrowing owl. It has withdrawn into the more remote parts of the midwest and the south-west states and Mexico. The range continues on south over almost the whole of South America, excluding the Amazon forests and Tierra del Fuego.

Burrowing owls are inquisitive, and use their large, forward-facing eyes and widely separated ears to good effect. The ears are sensitive, and, like the eyes, enable the bird to pinpoint a potential predator or likely prey, with great accuracy. To help the process, the bird bobs and weaves, moving its head up and down, and from side to side to broaden the base line from which it can 'triangulate' and fix the position of the object of its interest. This is why, like most owls, it has such an attractive, sometimes even comic, appearance as it sits beside its nest burrow, bobbing and turning its head to draw a bead on any intruder.

Although it sits beside its burrow, or on a nearby post, during the day, especially in the cool of winter, it is essentially a dusk and dawn hunter. Its call is a soft 'coo-coooo'. Where the ground is suitable and where there is plenty of prey, burrowing owl pairs often congregate into small colonies of perhaps ten or a dozen pairs. They may dig their own burrows, but usually take over those of small mammals. They do not share holes with prairie dogs, nor with rattlesnakes.

They eat mostly insects, such as big, crunchy beetles and Jerusalem crickets, as well as kangaroo rats, voles and some small birds. Most food is found in places with short grass: prairie dogs and ground squirrels provide the ideal situation. Where badgers dominate the smaller mammals, the grass grows longer, making food scarce and harder to catch; and the badgers themselves raid the owl nests. It is easy to see why a burrowing owl, given the choice, will live with the prairie dogs as near neighbours.

If a particular component of a painting is going to give me trouble with research and reference, it is usually the bird. Some species, by nature, are rare and almost unobtainable from a field study point of view, and I have to resort to studying skins from the British Museum. This picture differed in that respect. The owl itself had become quite familiar to me during my trips to the west coast of Florida, where there is a small but stable population.

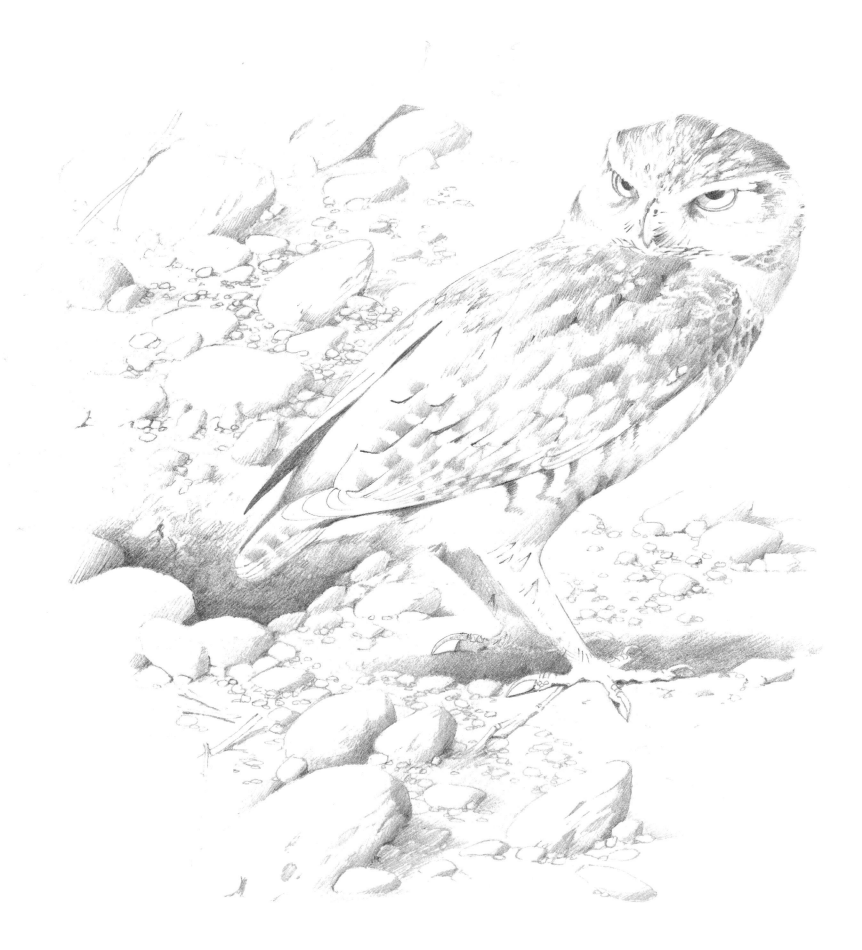

BURROWING OWL, 16 X 12IN. (40.6 X 30.5CM), PENCIL

BURROWING OWL, DETAIL (SEE PAGE 59)

The big problem was the cow skull. How could I obtain one to study at length, in order to reproduce the complex bone structure? Ideally, I wanted to have a skull on my desk, where I could examine it thoroughly. Anyone who has ever tried to obtain a cow's head will appreciate some of the difficulties involved!

My local museum had a very old and incomplete skull, which gave me a start, but did not furnish all the data fully. After many enquiries and telephone calls, my local butcher finally solved the problem by boiling down a head from a slaughterhouse.

Coincidentally, the painting of this hot and dry desert scene took place during one of the hottest and driest summers ever recorded in south-east England. It was fortunate, as it let me stand the skull outside for a few weeks and let the hot sunshine and the bluebottles complete the cleaning work that had been inaccessible to the butcher. I lost count of the number of times that the youngest of my labradors 'retrieved' the huge bone and presented it to anyone he thought might be interested!

Reaction to the picture varied from – at worst – abject revulsion, to - at best – polite but negative comments. Over a period of a couple of years, friends and relations who have grown used to the picture have at last come round to accepting it, and even admiring it. They perhaps appreciate the basic idea, and the amount of work involved. This large painting now hangs on a white brick chimneypiece in our sitting room, where the décor suits it perfectly.

If the author may be permitted to add a word or two about the picture, I must say that it was immediately the most dramatic and eyecatching item in the house when I first visited. This may be a subjective comment, but I thought it beautiful and remarkable from the moment I set eyes on it.

BURROWING OWL, 40 X 30IN. (101.6 X 76.2CM), GOUACHE ▷

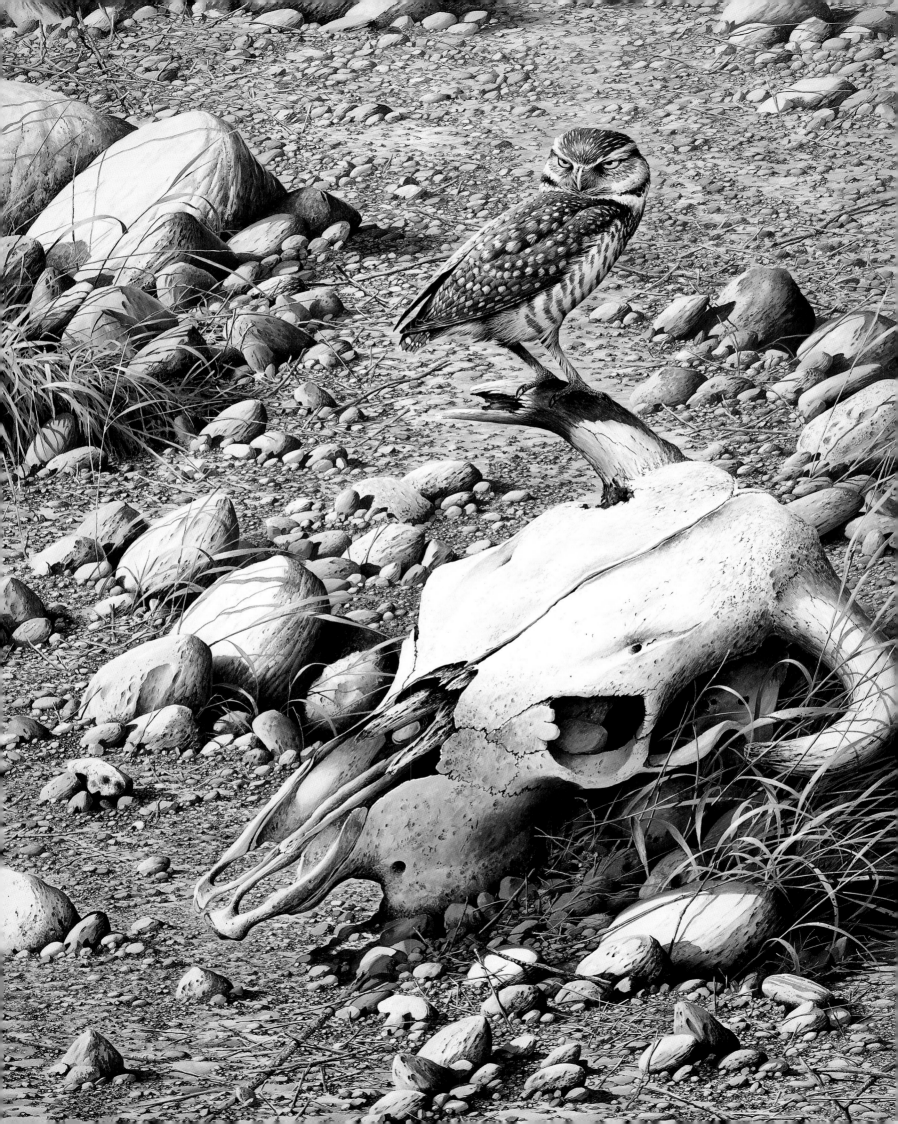

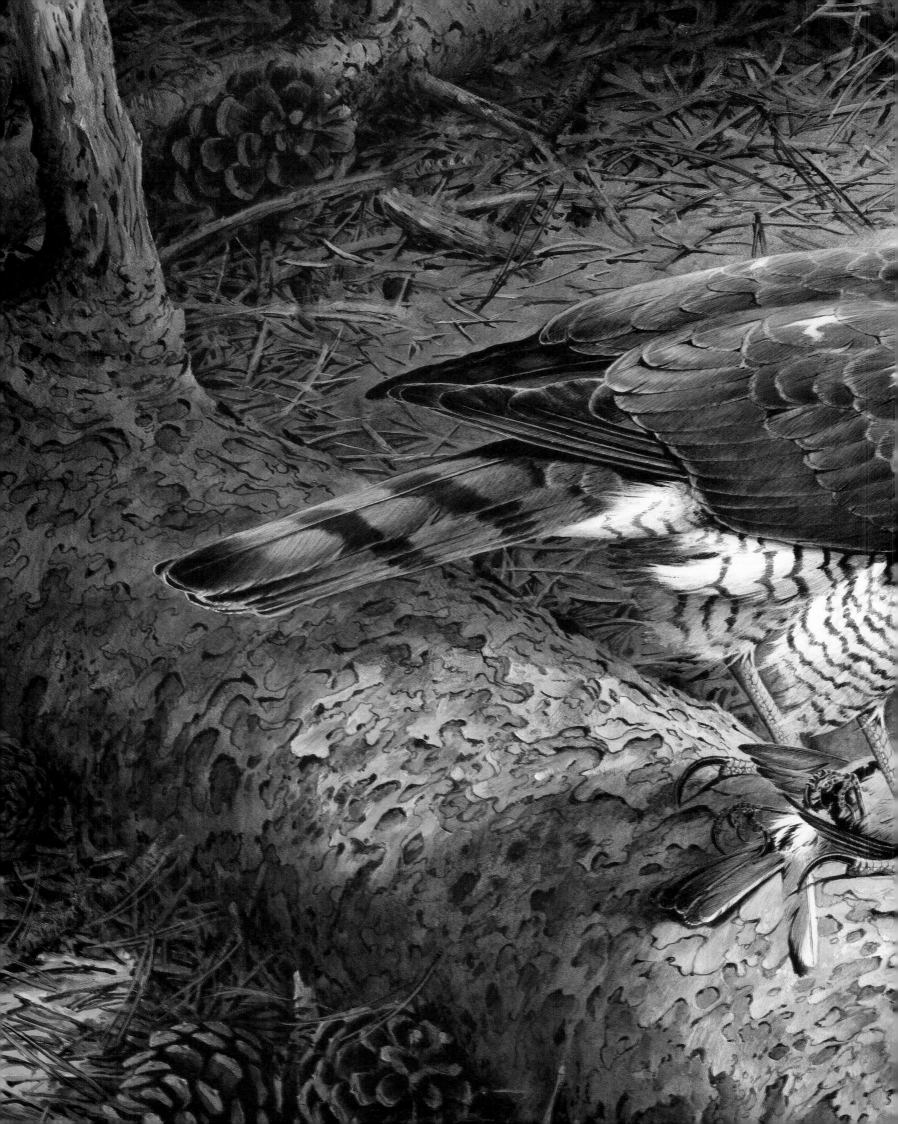

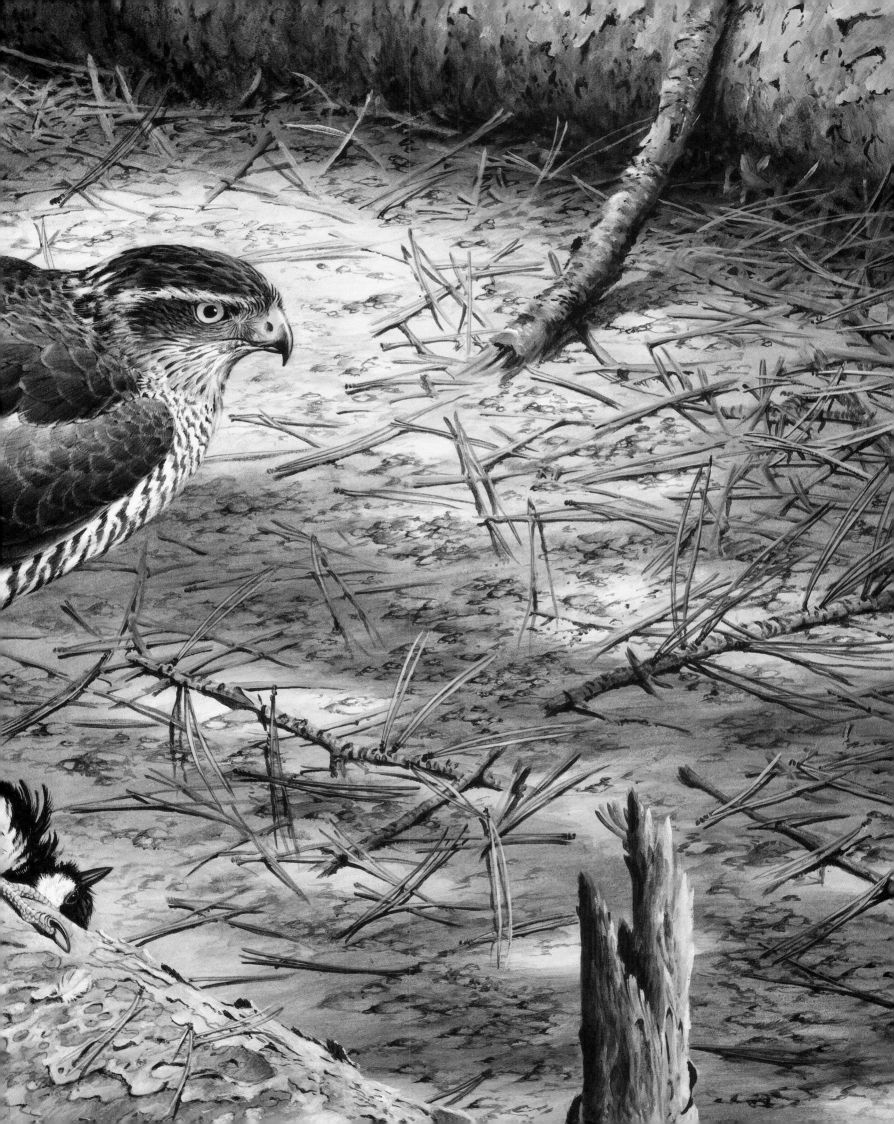

SPARROWHAWK
Accipiter nisus

T he great titmouse, which is about to become part of the sparrowhawk's calorie intake for the day is one of those little birds that is really satisfying to paint. It possesses the ideal combination of shape and colour, arranged in a pattern that emphasizes its anatomical features. The black head, white cheek patches, and black bib are all placed on areas that help the artist delineate and build up the shape of the bird easily. The sparrowhawk, however, is quite the opposite. Displaying a more or less uniform colour over the whole body, its only concessions to the artist are the series of parallel bars running around its breast and lower body, and the pale supercilium, or 'eyebrow', above the eye. These, at least, help accentuate its physique.

In the main, it is the nature and function of the sparrowhawk that makes it exciting to paint: it is the avian equivalent of a single-seater fighter aircraft, built for speed and manoeuvrability, and devastatingly efficient in the right circumstances.

Personalities should not be attributed to animal species. Reactions of animals are simply the end results of a sequence of certain stimuli. Accordingly, the shape of a species is dictated by its lifestyle. Having said that, however, my wife gets just as excited as I do when one of our local pair of hawks ambushes the birds on the bird-table, in pursuit of a greenfinch, or some similar small bird. Although she feels the exhilaration of witnessing the hawks do what comes naturally, it is tempered to a degree by a feeling of distress for the unfortunate victim.

Personally, I find the sight of one of these hawks gliding silently at low level around our trees and shrubs something to look forward to each winter. The loss of an occasional finch or sparrow is a small price to pay for that privilege.

Sparrowhawks, unlike kestrels, with which they are often confused, are specialist bird-eaters. They will not take voles and mice, nor do they have the characteristic hover commonly employed by the kestrel. Usually, as Terance describes, they hunt at low level, trying to surprise small birds by darting through narrow spaces between bushes, or flying alongside a hedge and then suddenly twisting up and over the top to take a bird that has been feeding, unwittingly, on the other side. Now and then, however, one will soar at a great height, and spy suitable prey from on high. Then it will half close its wings, and plunge at great speed, as often as not speeding right towards the middle of a tree or a thicket, as if it must surely dash itself to pieces against a branch. Nevertheless, it achieves a safe landing, and with a remarkable lightness of touch.

Sparrowhawks like mixed woodland and agricultural land, and can breed in the smallest of copses, although the best populations are found in more secluded, extensive forests. They are widespread in Great Britain, although they became very scarce in most places during the 'pesticide era' of the 1960s. Now they have staged a remarkable and gratifying comeback. Sadly, some people, who have forgotten, or never knew, what a properly balanced, healthy bird-of-prey population was like, see the increase as unnatural and something of concern. We do not all have the tolerance that Terance Bond describes, but a thriving sparrowhawk population means that there must be plenty of small birds about, otherwise the hawks themselves could not survive. In fact, it is a welcome sign of environmental improvement.

◁ SPARROWHAWK, DETAIL (SEE PAGE 63)

SPARROWHAWK (ADULT FEMALE), 30 x 24IN. (76.2 x 61CM), ACRYLIC ▷

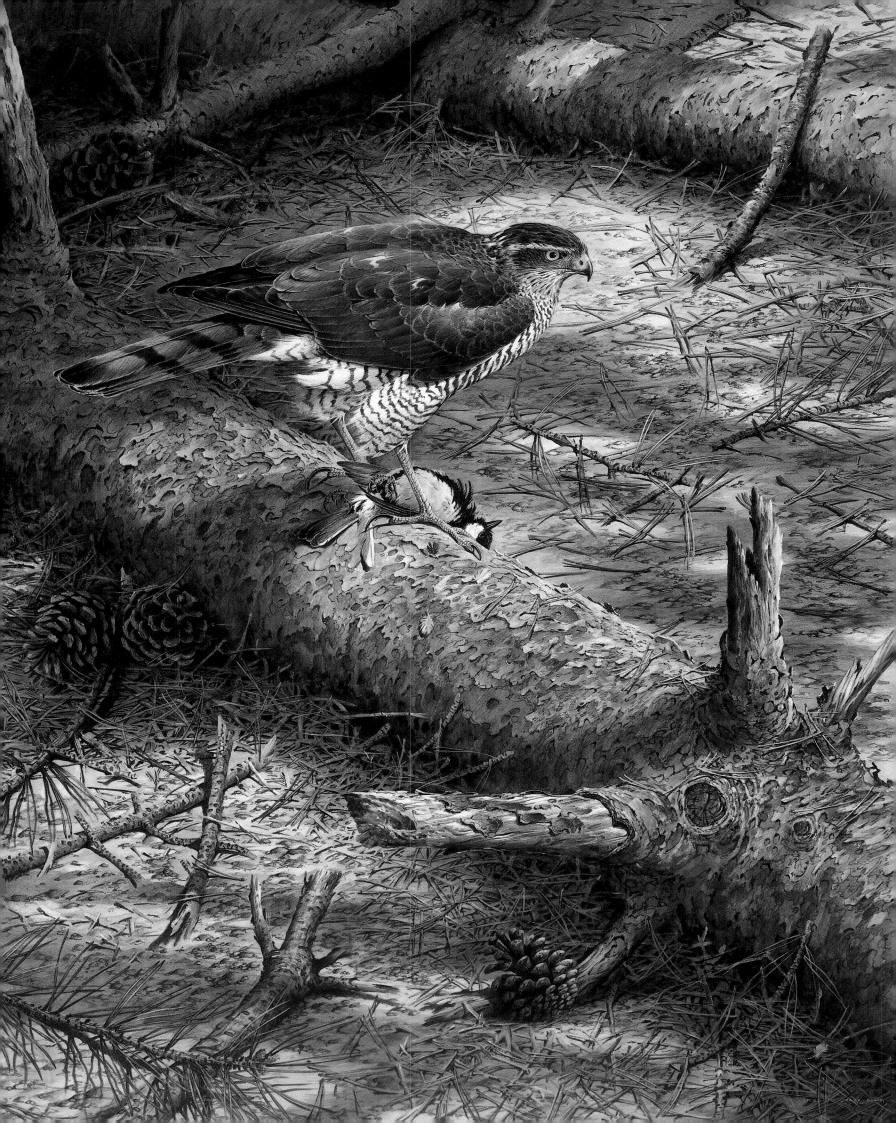

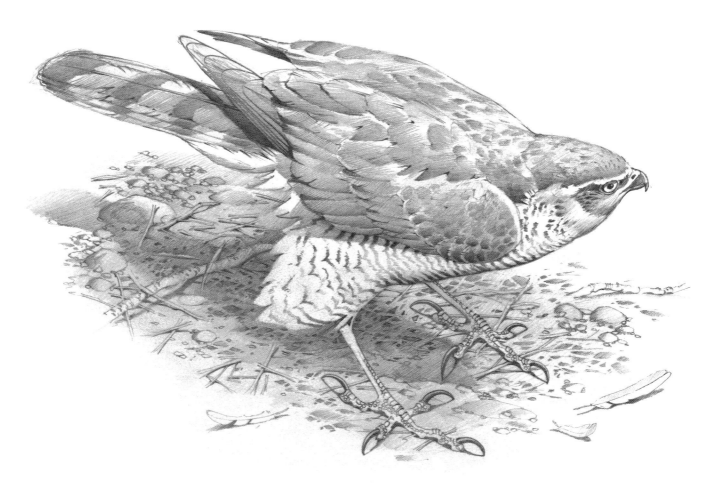

SPARROWHAWK, 12 X 16IN. (30.5 X 40.6CM), PENCIL

Normal flight for a sparrowhawk consists of a short, sharp flurry of wingbeats, then a flat glide, before more flaps, the next glide, and so on. It is a much more regular flap-glide-flap-glide pattern than the lazier, more languid flight of a kestrel.

Given a decent view, it can usually be seen that the tail is long and square-cut, while the wings are rather broad, even if the tips may be tapered back to a point. The outer wing never has quite the same long, slender, pointed shape of a falcon's wing.

In spring, sparrowhawks temporarily abandon their secretive lifestyle, because they have to perform courtship and territorial displays over the woods where they will nest. It is always exciting to sit on a hill, or at the edge of a clearing, on a fine, spring morning, waiting for the hawks to appear.

Suddenly, from nowhere, a large shape is seen over the wood: a goshawk, perhaps? No, it is not the larger hawk, but the sparrowhawk, flying with its special display action, wings stretched out and somewhat arched, head thrust forward, and wingbeats that are much deeper, slower and more relaxed than normal. All this combines to give the illusion of a much bigger bird. The hawk, or a pair, will soar up and fly to and fro like this, before a series of exhilarating 'bounces' across the sky. The bird then closes its wings and plunges, before literally appearing to bounce against an invisible surface that throws it back to its original height, before the next breakneck plunge, or a final plummet out of sight into the wood below.

GREAT TITMOUSE
— *Parus major* —

This small painting is one of a collection of ten images that were commissioned by the Royal Society for the Protection of Birds for reproduction on a limited-edition set of Wedgwood plates, which were issued to commemorate the Centenary Anniversary of the Society.

Round compositions are not the easiest of pictures to paint – small birds, however, tend to be incorporated into a design easier than large species. Coniferous woodland is not necessarily the preferred habitat of the great titmouse, the species is found more or less anywhere, but the bird's shape and colour integrate well with trees, and with such a directional element as pine needles, the overall structure of the painting within the confines of a circle was easy to achieve.

Thematically the subject and its associated background made it the obvious choice as a companion to the sparrowhawk painting on page 63.

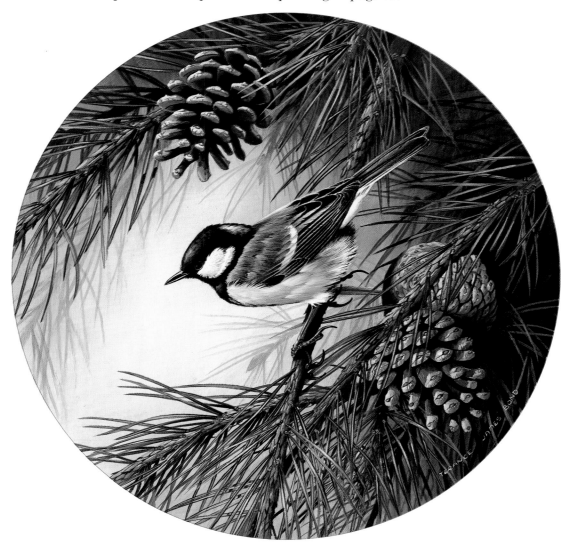

GREAT TITMOUSE, 10IN. (25.4CM) DIAMETER, GOUACHE

GREAT HORNED OWL
Bubo virginianus

Late one afternoon I was returning with a group to a hotel in Sarasota, Florida. The day had been organized by Mill Pond Press and the local Audubon Society. It had been an unforgettable day. Most others in the group were American artists but to me, on just my second visit to Florida, everything was still new and exciting. I look back at the birds I saw – from frigate birds and bald eagles to blue jays – and have to remind myself that I really was there.

Nearing the hotel, we stopped at a set of traffic lights in a typical Florida suburb. The houses had large, wooded gardens. Glancing round, I noticed a large, dark shape against the trunk of a pine. It was obvious what it was as soon as I saw it: but somehow the setting did not seem credible.

As we moved off I mentioned that there was a great horned owl in the tree beside the road. There was a mad scramble for binoculars and it was confirmed. The bird I have painted here is shown in a more rural environment than my traffic-light owl. They are quite common in Florida suburbs, but the rural setting seemed to me much more appropriate.

While there are several 'eagle owls' of Europe, Asia and Africa, only one, the great horned owl, occupies North and South America. In consequence, perhaps, it has been able to diversify and occupy a greater range of habitats. Effectively, it takes the place of the whole range of Old World species.

It has an immense range, from the western shores of Alaska to the southernmost tip of South America. In between, it lives in northern coniferous forest, in all kinds of mixed woodland, in mountains, in deserts and even in coastal mangrove swamps. It is truly an owl for all seasons and all places.

It is big. It looks solid, a bulky, broad-chested owl, with a large head topped by two feathery tufts, or 'horns'. These are simply ornamental, and are perhaps used in display, or useful camouflage, and good for communication between a pair of owls. They are not, however, related to the owl's ears.

This massive owl is almost the equal of the eagle owl of Siberia in terms of size and power. It is a formidable bird: indeed, it may even be little removed from the eagle owl as a species, other than on obvious geographical grounds. It seems likely that the prototype eagle owl originated in Africa, and then spread throughout Africa and Eurasia, splitting into about ten species as it went; however, the spread into America was much more recent.

Although not yet split into separate species, great horned owls of different regions are quite distinct in appearance. The birds of the far north are the biggest. The larger the size, the smaller the surface area of the body relative to the volume: this means that a bigger bird loses less of its body heat in cold climates than a small one. Owls of wet forests are darker than those from dry places; the desert birds are the lightest, and sandiest in colour of all, and are also particularly small.

Great horned owls roost until about sunset, then bestir themselves, often to fly to a favourite perch from which to survey the scene for a while before getting down to the serious business of hunting. Roosting owls, if found by day, tend to look tall and tense, stretched upright in a tight pose, camouflaged against an upright branch. When they prepare to move, they visibly relax and fill out.

GREAT HORNED OWL 36 X 27IN. (91.4 X 68.6CM), ACRYLIC ▷

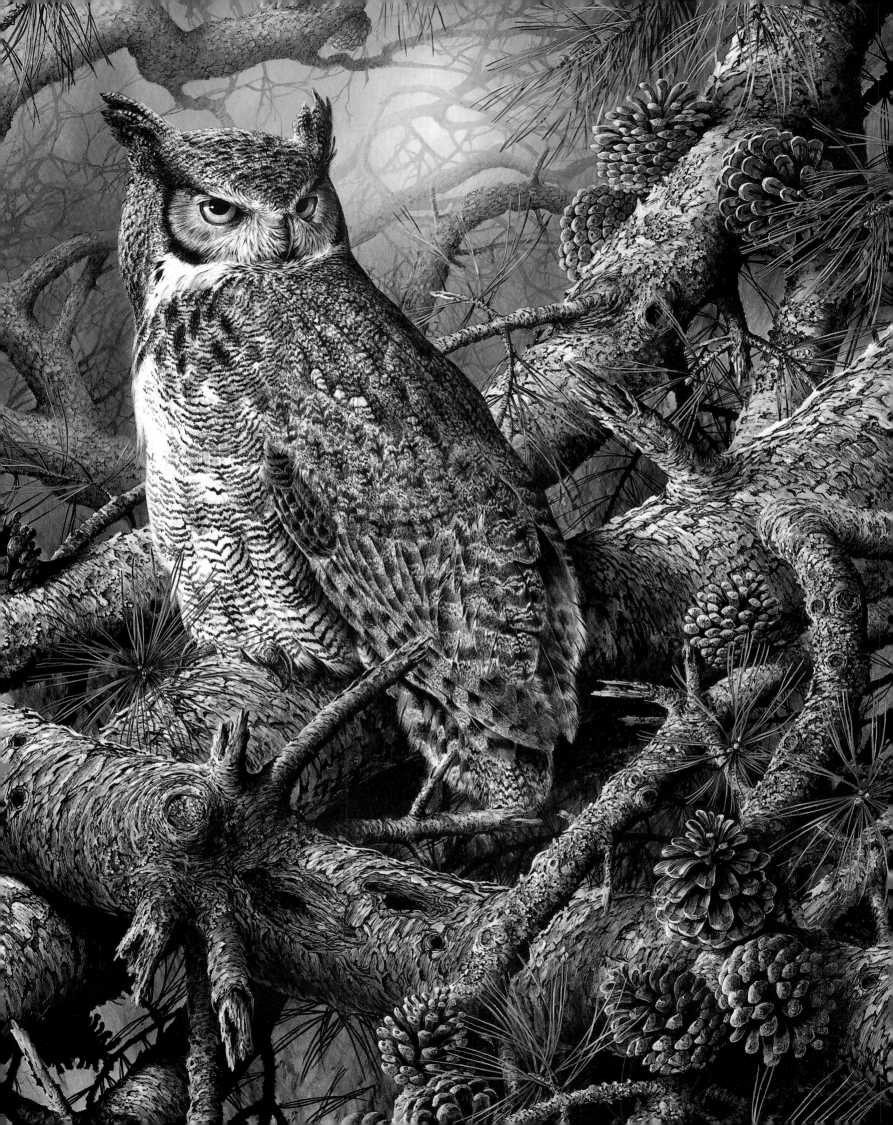

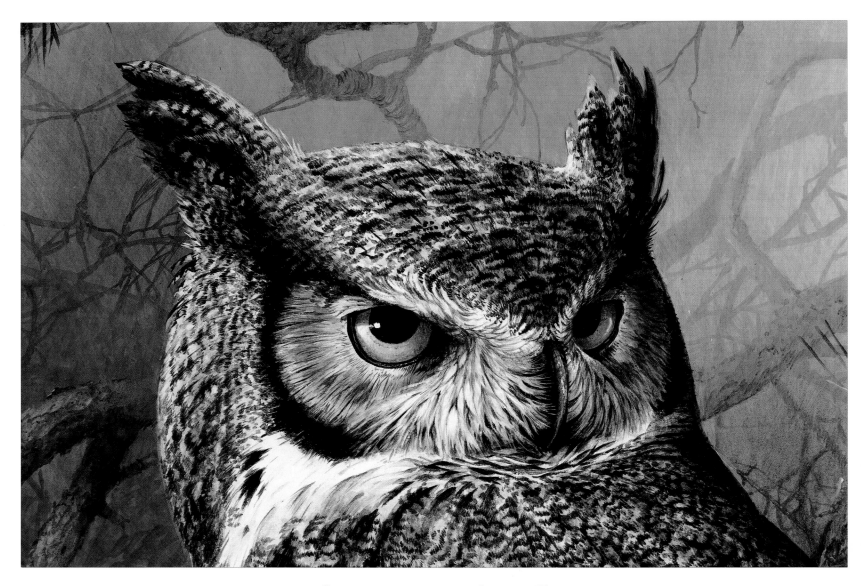

GREAT HORNED OWL, DETAIL (SEE PAGE 67)

As dusk falls, the birds begin to call. The chief call is a deep booming song, soft but far-reaching and causing the small mammals of the neighbourhood to scuttle back out of sight. The male gives a series of hoots, 'hoo, hoo-hoo, hoo, hoo', and the female answers with six or eight lower notes, usually 'hoo, hoo-hoo-hoo, hooo-ho, hoo-oo'. Sometimes a courting pair will give a strange, cat-like, squawling performance.

These big owls drive out other owls and most daytime birds of prey from their territories. They kill a number of other owls, and even a variety of bigger birds, such as buteos. Their diet varies according to the situation. Plains birds eat jack rabbits and cottontails, and frequently take mice and meadow voles; forest owls eat squirrels; and coastal ones may take crabs. Mallards, bobwhites, even swans and herons are right to feel threatened by this 'super-predator'.

A strange feature, however, given this generally aggressive and menacing character, is that the great horned owl will sometimes settle and nest within a colony of other birds, such as herons. It will occupy a large, stick nest made by a pair of herons in a previous year, often taking a central site within the colony.

It appears that this is rarely any problem for the herons, and the owls may benefit from the proximity of such a large number of big birds that are, themselves, well equipped to deter potential predators with their long, sharp bills.

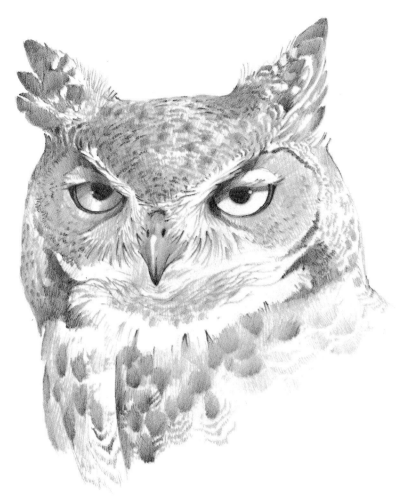

GREAT HORNED OWL, 16 X 12IN (40.6 X 30.5CM), PENCIL

The big, life-size great horned owl in Terry's exciting picture (see page 67) hangs on a plain, pale wall in his house. It is undeniably a striking and impressive piece of work.

As is so often the case with his paintings, the viewer is drawn like a magnet – really too close to appreciate the picture – simply in order to take in the minute details that are so perfectly portrayed. It is as if the smell of the pine resin can be breathed in, the sleek, smooth lines of the leathery needles pulled between finger and thumb, the sharpness of the bird's claws tested against the skin of a fingertip.

Then there is a second phase, a standing-back to appreciate the whole painting. This is, if anything, even more impressive: the complete composition, the combination of colour and form that evokes such a powerful and pleasing image. The detail, impressive as it is, becomes subservient to the overall effect of owl and tree in concert.

It is a shock, too, to realize the sheer size of the owl. Can it really be so big? In America, life-size models of great horned owls are sometimes placed on chimney tops and roofs to deter the messy gulls, which would rather like to perch on the ridge of the roof. In England, too, such owls can be seen placed incongruously on yachts moored in southern harbours again, as a deterrent to the gulls. Wherever they are, the models look unreal, too big: but then, so do the real live owls.

The shape, of course, is a familiar one to all. The broad chest, the square head, the flattened triangular tufts of feathers that look so much like ears, have long been immortalized in images of 'wise old owls' in cartoons and story books the world over.

LONG-EARED OWL

Asio otus

As well as several of the world's eagle owls, there are other owls that have 'ear tufts', ornaments of upright feathers at each side of the head. These 'eared owls' include the long-eared and short-eared owls of Europe and America. The long-eared owl also has separate populations in Africa.

Long-eared owls are particularly secretive and elusive. They keep themselves very much to themselves, and usually make little noise. In winter they sometimes roost in surprising numbers – perhaps twenty or thirty sharing a clump of willows or a stand of tall pines. Even in such numbers, it is only their accumulated white droppings and grey pellets that will give them away.

In summer they resort to pine forests, shelter belts and thickets to breed, using an old nest of some other large bird such as a crow, or magpie, in which to lay their white eggs. They are active only after dark, when their deep, mournful, moaning hoots may occasionally be heard. Much more useful as a clue to successful breeding is the hunger call of the young owl: it is a high, thin, squealing squeak, often likened to the sound of a gate swinging slowly on a rusty hinge.

In response to a lack of natural nest sites in parts of eastern England, where some long-eared owls spent the winter but rarely stayed on to breed, experiments with artificial nests were undertaken. Old apple-pickers' baskets and, later, specially made wicker baskets, were lashed to tall willows. The owls took to them remarkably well; many long-eared owls, alive and well in East Anglia today, started life in a woven basket!

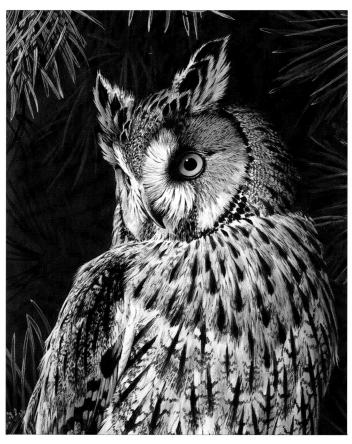

LONG-EARED OWL, DETAIL, GOUACHE

EAGLE OWL
Bubo bubo

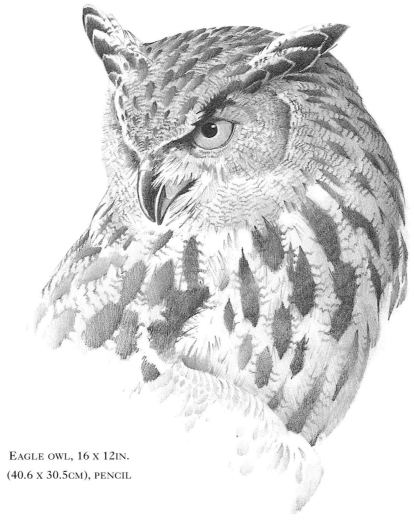

EAGLE OWL, 16 X 12IN.
(40.6 X 30.5CM), PENCIL

Eagle owls are among the great birds of the world: they are enormous, powerful, fiercely predatory, yet irresistibly attractive. Sadly, most people only know them as captive birds.

Such birds are at their best in the wild, particularly the remote fastnesses of central European mountains and northern forests. Eagle owls in western Europe are richly coloured, with a golden or rusty ground colour overlain by mottles of buff and cream, and bars, streaks and speckles of brown and black. Siberian birds tend to be even larger, but are paler and less strongly marked. Others, the so-called Pharaoh's eagle owls, live in the deserts of the Middle East and North Africa. These are the smallest and dullest in colour, being suitably adapted for their hot, arid, and sandy habitats. All share the same intensely orange eyes.

Eagle owls are biggger in size than most populations of the great horned owl, but otherwise are similar in structure and lifestyle. They prey on a great variety of birds and mammals, and are capable of taking very large prey, but the average catch is the size of a rabbit or hare, or a medium-sized bird.

In most parts of Europe the eagle owl is now a very rare bird: such a big, bold, but shy bird does not fit in well with civilization. There are pockets of France and Spain, and northern Scandinavia, where good numbers hold on, but these are wisely kept secret. In Britain, it is doubtful if the eagle owl has ever been a proper member of our avifauna: all recent sightings have been of captive birds that have escaped confinement.

KESTREL

Falco tinnunculus

F*amiliarity is supposed to breed contempt. With regard to the kestrel, I think the opposite is true as far as I am concerned. This small falcon has been a particular favourite since my childhood and it is unlikely that I will ever tire of painting it.*

Various reasons dictate the creation of a painting. In the case of this large work it was the response to the loss of a nearby large, mature, elm tree. This huge old elm succumbed to the recent and severe outbreak of Dutch elm disease, which has so devastated the elm population of England. When the tree had been felled and was being sawn up, I asked the local farmer if I might help myself to a six foot section from the top to use as a reference for the picture.

Following instructions laid down in an information sheet produced by the Royal Society for the Protection of Birds (RSPB) I constructed several kestrel nestboxes and placed them around my property. Suitably 'aged', one of these nestboxes has been incorporated in this painting. This work is considered by many of my acquaintances as the best I have ever done. There are a few paintings in this book that I wish I had never sold: this is one of them.

To date I have had limited success in attracting a kestrel to my nestboxes. However, during the preparation of this book, a female kestrel started to take great interest in one such box situated in a large oak tree within sight of my studio window. I felt that watching the female's investigation of the nestbox from my window illustrated two things: the insistence that the artist has on painting birds that he knows well, in familiar settings, and something about the nature of the bird in question, the kestrel. Much of this book could indeed have been collected together under the title 'From my studio window'.

Kestrels are quite likely to nest near buildings, especially farm buildings set in a rural landscape. They have also been known to breed on window-ledges of great city buildings, even in the middle of London, while a pair was recently photographed rearing young on a ledge of Peterborough cathedral. Others may nest on tall factory chimneys, on power stations, or on a sheltered ledge alongside a gasholder.

Some, however, choose much wilder places to nest. Although a kestrel in a city adds a welcome touch of life and colour to the often dismal surroundings, it is a kestrel on a spectacular sea cliff, or floating above a wild and rugged corrie on a Scottish mountainside that really shows itself to advantage. There, in the turbulent air, and in a grand, powerful setting, the kestrel can reveal an unexpected skill and flair in the way it soars and dives, every bit a falcon.

Yet kestrels are mostly more familiar than that: they are, after all, the birds of prey of the roadside, the motorway embankment, or the railway siding. Everybody knows the bird that hovers high above the ground, flickering and tilting, ready to plunge for some tasty titbit: perhaps a beetle, or a worm, or something more substantial such as a vole. City kestrels, deprived of the long grass in which voles thrive, make a better living out of chasing sparrows.

KESTREL, PRELIMINARY PENCIL SKETCH (SEE PAGE 75) ▷

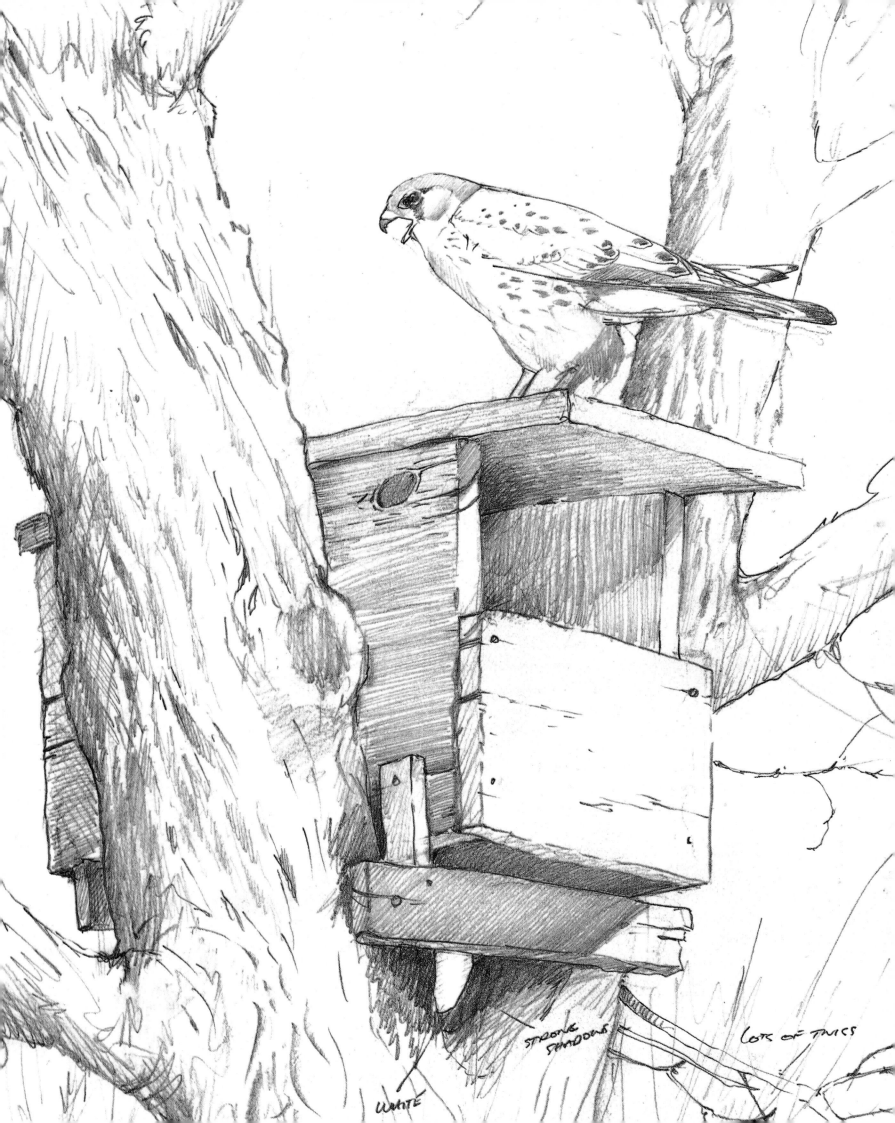

STRONG
SHADOWS

LOTS OF TWIGS

WHITE

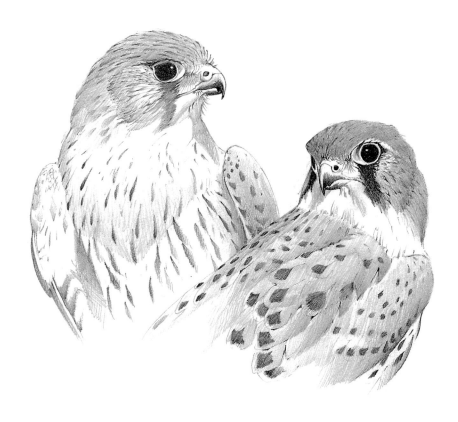

KESTRELS, 12 x 16IN. (30.5 x 40.6CM), PENCIL

A kestrel is a true falcon, but rarely shows itself in such a light in lowland Great Britain. It tends to hang about roadsides and sit still on wires, although in spring its displays are certainly lively and intense.

In upland areas, however, and especially over crags, quarry sides and sea cliffs, the kestrel proves itself to be every bit as accomplished in the air as more vaunted falcons, such as the peregrine. Of course, a kestrel will never have the power of a peregrine, or attempt such magnificent stoops and plummets, nor is it a threat to any but the smallest bird. Nevertheless, it can soar wonderfully well in updraughts, and its long dives from a great height to perch on a suitable rock can be quite breathtaking. Family parties often engage in playful chases, twisting this way and that with great agility. Like ravens tumbling in a strong wind, they give every impression of play, or enjoyment, revelling in their true element.

Accompanying this energetic and boisterous performance will be the loud, but quite peevish, screeching calls so typical of the kestrel. They have a tight-nosed, squealing character, but run together in long series of keening cries.

The clifftop and moorland kestrels still hover a great deal, especially where there are no fences, wires or poles for them to perch on. In a gusty wind they have to work hard to keep their fixed point above the ground, alternately flapping hard and deep, then flickering delicately with just the wingtip, to keep in perfect trim in the changing air. All the time they are swaying and bobbing, yet the head is kept perfectly still.

KESTREL, 40 x 30IN. (101.6 x 76.2CM), GOUACHE ▷

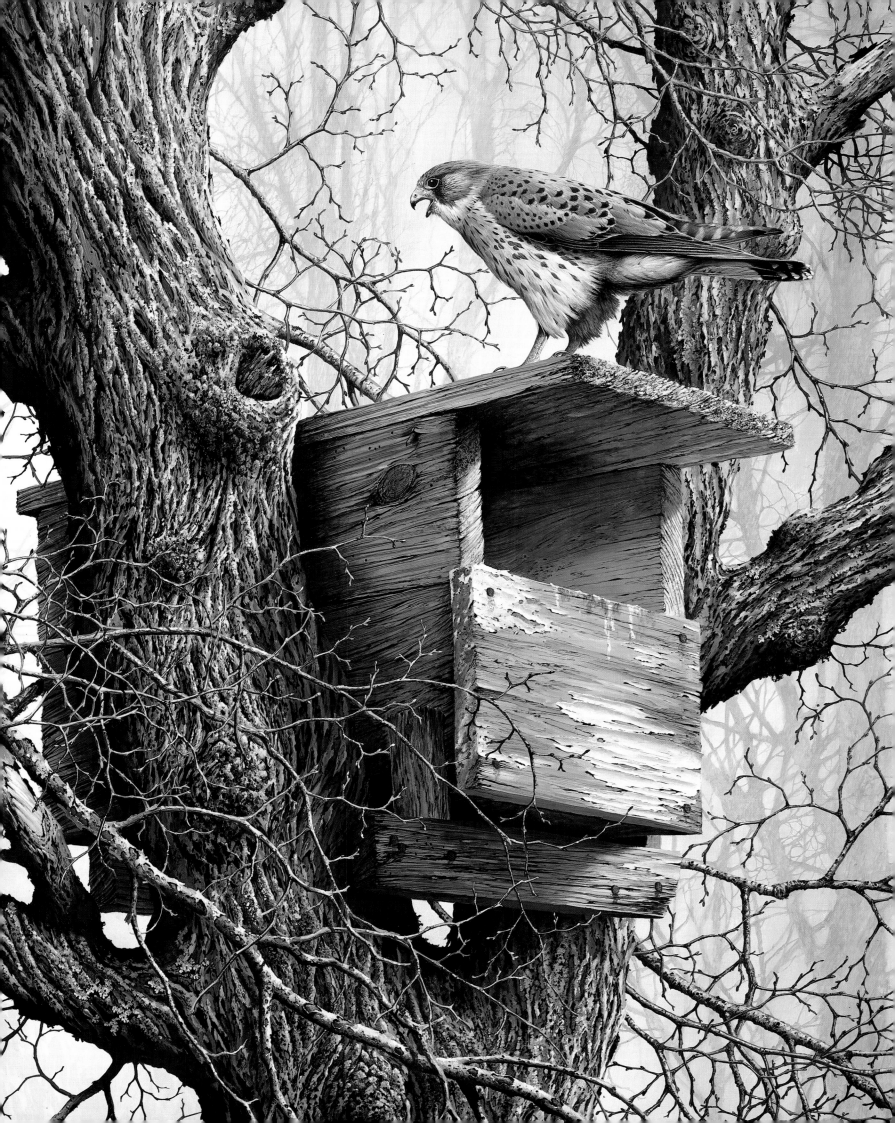

GREAT NORTHERN DIVER
Gavia immer

In North America, where the species is known as the common loon, this is the most familiar diver. In Great Britain, it is little known to most people. There are some divers breeding in Scotland, but they are red-throated and black-throated divers. The great northern breeds in Iceland and beyond, and visits Great Britain primarily in winter, although a few immatures remain all summer in sheltered Scottish coastal waters. It is a lucky observer who sees an adult in spring in its complete glory, when the dull brown and white of winter is replaced by the incomparable boldly blocked and striped black and white of breeding plumage.

In winter, the divers may be encountered in sheltered harbours (in the USA some appear on large lakes as well as on coastal waters). Most prefer shallow bays above a sandy sea-bed, or the rockier sounds of the Inner Hebrides; in the south of Great Britain, they are rather scarce birds, feeding in the outer parts of larger estuaries and bays, and sometimes drifting closer in on a rising tide.

With that big, angular bill, and a wide, elastic throat, the diver is well equipped to tackle quite big fish, including flounders and other flatfish that are taken from the bottom. Underwater, the diver progresses with powerful kicks of its large feet, which are set well back and have broad lobes on the toes to add to their propulsion. Big fish are often brought to the surface, and manoeuvred for several minutes before they are finally turned head-first and swallowed.

In flight, the diver is a large and impressive bird. It has narrow wings, but they are long and rather angular. The head, neck and heavy bill are thrust out in front, with a slight droop, while the short legs and big feet, mounted at the tail, trail droopily behind. It is not capable of tight turns or aerobatic performances, but is still quite a sight as it dives in steeply, splashing down with outspread wings, chest-first.

The dramatic chequerboard pattern of the shoulders, combined with a suede-green head, makes the great northern diver look rather special. Looking like 'a duck in a dinner jacket' was how one visitor described it: I don't think that is such a bad description!

The top of the painting on page 79 is more or less all diver, so, just to offset the attention-grabbing plumage of the bird, I chose to fill the lower portion with a dark reflection. It offers almost a mirror image and prevents the work from becoming unbalanced. The perspective of the waterside vegetation deliberately draws the eye past that splendid head and into the background. Generally, I think it works well.

Terry Bond considers the great northern diver on page 79 to be one of the best constructed of his paintings. Of those that hang in his studio, this has aroused more comment than any other over the past few years.

As the painting shows, the diver is not made for dry land. The legs are so far back, and so short that it is practically unable to walk. All it can do is to slide onto and off the nest – which is always right beside the water – and raise itself above its big, dark eggs. Once afloat, however, all signs of such clumsiness fall away, and it becomes a bird admirably adapted to its watery element, a graceful swimmer and a most expert diver. The only problem with a close-up view of a great northern diver is that it is likely to be short: once the bird dives, it will most likely swim away underwater, out of sight, to reappear a long way off along the coast or far out to sea.

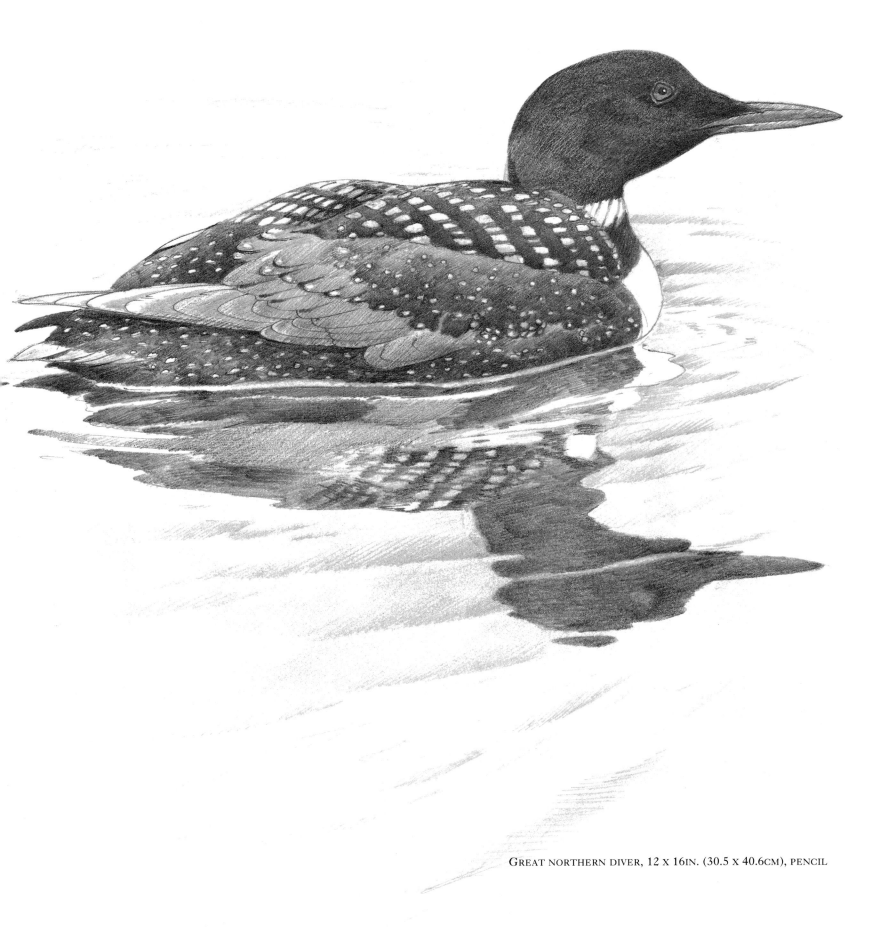

GREAT NORTHERN DIVER, 12 X 16IN. (30.5 X 40.6CM), PENCIL

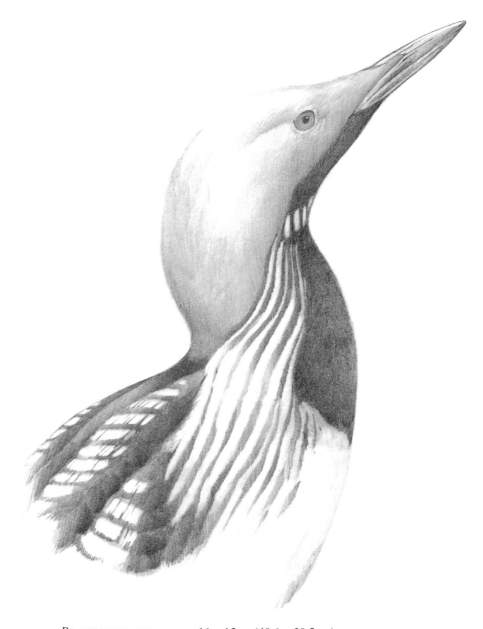

BLACK-THROATED DIVER, 16 X 12IN. (40.6 X 30.5CM), PENCIL

Black-throated divers are, if anything, even more mysterious and beautiful than the great northerns. They have an immaculate pattern of fine black lines on the neck and chest and a subtle, velvety grey head shading to black on the chin.

Black-throated divers nest on large, freshwater locks in Scotland, where they prefer to nest on tiny islets. Many nests are flooded and others fail through disturbance, while crows, foxes and otters take a number of eggs each year. Yet, despite very low rates of reproduction, the population remains fairly stable, (around 100 pairs), indicating a long life expectancy once the birds reach adulthood.

'GETTING COMFORTABLE', GREAT NORTHERN DIVER, 30 X 24IN. (76.2 X 61CM), GOUACHE ▷

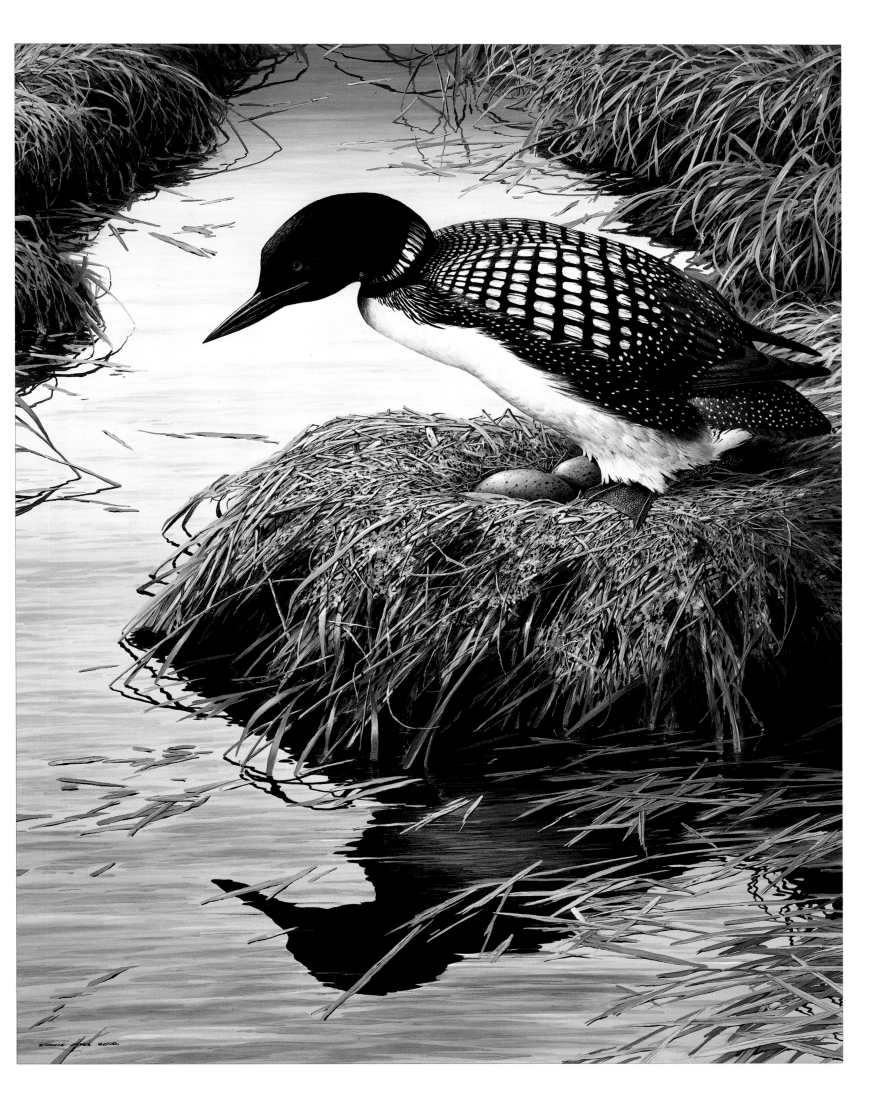

SNOWY OWL
Nyctea scandiaca

This great owl invokes all the clichéd superlatives generally applied to big, beautiful owls: and it deserves them all. It genuinely is huge, with sensational yellow eyes, a big, round cat-like face, and a wingspan that dwarfs most other birds in its realm.

Snowy owls live in the tundra zone that encircles the Arctic. In summer when the snow melts for an all too brief interval, they like the stony ridges that rise from the monotony of the rolling, boggy terrain. The tundra swarms with mosquitoes in summer, and a thriving population of small waders arrive for their breeding season. These birds spend the winter on coastlines far to the south and return for the brief summer spell, to take advantage of the abundance of insect food and twenty-four hours' daylight, to breed. Lemmings and voles are also active at this time; the whole tundra is brought to life.

Summer is a time of easy pickings for the snowy owl. A snowy owl's breeding habits are closely linked to the availability of food. In a good lemming year, many chicks will be reared. In a bad one, there may be just one or two, or none at all. If small mammals are few, the owl is capable of catching waders, from the small dunlins to much bigger birds, such as oystercatchers and curlews. Even large gulls and skuas are not safe from this formidable predator.

The male is almost wholly white, except for his eyes, which, although vividly yellow at close range, tend to look simply 'dark' at a distance, and contrast with his white face. The female is more heavily marked with black and brown bars. Both have enormous snowshoe feet: big toes with awesome claws, all swathed in a great bundle of long, wispy feathers.

In winter the dense plumage really comes into its own; nevertheless, the owl finds life tough in the Arctic winter. Some have to move south in search of food, and, on rare occasions, one or two will reach more populated areas of North America or north-west Europe, attracting the admiring attention of hundreds of birdwatchers.

The snowy owl pictured on page 83 is another fairly monochromatic painting. It has a slightly different range of colours from the burrowing owl picture, but gives a similar result. In this work, however, the sheer size of the owl dictates the mood of the picture. This is, to all intents and purposes, a portrait with little concession given to the background. I really intended the viewer to concentrate on the beautiful head and golden eyes. This is the female, quite different from the older males, which become almost entirely white.

At some stage I would like to create a large painting showing a pair of birds in a suitable tundra setting. By necessity it will have to be big, something on the lines of the bald eagle picture on page 107. The idea is there, I just need a couple of spare months!

The drawing of the snowy owl's head clearly shows some of its special features. It has large, forward-facing eyes; their size and sensitivity allow the owl to see quite well in the gloom of an Arctic winter, although its abilities are not much different in this respect from a human's (owls, however large their eyes, cannot see in real darkness). The fact that the two eyes face forward (and are not on either side of the head, as on most songbirds, for example) allows the owl to focus both eyes on its intended prey: this is crucial, as only with binocular vision can an owl, or a human for that matter, pinpoint the precise position of an object and judge its exact distance.

The face of the snowy owl is quite round, and has little of the obvious 'dish' so evident on many owls (particularly woodland ones). Their flat, dish-like face acts rather like a satellite dish, focusing sound on to the owl's ears.The snowy owl's ears are hidden, but they are large and acute; its hearing is crucially important, but the 'dish' is not well developed.

On top of the head, the snowy owl sometimes raises two tiny, square tufts of feathers, as if they are the relic of some past 'eared' form with big tufts of feathers, such as those of the eagle owl or long-eared owl. The tufts are not in any way linked with the ears: they are there for visual communication purposes.

SNOWY OWL EGGS, 12 X 16IN. (30.5 X 40.6CM), PENCIL

The snowy owl's eggs are typically owl-like, being round and white (although these ones soon become discoloured). Most owls nest in holes, either in the ground or in trees, or in dark cavities in walls and old buildings, in which case, the white egg is a useful adaptation, since the owl is able to see it easily in the dark and avoid accidental breakage, which is all too easy with such long, sharp claws. In the snowy owl's case, however, the white eggs are less well adapted to the bird's circumstances, since the eggs are laid on open ground, and the white eggshells make them more easily noticeable to hungry predators.

Snowy owls nest on long, often rocky, ridges or, failing that, in a region of monotonous, flat tundra, or on whatever hummock or mound may be available. They always give themselves the best possible all-round view and they rarely leave the eggs unguarded throughout the laying and incubation period. Through a powerful presence and intense surveillance, the birds are able to overcome the possible problems of easily visible eggs, which might otherwise attract the unwelcome attention of arctic foxes, skuas or gulls.

The snowy owl, like many other birds, varies its reproductive behaviour according to the abundance and availability of food. In a good year it will lay a large clutch of eggs; in a bad year, when food is scarce, it may lay only two or three eggs, or may even opt to give the season a miss altogether. Like the barn owl, the incubation of the eggs starts before the full clutch is complete, so the chicks hatch out at intervals. By the time the last is hatched, its older siblings may be several days old and two or three times its size. If food is short, they take what is on offer and the youngest hatchling, too weak to compete, quickly starves. It is the owls' way of ensuring that the fittest survive, rather than a whole brood of equals dying of starvation.

SNOWY OWL, 30 X 24IN. (76.2 X 61CM), GOUACHE ▷

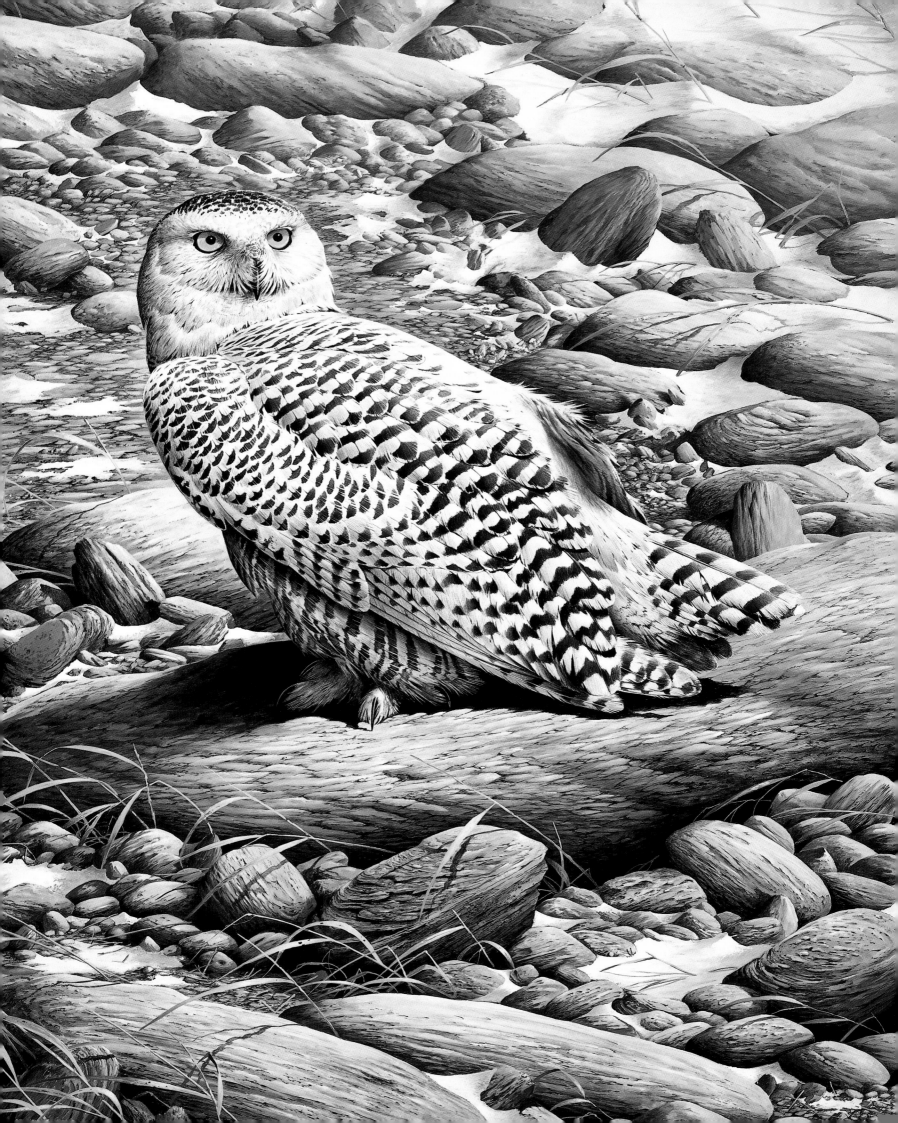

AMERICAN KESTREL
Falco sparverius

This is the smallest but most common falcon of North America. It is widely distributed, with summer migrants getting right into Alaska and across to Quebec, and a resident population over almost the whole of the USA. Some move south to Central America in the winter.

They show much the same diverse choice of habitat as the European kestrel, being found in some cities as well as over all kinds of open ground. Like the European species, American kestrels hunt by watching from a perch, often a telegraph pole or electricity pylon, or by hovering. The latter method is well perfected, with quivering wings and spread tail holding the bird in position, as if on an invisible string. The body moves in the wind, the wings and tail flicker and flex in response to changing air currents, but the head remains absolutely static: the ideal viewpoint from which to detect prey.

What is it looking for? In much the same way as the kestrel, it is a generalist, an all-rounder when it comes to food, but it is a little smaller, and even less likely to take on big, strong prey. It goes mainly for lizards, beetles and voles, but, especially in winter, its speed and agility are enough to capture small birds.

Like so many birds in North America, this one is often relatively tame and approachable compared with the average European kestrel. Sometimes an American kestrel will sit on a low fence post and allow not just a close approach, but several minutes intense study. With a good, tripod-mounted telescope, it is possible to count the eyelashes on such a bird! They are seen, in a view like this, to be wonderfully perfect, finely finished birds – although almost any bird in good view will look beautiful.

It is a peculiar circumstance that birds of prey in Britain and Europe are so shy and unapproachable, in the main, while elsewhere they can be so confiding. In Africa, it is quite possible to walk up to a tree with an eagle in it – a tawny eagle, a fish eagle, a brown harrier eagle or whatever – and the bird simply stays put. It may look down and take an interest in its admirers, but it needs a bit of a push to get it to move from its perch. In Scotland, it is an achievement to get within half a mile of a golden eagle, and even then it is probably going to be seen tail-end on as it flies away.

It is not, surely, only a question of history, that African and American birds have been less persecuted than those of Great Britain and Europe? It is not just birds of prey that exhibit this difference: waders, such as grey plovers and sanderlings, may be quite shy in Europe (not always), while on American beaches they scarcely move out of one's way. Certainly, the American kestrel seems to prefer to get on with its life and mind its own business, without caring too much about what goes on around it.

The American kestrel has, along with a few other falcons, been studied with the aid of high-speed filming to see just how it manages to strike and kill its prey. It descends steeply, with its wings held angled backwards, until just before the impact. At this point it spreads its tail and wings to brake its descent, while swinging the rear of its body forwards and downwards. This brings the pelvis forwards while the legs and toes are stretched out. The toes are not opened until the very last moment, when they are suddenly released in a downward stab. So, the bird is moving fast downwards, the pelvis is moving even faster forwards, the feet are moving even faster than the pelvis as they are lowered and the toes add even greater speed as they are spread. The whole effect is to 'punch' the prey with a cumulative force that is much greater than might be expected from such a relatively lightweight bird. Even these small kestrels are able to deliver a blow and then a crushing force from their talons, which leaves their prey with little chance of escape.

AMERICAN KESTREL, 25 x 17IN. (63.5 x 43.2CM), GOUACHE ▷

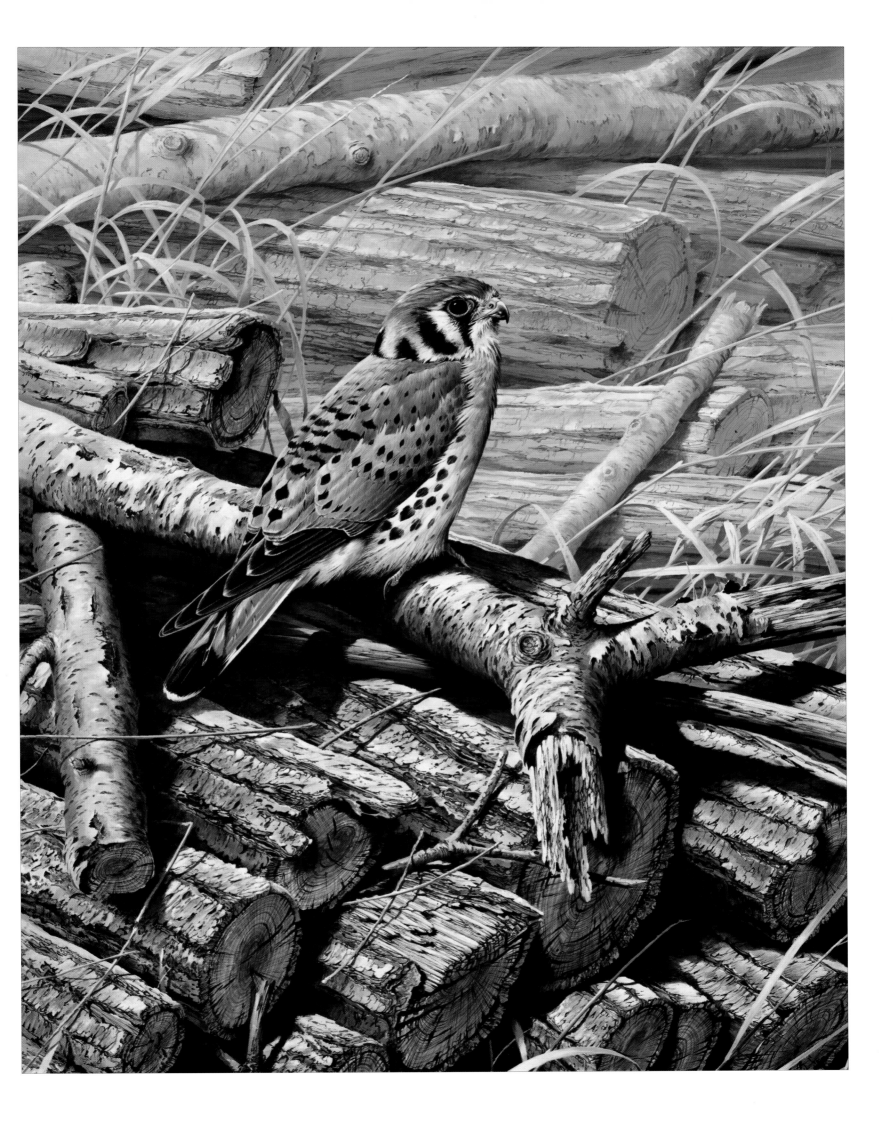

AMERICAN KESTREL, 16 X 12IN. (40.6 X 30.5CM), PENCIL

While watching this miniature falcon hunting in Florida, two things became apparent quite quickly. First was the sheer number of these birds: they were on just about every stretch of telephone and electricity cable, from where they would fly out after flying insects, dragonflies in particular, or drop down onto some small 'furry job' in the roadside vegetation. Second, it was clear (and was reinforced when I came to the painting) that the male had colours almost identical to those of our own kestrel: it was just that they were arranged in a different pattern.

American kestrels are also commonly found along roadside wires and on telegraph poles in parts of California. They are not, however, as fond of hovering as their European counterpart, and when they do, they tend to adopt a steeply sloping pose, using faster wingbeats. In full flight they have a sharper, narrower-winged and shorter-tailed look, rather more like a slim merlin or a shorter-winged hobby in shape.

The male has the most striking head pattern, but the best distinction between male and female is the wing: on the male it is mostly blue-grey, on the female it is barred rusty-brown, just like the back. While a male European kestrel has a blue tail with a black band, on the American kestrel it is clear rusty-red with a black band; females have barred tails.

One American kestrel has been seen in Great Britain; a bird turned up quite unexpectedly on Fair Isle, a tiny island between Orkney and Shetland, which is famous for its long list of waifs and strays.

AMERICAN KESTREL, DETAIL (SEE PAGE 85) ▷

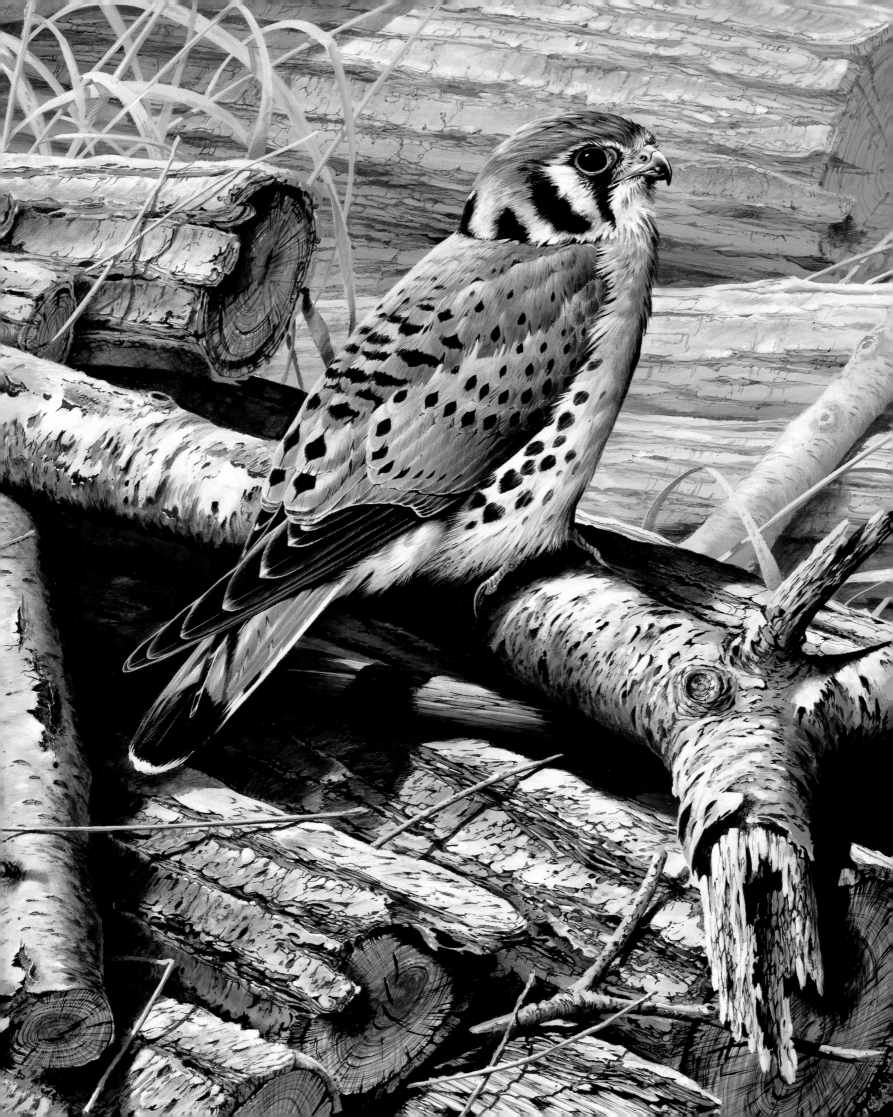

BELTED KINGFISHER

Megaceryle alcyon

This is really a painting of stones. It is a technical challenge to impart the illusion of heaviness and solidity, linked with the knowledge that each stone is liable to shift under the influence of moving water. In the case of this painting, they have already moved and tumbled into their present positions prior to the eventual drying-out of the stream.

Two very tangible components form the background of this work: the silver birch tree trunk, resting for a time against the heavier and infinitely more durable material of the stones.

Even more vulnerable and transient is, of course, the belted kingfisher itself. Perched in a seemingly precarious way on the end of a log, it must soon decide whether to stay and hope that rain will restore this part of its territory, or to move on to a new area in search of food. I rarely give titles to my paintings, but this one pleased me so much that I wanted to convey my own feelings: 'Waiting for Rain' seemed to encapsulate the dilemma of the bird.

It seems obvious to readers in America or Europe that the problem faced by a kingfisher in a drought, is where can it fish? It is not, however, a difficulty common to all the kingfishers of the world, or even to the majority of them: most species feed on dry land.

It is a pure twist of history that the European kingfisher was the first to be studied and named, and taken as the 'type' for a very widespread group of birds. Had the first been an African species, we might now call them all 'bushbirds' or 'lizard catchers'! In fact, small lizards, crickets, locusts and big beetles form the bulk of the diet of many kingfishers, from the Australian kookaburra to the African grey-headed kingfisher.

Belted kingfishers conform more to our traditional ideas of what kingfishers should do: they fish. The method of fishing has been well studied. They perch near or over water and dive headlong to grab fish in their long, heavy bills. Most fish are caught in the top half metre or so of water, rarely in a deeper dive. They are grasped around the forepart of the body. The kingfisher has its wings spread as it dives, to control the descent and reduce its speed, and as it hits the water its membranous third eyelid closes as a protection. They then take the prey back to a suitable perch to subdue it, usually by a good whack against a branch, and then swallow it in one slippery mouthful.

Belted kingfishers eat a variety of food, particularly brook trout, freshwater sculpin, sticklebacks and young salmon. Other fish recorded as prey include chub, black-nosed dace, minnows, banded killfish and yellow perch. On average, the fish caught are 3.5 in (9 cm) long, but bigger ones, up to 5.5 in (14 cm), are sometimes taken. They vary this fishy diet with crayfish, frogs, salamanders, newts, dragonfly nymphs and other water creatures, as well as the occasional young bird and even, in winter, some berries.

In most of North America belted kingfishers are the only type of kingfishers to be found. In summer they extend north to Alaska and south to Florida and the Gulf. Except for the milder coastal districts of the north-west, however, the north is vacated in winter, while the south-western United States and Mexico are visited by migrants, some of them overlapping the range of the very similar but essentially Central and South American ringed kingfisher and the green kingfisher.

BELTED KINGFISHER, DETAIL (SEE PAGE 91)

Belted kingfishers inhabit rivers, brooks and ponds and, frequently, coastal estuaries. Although sometimes found beside quite small waterways, it is difficult for a large kingfisher like this to survive on a tiny, ephemeral stream at the edge of a desert landscape. More often, they inhabit true wetlands, where permanent lakes and rivers support a more dependable supply of food.

Male belted kingfishers are blue-grey and white. Terance has chosen to show a female, which if anything, is even more handsome with its breast and flank patches of rich chestnut-brown. The crest is raised most of the time, and sometimes pushed forwards in an exaggerated fashion, as if an indication of excitement or even irritability. It is used so freely in this way that it seems to have little extra specific meaning between male and female in the breeding season.

Belted kingfishers are big and often conspicuous birds, frequently found perching on the mast of a boat, the corner of a pier, on top of a telegraph pole, or on a power line. Adding to their up-front behaviour is the loud, dry or harsh rattle that they often give as they fly from perch to perch. In flight, the belted kingfisher is usually detected by this rattle, and identified by its curiously large head, short tail and broad, but quite short wings, which move in a curiously uneven, hesitant, almost unsynchronized fashion.

This is one of many species, perhaps appearing to be among the least likely, that have more than once crossed the Atlantic to turn up in Great Britain and Ireland. One survived all winter in Cornwall, a splendid sight and quite at home, even if somehow a little out of place along an English river. Others have survived long periods in Ireland, but it is highly unlikely that such a bird could ever struggle back westwards, against the prevailing wind, to return to its New World home.

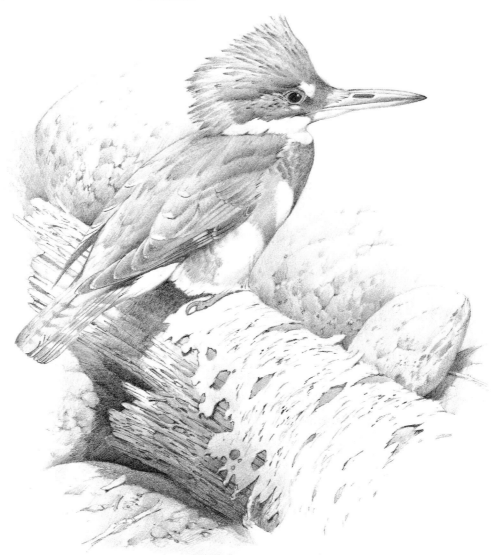

BELTED KINGFISHER, 16 X 12IN. (40.6 X 30.5CM), PENCIL

'WAITING FOR RAIN', BELTED KINGFISHER, 30 X 24IN. (76.2 X 61CM), ACRYLIC ▷

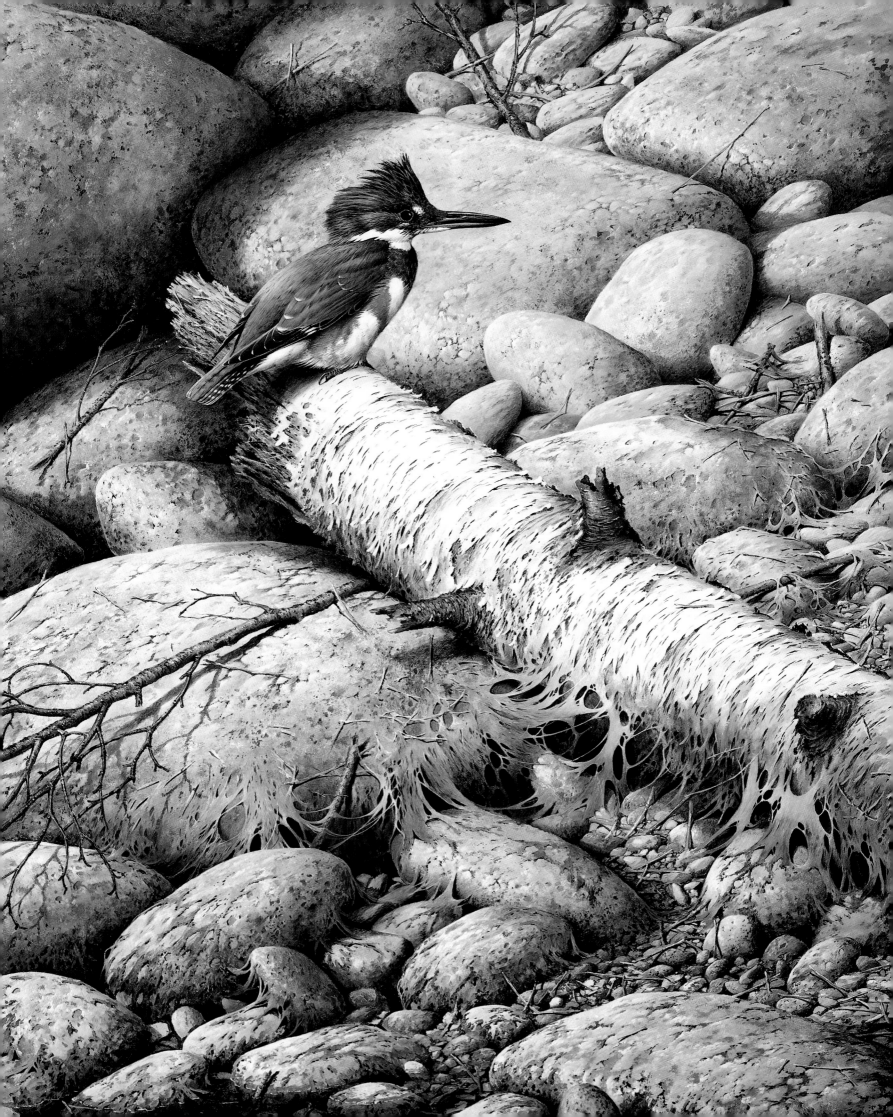

RED-LEGGED PARTRIDGE
Alectoris rufa

In Great Britain the grey partridge is the native partridge and the much smaller quail is a summer visitor of somewhat irregular status, but an equally genuine, natural breeder. The pheasant and the red-legged partridge are quite different: both have been introduced by human agency.

While the pheasant comes from far afield, the red-leg is native to Spain. It was brought to Great Britain for shooting purposes. Ironically, but much to the detriment of the species, it was felt to be wanting in sporting qualities (having the sense not to fly if it could get away by running), and since many chukar partridges from the Middle East, Turkey and Greece have more recently been set free in England, all kinds of hybrids have resulted. What is far worse, similar hybridization has been happening in Spain, where the true red-leg should have been left untouched. Now, a really beautiful little partridge risks disappearing into a melting pot of hybrid birds: a threat every bit as serious as habitat loss or persecution, but largely ignored by the conservationists.

The red-legged partridge is a paler, sandier brown above than the grey partridge, and looks much plainer on the back (the grey is streaked). Instead of a grey breast with a large brown horseshoe patch, and narrowly barred flanks, the red-legged partridge has a much bolder pattern of broad, vertical bands along its sides. And, most striking, it has a white face surrounded by black, the bib breaking up into a network of wavy streaks and flecks over the neck.

In the introduced chukar, the bib is a large, white patch surrounded by a narrow, clean-cut band of black, without the extension onto the chest or the speckling of the true red-leg. The bars on the flanks are also different on a chukar, but in much of England now it is difficult to find a bird that is true to the character of either species, since the whole population is swamped with hybrids. It is well worth scrutinizing your local partridge population to see just how many of each kind can be seen.

Red-legged partridges are gregarious birds, usually living in flocks of ten or a dozen, up to even thirty or forty at times. In exceptionally cold weather, as many as 200 or more have been seen together. In places, it seems that males form separate groups away from the females and immature birds in winter. Yet, despite such apparent segregation and the general preference for a communal lifestyle, the birds are monogamous and the pair will usually stay together for the whole summer.

The male does not normally incubate the eggs, but will do so if he returns to the nest to find the female absent. More interesting is the occasional case in which the female lays two clutches and the male sits on one while she incubates the other. Both hatch at the same time and the male leads his brood while the female leads hers quite separately. Where there are several pairs in close proximity there may be mixing of chicks between broods.

The parent talks to its chicks almost continually, whether it be the female or the male leading his own group. There are a variety of quiet, intimate calls and also special alarm calls that cause the chicks to squat and freeze, or dash instantly under cover. The adult bird also calls to draw attention to morsels of food and will sometimes pick up and drop a piece of food so that the chicks come to recognize what is edible: although they are not fed in the conventional sense, the chicks are certainly taught by their parents.

The chicks often shiver and show signs of being cold and exposed and may then push underneath the parent bird for warmth. The adult will often scrape a hollow in sandy ground in order to brood the chicks during the day, between bouts of feeding. At night, when they are very young, the chicks are shepherded under cover and out of sight, but later the whole family roosts in the open.

'Incubating Hen', red-legged partridge, 12 x 16in. (30.5 x 40.6cm), pencil

Red-legs do well in the drier, sandier parts of eastern England but also thrive in other situations, from inland heaths to coastal dunes. They are still, however, predominantly English in their distribution within Great Britain. They may sometimes be seen perched incongruously at the top of a haystack, or on a barn roof, where a grey partridge would certainly not find itself in the normal course of events. From such prominent perches they may produce a variety of calls, some with a peculiarly squeaky or wheezy quality, and a strange 'chuffing' rhythm, sometimes likened to an old steam engine! A loud, throaty 'chuk chuk-kar' is a typical call, too.

Red-legged partridges nest on the ground and, like other partridge species, lay a lot of eggs – perhaps a dozen or fifteen in a clutch. The downy chicks leave the nest soon after hatching and may often be seen running after a parent bird. They are also capable of flying before they are full-grown, giving rise to a potential risk of confusion with the smaller quail. Most gamebirds have this adaptation, which is clearly designed to reduce predation by mammalian predators such as foxes and stoats. It goes against the general rule in birds – that juveniles are already virtually full-grown when they fly for the first time.

Red-legged partridges, detail (see page 97) ▷

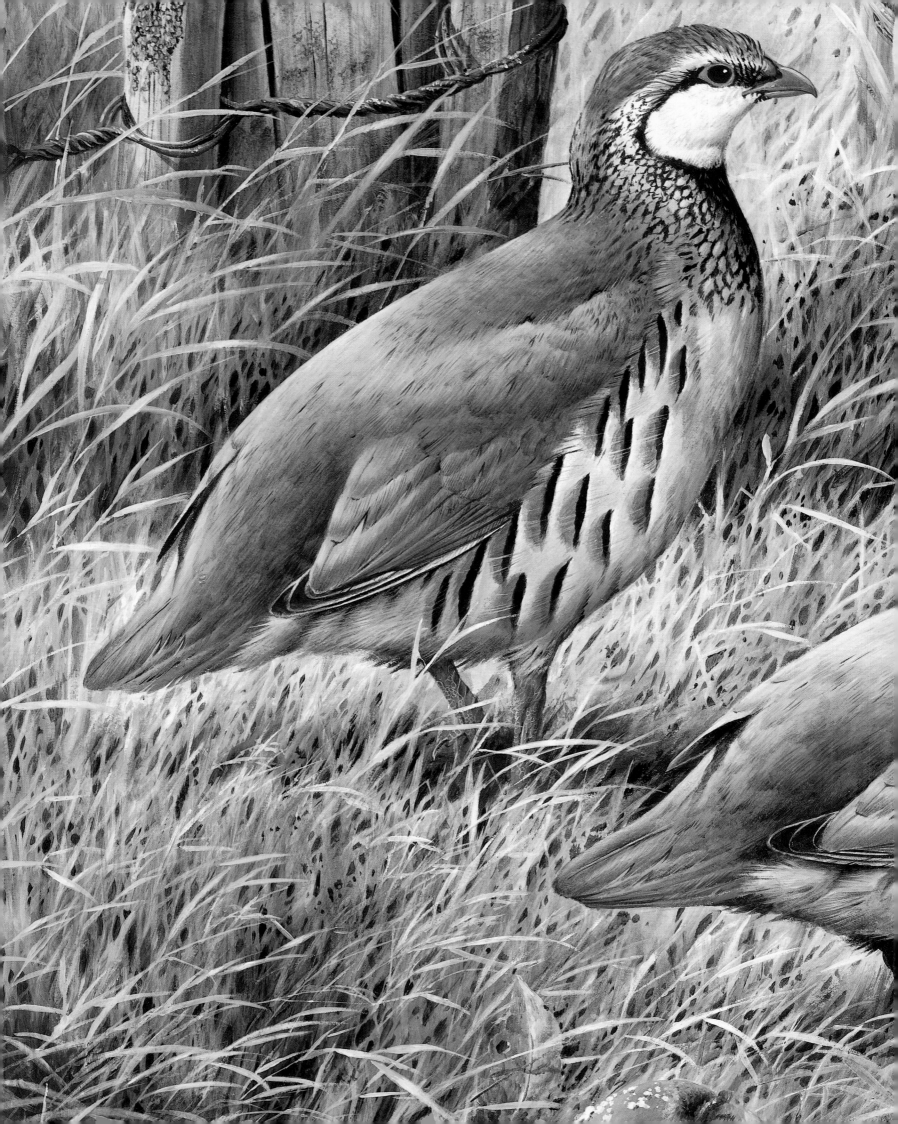

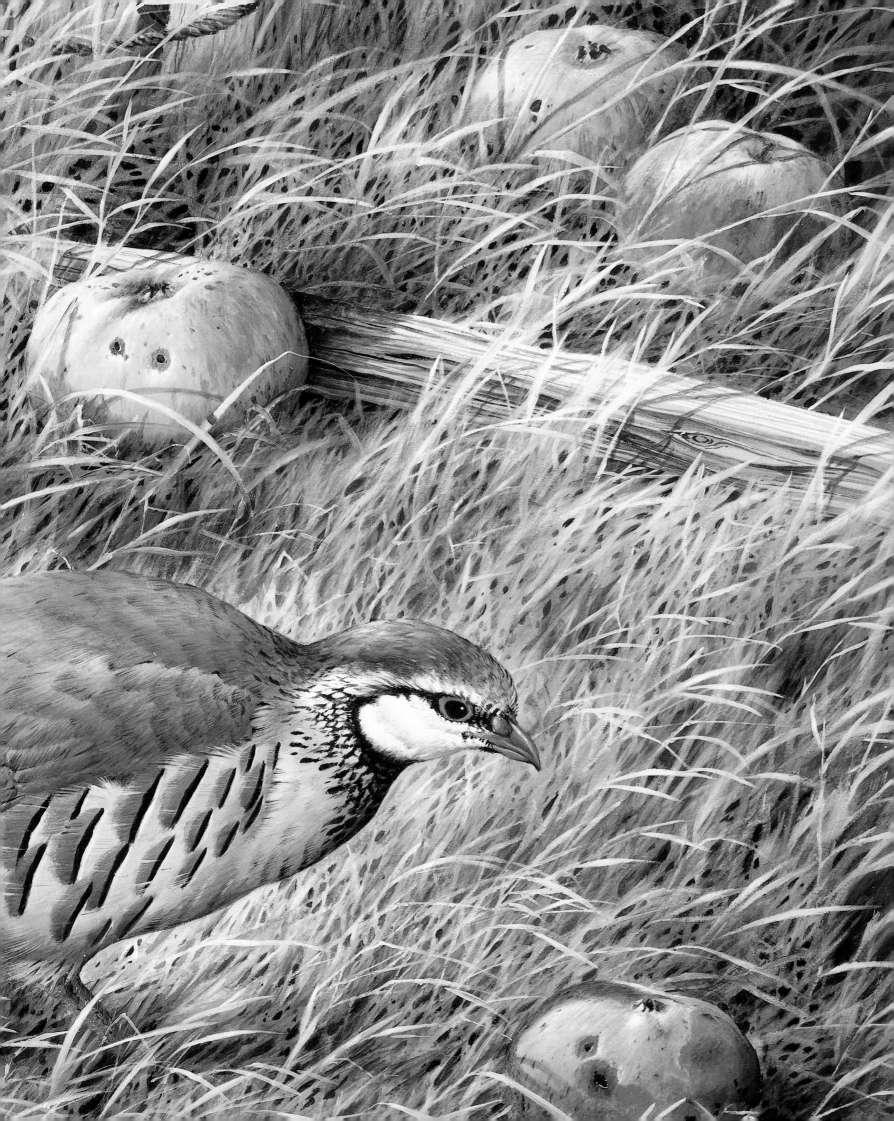

RED-LEGGED PARTRIDGE, 16 x 12IN. (40.6 x 30.5CM), PENCIL

The neutral colouring of the chestnut-rail fencing running through the top half of this painting helps to stabilize and anchor what is, in essence, a complicated design. At the same time it provides a link with the grey on the bird's breast.

During my daily walks around the local fields, I pass a neighbour's old orchard. The ancient trees that make up this old planting have provided background material for several paintings in the book, but it was the windfall apples lying under the trees that sparked off the idea for this picture. Red-legged partridges often live around buildings and country gardens. A recollection of early childhood is going to bed by daylight and listening to the partridges calling to one another outside the garden perimeter.

Initially I proposed to include twice as many apples in the painting as are shown in the finished work, but even on a large painting such as this, a misplaced apple or two can play havoc with the composition. Finally, I selected five main fruits and two less colourful specimens in the bottom left-hand corner. These I then 'threw away' by placing them in an area of shadow.

Red-legged partridges have fine qualities as an artist's bird, with such bold, rounded, full forms, strong patterns and rich colours. A touch of red on bill and legs sets off the whole image. They are, perhaps, less fully appreciated than they should be, at least in East Anglia, where their large and portly figures are familiar on the open, sandy fields and brecks. It is all too easy to become neglectful of the common, everyday birds, and it is a particular quality of Terance's work that he reminds us, or even informs us, of what splendid creatures we have on our doorsteps.

In its natural habitat in Spain, the red-leg is often a much less obvious bird. It is elusive, keeping to weedy growth at the edge of dry fields of crops, or creeping through the thorny, aromatic herbs of a scrubby hillside. Numbers in central Spain are increased through management, including some worryingly thorough elimination of predators large and small, for the benefit of visiting gunmen.

RED-LEGGED PARTRIDGES, 30 x 24IN. (76.2 x 61CM), ACRYLIC ▷

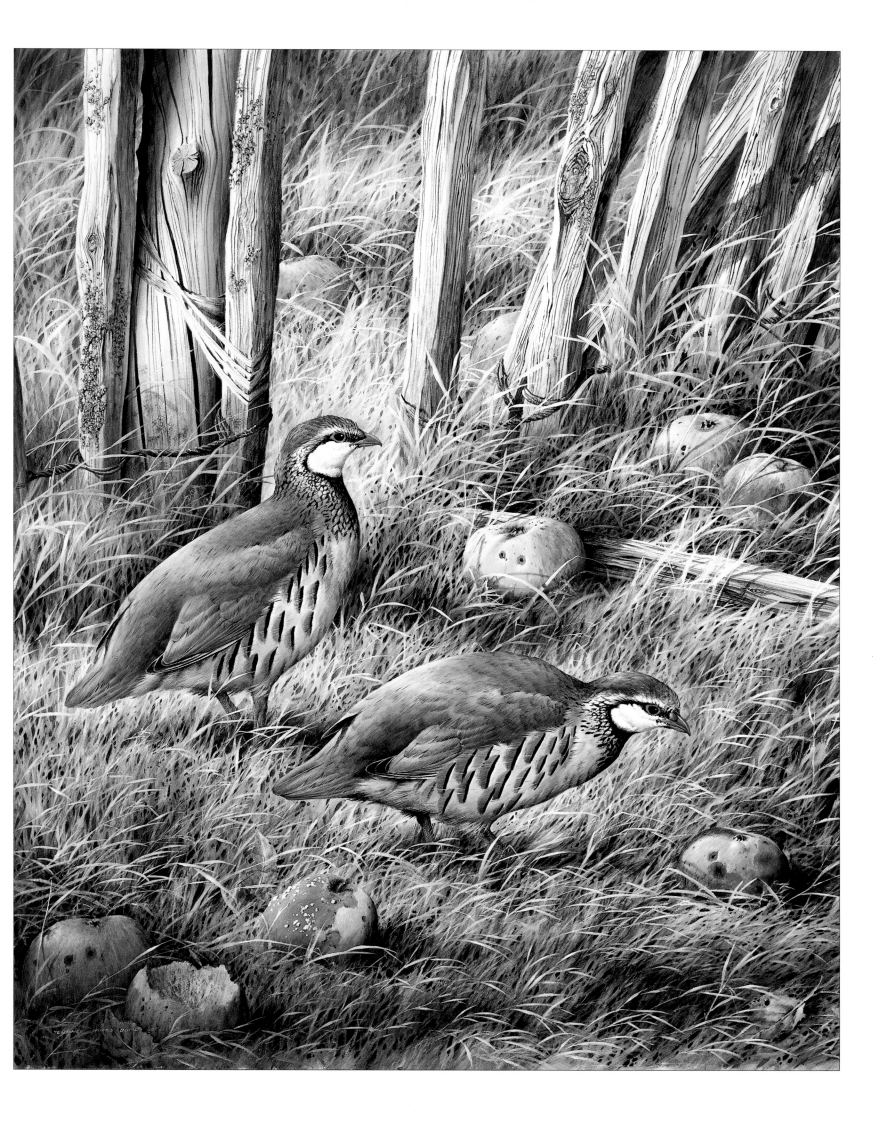

TAWNY OWL

Strix aluco

Tawny owls have a remarkable ability to survive in a relatively small territory for the whole of their adult lives. Many owls are wanderers, their movements being in response to changing food supplies. A concentration of voles creates an influx of short-eared owls; a reduction in voles will see a mass exodus of these predators.

Other owls also regulate their breeding behaviour to their food. A pair of short-eared owls in an area teeming with prey rears ten or a dozen young. When voles are few, they rear only one or two.

Tawny owls, however, have a much more stable life, and do not move from place to place to find food. Instead of specializing on one kind of prey, they generalize: if there are voles, they will catch them. If not, they turn to birds. In any case, they will take a mixture of beetles, grubs and earthworms. If need be, they will even catch a fish or two. If there is plenty of food they will rear two, three or four young. Even if food is not so plentiful, they still lay more or less the same number of eggs and rear the same-sized small family. Suburban tawny owls, in particular, have a very stable way of life, related to the high density and stability of the small birds and rats that form their prey.

One important result of their more sedentary nature – indeed, a vital requirement that allows such a lifestyle to be successful – is a deep and intimate knowledge of the territory. A tawny owl cannot see in utter darkness, but it can often move around: it knows every branch, every twig in its home range through years of familiarity. It knows how to escape predators, and it has the best idea of where to find food.

In short, its whole strategy is the opposite of that employed by other owls. It is not a wanderer, nor is it an opportunist: it is a home bird, with a stable lifestyle based on a thorough familiarity with its chosen territory.

The nest itself is found in a variety of places. In fact, the owl does little more than scrape a few bits and pieces beneath itself and its eggs, more or less as it broods. It may lay eggs in a rabbit hole, in a soft depression on the forest floor, in the old nest of a crow, or on top of a squirrel drey. By far the most usual site, though, is a cavity deep inside a large tree. Often this is where an old branch has broken off, leaving a soft, rotting core, which eventually hollows out into a deep hole. Nestboxes for tawny owls are often successful, so long as they mimic this long, deep cavity. Old barrels and big, deep boxes placed at a steep angle along a rising branch are the best.

The eggs are pure white, as with other owls and most hole-nesting birds, since by the time a predator has found the nest, there is little point in the eggs being camouflaged. It is much better that the eggs are white, so that the owl can at least get a dim gleam from them in the dark, and there is less risk of a sharp claw or heavy foot clumsily breaking the fragile shells.

Like other woodland owls, the tawny is able to turn its head almost back-to-front, so that it can look around from a perch without having to change stance. Its head is, indeed, like a living radar dish, with big, sensitive eyes and, although they are hidden, immense and even more sensitive ears.

The eyes are little better than ours in really dim light. Often in near darkness we can see something out of the corner of our eye, but not in the centre of our vision. This ability relates to the differing proportions of 'rods' and 'cones' on different areas of the retina. The centre of a human's eye is sensitive to detail, while the outer part of our field of view performs better at low light levels. The owl is also able to make out shapes in poor light, but is less able to see fine details.

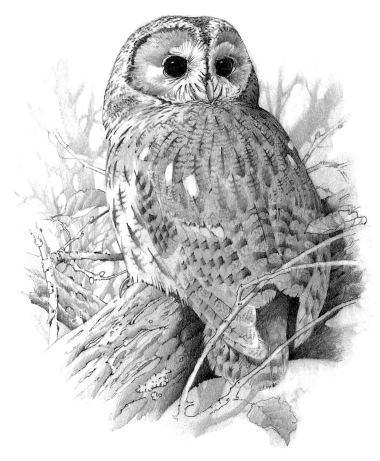

TAWNY OWL, 10 X 10IN. (25.4 X 25.4CM), PENCIL

It is the ears that come into play when detailed information is needed. The owl has a flattened facial disc, which, literally, funnels sound into the ears. One ear is slightly different in size, shape and position from the other. By bobbing and turning its head the owl uses the tiny variation in sounds detected by these asymmetrical ears to pinpoint the source with remarkable precision. A mouse on a woodland floor, even an emerging earthworm, can be heard and located. Then, when the rustle stops, the owl pounces.

The final feature of the head is then used: the bill. So well hidden in dense feathers, it is actually long and deeply hooked. A road victim – sadly frequent in these days of fast and dense traffic – gives the best chance of examining an owl's bill; the feathers can be drawn back to reveal the true size and shape of the powerful mandibles. The bill is used to despatch prey efficiently, and opens to reveal a wide gape: even a sizeable rat can be swallowed whole, although the long, scaly tail may hang down from the bill for quite some time, until the beginnings of the digestive process make room for more inside!

The owl is also equipped with curved, needle-like claws at the end of fully feathered toes. The claws are for catching the prey, just like a cat's, while the bill usually does the killing. It is easy to imagine the chances of a small rodent, once hooked by these merciless claws at the end of a surprisingly long, outstretched leg. The owl is a particularly efficient predator, not the most agile, but extremely good at what it does: catching small prey on the ground.

Tawny owls in towns are surprisingly good at catching thrushes and blackbirds at night, often taking more females than males, presumably snatching them from their nests as they incubate eggs in spring. The tawny owl can also be found in city streets, taking rats from the litter-strewn gutters outside fast-food shops and take-aways!

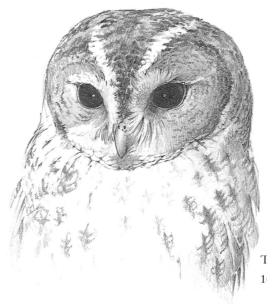

There is a funny thing about owl paintings: it seems to me that there is always a feeling of disdain, even annoyance on the part of the bird at having been disturbed by the viewer.

Most of my owl paintings offer a face-to-face confrontation: none more so than this one. This bird rotates its head to glare over its shoulder at whoever has blundered so noisily into its private world. I have done it myself many times, and almost feel like apologizing to the owl before retreating!

Old apple trees such as the one illustrated are fascinating to paint. They give the impression of great antiquity, without actually reaching a great age. The temptation is to get carried away with all the lichen, moss, holes and so on that festoon the tree, and some degree of self-discipline is required. My local tawny owls frequent an old orchard in a neighbouring field and the image that I have included in this collection is a familiar one to me.

An owl in the hand – alive, or perhaps picked up dead – is a fascinating object. A little owl is thickset, heavy and solid. A tawny owl tends to be skinnier, covered in deep, soft feathers. Its size, nevertheless, makes it a formidable predator of small and medium-sized rodents and small birds.

The feathers themselves are remarkable. On the long, outer feathers of the wings – the primaries, quills, or flight feathers – the outer margin is fringed with short, fine barbs or soft bristles. The whole surface is soft, with a velvety pile or bloom. On a barn owl, especially, there is a feeling almost of lanolin, or soap. These adaptations all aim to make the owl as silent as possible in flight. After all, a tawny is a relatively big, heavy bird, and as it flys through the air one would expect to hear quite a rush of wings. From personal experience, I can confirm that an owl flying from behind slides past one's ear and is away before there is the faintest indication that it is coming! It can be, therefore, an exceedingly dangerous creature if one is unlucky enough to find one that will attack people at a nest, which is fortunately not the norm.

Some tawny owls are rustier, some greyer, but all are beautiful creatures. All have eyes that deserve to be described as deep, limpid pools. Yet their chief glory, of course, is their voice.

A typical tawny call at dusk is a loud, sharp, slightly nasal 'kewick' or a more drawn out, almost whippy, 'keer-wik!'. This, one may suppose, is the popular 'tuwit'. It is not really followed by 'tuwoo', although the sharp call is often succeeded, after a pause, by the hoot. It is an incomparable sound: a beautiful, clear (but sometimes breathy at close range), quavering hoot, in a rhythmic, tremulous sequence: 'Hooo! Ho: ho-hu-hoooouououou!'.

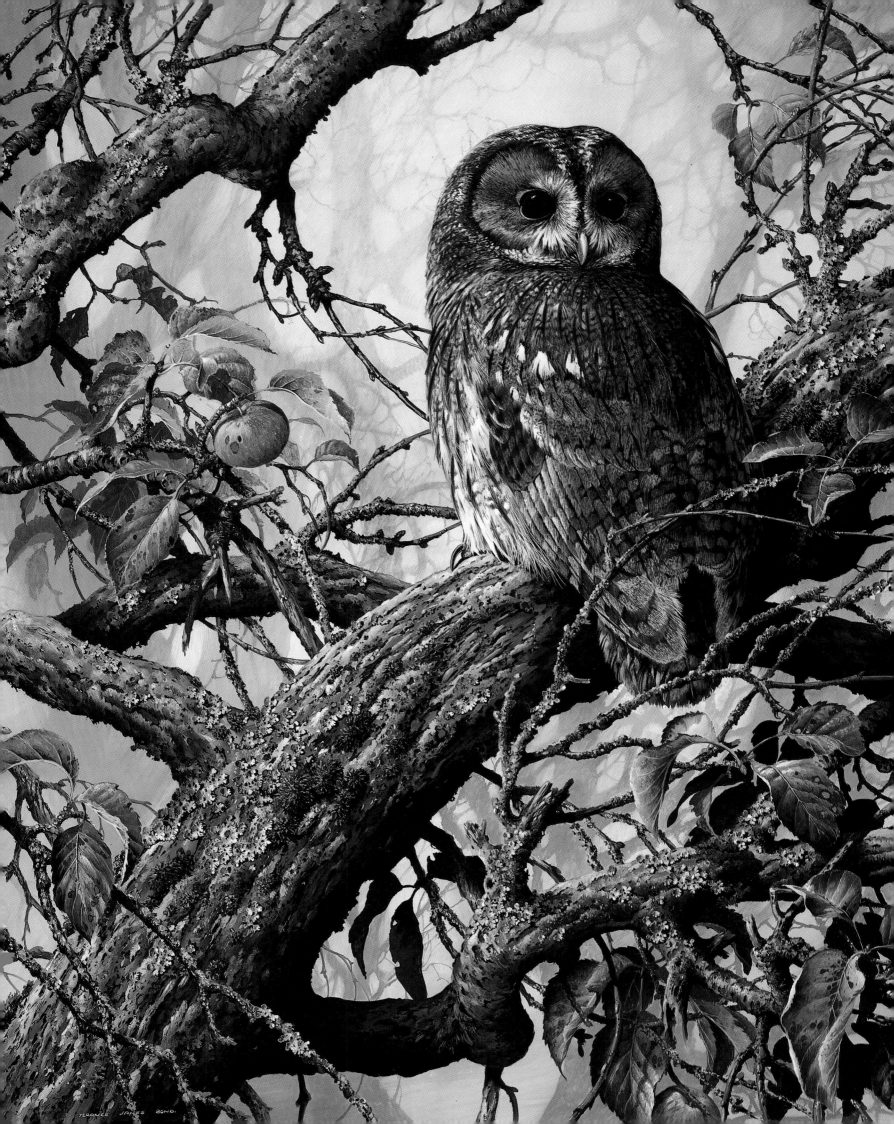

BALD EAGLE
Haliaeetus leucocephalus

Emblem of the USA, the bald eagle is a splendid, majestic example of the sea eagle family, which includes the white-tailed eagle of Europe, Steller's sea eagle of Asia and the striking fish eagle of Africa.

All are, to a greater or lesser degree, associated with water or watersides, although by no means all are tied to such a habitat as much as the fish eagle. The bald eagle is a large eagle, distinguished from others such as the golden eagle by its deep, strong bill, a longish head and neck that protrude in flight, a particularly short tail, and broad, squared or round, deeply fingered wings, which are held straight and flat in soaring flight.

The bald eagle combines impressive size and a magnificence of form with an eye-catching pattern. Adults are very dark brown, except for a pure-white tail and a wholly white head and neck, made all the more distinguished by the bright-yellow bill. Immature birds are much dowdier, with a dark head and tail, but still distinctively big and broad, like a 'flying barn door' when in the air. They have more or less white blotching on the underwing, but little clear-cut pattern. It is five years before they assume the full adult appearance.

Compared with other very large birds of prey in North America, the bald eagle is flat-winged; whereas the turkey vulture, for example, soars with its wings raised in a 'V'; the black vulture is not built on anything like so grand a scale; and the California condor is practically ruled out of the equation because only very slowly is it being reintroduced to the wild, after a last-ditch captive-breeding programme to save it from extinction.

Bald eagles are found along the southern coast of Alaska and down the west coast of North America just into California; across the interior of Canada and along most of the Rockies; around the Great Lakes and in isolated pockets south to Florida and the Gulf coast. In winter, the Canadian breeding population moves south, to escape the harsh winter conditions. In winter, bald eagles visit the central states of the USA to the Texas coast and even southern California.

Like most large birds, bald eagles prefer to conserve energy as they fly and find continual flapping-flight very tiring. To beat such broad wings, which have a considerable resistance as they push through the air, takes a good deal of strength and the breast muscles of the eagle are not especially large.

To overcome this, large birds of prey and many other species that have long, broad wings have developed a special means of using the upcurrents of warm air, which develop over land. A 'hotspot', such as a desert hill, or a sun-warmed slope, produces a warming effect on the air and creates a 'bubble' of warm air that rises, often beneath a puffy white cloud. This is known as a thermal. Bald eagles, like many other birds, find the rising air, and circle around within it to gain height, without beating their wings at all. Then, at a great height, they steer in the desired direction and sail away in a long, gently descending glide, before rising again in the next thermal. In this way they travel great distances without expending any energy.

However, thermals do not occur over large areas of water and the birds find difficulty in migrating over seas. Hence, at places such as Gibraltar and the Bosphorus in Europe, the narrow sea crossings attract huge numbers of soaring birds every spring and autumn.

Bald eagles also survive in colder areas, where thermals are unlikely. This is why, in common with some other species of 'sea' or 'fish' eagles, they may sometimes be seen looking rather less than noble, sitting about in trees, on beaches, even on riverbanks, where there are concentrations of food: shoaling salmon, scraps of offal, even perhaps a beached whale. In such circumstances, they are little different from scavenging gulls, crows and vultures.

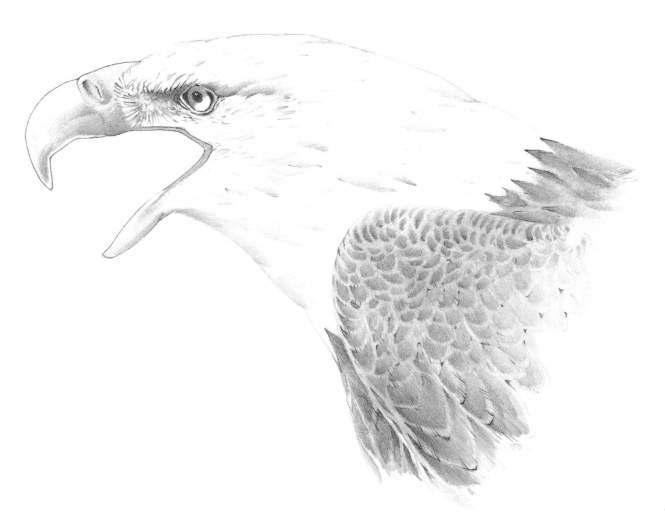

These big eagles, still quite common in Alaska, but relatively rare elsewhere, like to be in the vicinity of big rivers, lakes and the sea coast, and feed largely on fish. At times, in some favoured places in the north-west, large groups gather to feed on running salmon, catching fish in the shallows and taking them off to a suitable pine or a nearby rock to feed. They catch the fish in their powerful feet and tear into the muscular, tough flesh with their hooked beaks.

Bald eagles nest in trees, constructing broad, deep platforms of big sticks, which remain in place for many years and are added to over successive generations. General disturbance, accidental poisoning, plus some deliberate shooting and harassment have seen numbers plummet in most areas, especially in the south; fortunately, eastern populations now seem to have stabilized with increased protection and recovery programmes.

It would be a sad loss indeed, if the bald eagle were to disappear from areas where it has been known and revered for many decades.

BALD EAGLE, DETAIL (SEE PAGE 107) ▷

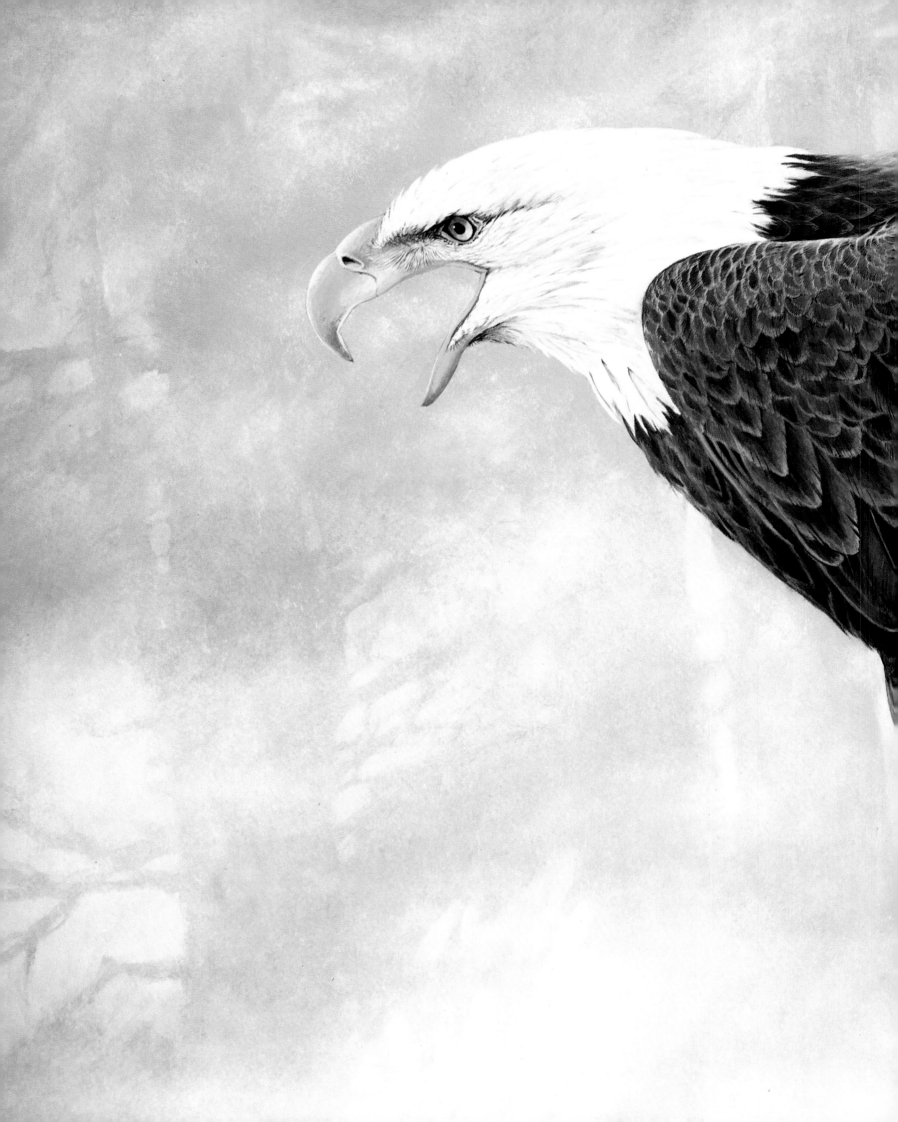

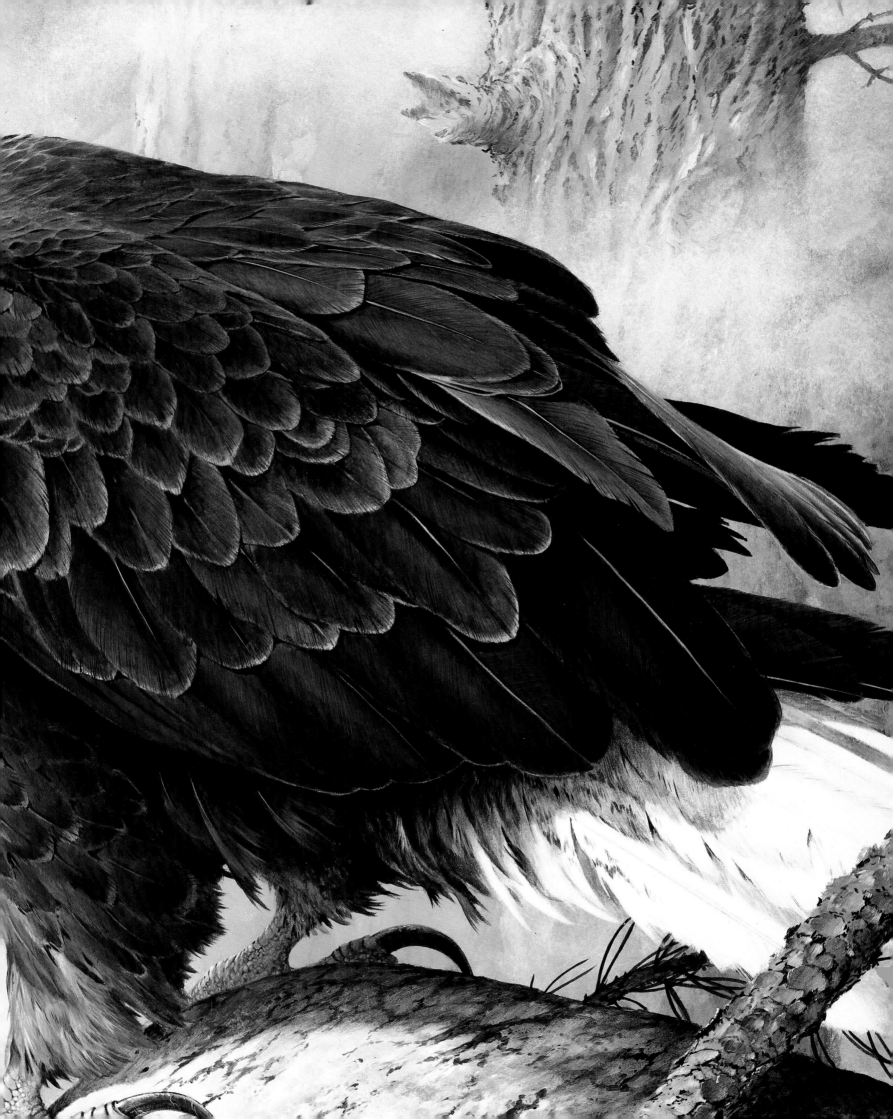

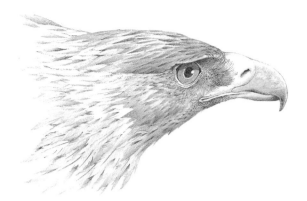

The bald eagle painting is one of the largest in this collection, and at forty by thirty inches (100 by 75 centimetres) is about as big as I would want to paint. Mind you, it had to be large: the bald eagle is a big bird, and I felt that to do it justice some proportional effort was required from me.

My motive was to paint a picture that was not just all eagle. There had to be some hint or indication of the environment in which the bird is usually found. Having said that, I still vividly recall my first introduction to wild bald eagles during my first trip to Florida. A representative from the local Audubon Society showed me two nesting birds: one in a large pine tree growing in a suburban back garden!

Paintings of eagles are in danger of becoming a cliché, big and fierce just for 'big's sake', but I felt satisfied with the outcome of this painting, despite the fact that I decided to crop the bird's tail and primaries. No one seemed to object. Without exception, visitors found it impressive: and probably unavoidable! It is hard to concentrate on anything else while a male bald eagle is in the room.

Favourable comments, however, were made with regard to the softly delineated trees in the background, contrasting with the large trunk in front. This was gratifying: I felt that it proved that the composition worked. The eagle is there in all its majestic glory, but the rest of the painting gets its fair share of attention.

Sadly, because of their symbolic importance, bald eagles more than almost any other species, have been subject to some of the worst bird art around! Many products and 'corporate images' use the eagle as an emblem, but few come even close to portraying it accurately, which is a great pity. No imaginary, awkward, ugly eagle can match the real thing, which combines a surprising degree of grace and elegance with its undoubted power.

It is, though, a difficult choice between bald eagle and golden eagle for the most assured and complete bird of prey. The bald eagle is somewhat broader in the wing, shorter in the tail, yet set off so wonderfully well by its pure-white head and tail. The golden, on the other hand, has a longer, more flexible wing, and a more protruding head, balancing the long, squarer tail, which is used much more frequently to give poise and balance in flight. It does, perhaps, compensate for its less contrasted plumage with a more beautiful flight.

One feat common to the 'sea eagles' or 'fish eagles', the group of species to which the bald eagle belongs, is seen during courtship and territorial display. Two birds will come together high in the air and, with wings fully spread, reach out to clasp their talons together, while swirling around like the sails of a windmill as they fall out of the sky. It is a dramatic performance, which any birdwatcher would feel exceedingly lucky to have witnessed.

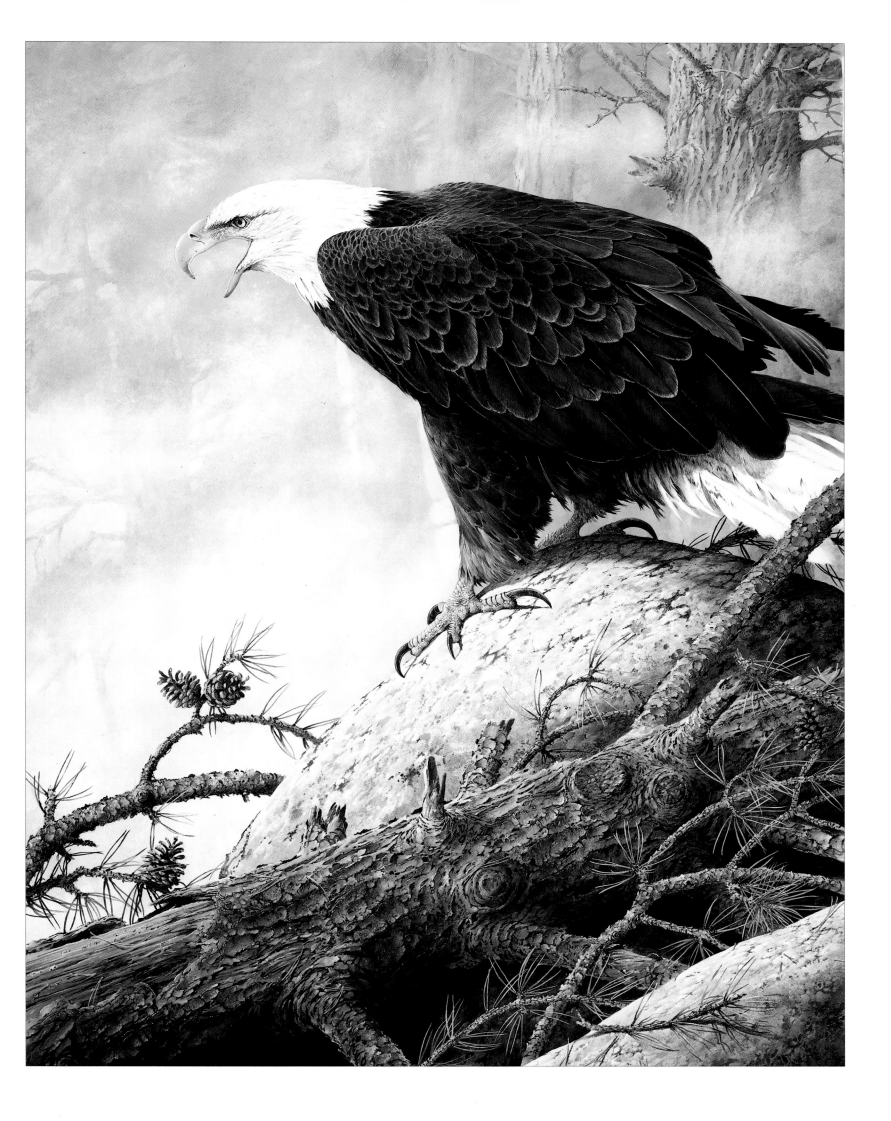

BARN OWL
Tyto alba

It has often been said that the barn owl has the widest natural range of any land bird. It is, indeed, widespread, but it is largely absent from many parts of Europe and Asia, where the severity of winter weather proves too much for it to tolerate.

Nevertheless, it makes up for this by its presence in all kinds of out-of-the-way places, including many isolated islands and archipelagoes almost worldwide. It has also been introduced by man to other sites where it does not occur naturally. In some, where the native birds are singularly ill-equipped to cope, it is a serious predator: on the Seychelles, for example, there is a price on the head of any barn owl, as they create havoc amongst the breeding seabirds.

Barn owls vary considerably across their range. The birds of Great Britain are among the most beautiful of all, being the palest, clearest buff and golden-yellow above, freckled with grey and white, and unsullied white below. Those of much of Europe are grey on the back, with the speckling more intensive, and almost as dark beneath, with their underparts deep buff. In North America, barn owls vary from white-breasted to more cinnamon-coloured, while in Africa the barring and dark speckling on the underparts is more intense.

Barn owls are essentially rodent-eaters, catching small voles, mice and rats, usually at night. In bad winter weather, or during the summer when they have many young mouths to feed, they can be seen in good daylight. They have a problem in the more intensively cultivated areas, including much of Great Britain; voles cannot survive in many crops, such as wheat or oil seed rape. They require rough grassland, but if the grass is too long, the owls cannot see, hear or catch them. The balance is quite fine and while 'rough grassland' sounds as if it should be easy to find, it is in fact all too difficult in a world of intensive farming, where fields are ploughed right to the edge (removing the old headlands where owls used to find food), road verges are kept closely mown and much 'waste' land becomes converted to industrial use, hypermarkets and superstores, service stations or housing.

Barn owls also need holes in old buildings, or big, hollow trees. These also tend to disappear from the tidy, efficient modern landscape: hedges are removed, trees are felled, and old barns are converted to holiday cottages. The holes are crucial roost-sites for owls all year, and breeding places in summer. Even a barn owl with a secure nest site needs one or two other holes, in which it can rest safely in interludes between night-time hunts. Without such security, the owls disappear even if the voles are still available.

Fortunately, with proper farm management, including subsidies for farmers willing to leave some land free of crops, and the provision of artificial boxes, barn owls can often be given a helping hand. In some upland areas, old plastic drums roped onto conifers make ideal nest sites, and barn owl populations have boomed.

Breeding barn owls employ an effective strategy, although it may seem a sad or even cruel one to us. They lay more eggs than can normally be hatched and reared successfully. The over-production of eggs and chicks is a simple safeguard against food shortage. The eggs are incubated from the first or second one to be laid, so that the next will hatch out a day later, the next a day later still and so on. This inevitably results in a succession of sizes, from the biggest, oldest chick to a much smaller 'runt', the last-born. If there is plenty of food, all the chicks get a share and survive. Should food be short, only the bigger ones will take it, forcing the younger, weaker chicks out of the scrummage when the parent returns with meagre supplies. The small chicks soon die.

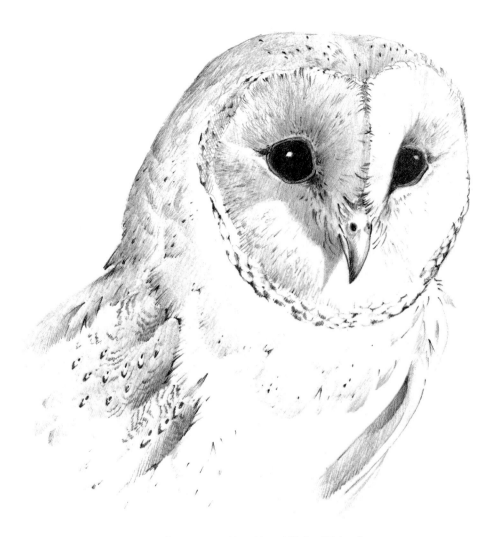

BARN OWL, 10 X 10IN. (25.4 X 25.4CM), PENCIL

It is better, from the owls' point of view, to rear two or three strong, viable young than have six or eight all equally short of food and maybe no fledged young at all. This is different from the tawny owl's technique, which is to live in a smaller territory that it knows intimately well, and feed on a wider range of food, so that it can rear a small family year after year. In the end, the arithmetic works out very much the same: ten years of three per year for the tawny, and for the barn owl, two tens, a five, a three and a couple of ones for the same ten-year period.

It is so with many aspects of bird biology: there is no apparent single answer to the problems of survival, no one 'right' method that is necessarily better than any other. Birds have generally found more than one solution to the same problem, be it to do with breeding, or feeding, or migration. The same diversity is also apparent with displays, courtship and territorial defence.

One odd thing about barn owls is their apparent vulnerabilty to drowning. Quite a number are found each year drowned in water butts and drinking troughs of some sort. It seems that they are attracted to drink, but fail to get out of a deep, steep-sided receptacle. It is not clear what happens, but an owl with waterlogged feathers deep in a butt half-full with water will soon become exhausted in its efforts to fly out, and fall back in to drown.

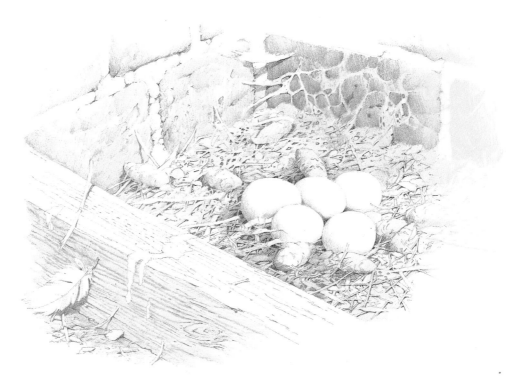

The unusual viewpoint of this painting – looking out of the barn past the owl – proved to be a popular one. Most people who saw it were quite taken with the composition, even those clients who normally express a dislike for owls and birds of prey (and there are many). They felt that this was one that they could live with.

Seen at close quarters, barn owls are incredible. The mixture of minute speckles over a ground colour of cream and white looks much the same as a sprinkling of salt and pepper over the feathers.

It is undoubtedly this perfection of plumage and pattern that appeals to most people when confronted with a barn owl, although it is a much simpler impression (of rich buff and white) that is normally obtained. To appreciate the peppered effect requires an exceptionally close view.

One other attribute that makes the barn owl famous is its voice. The infamous 'blood-curdling screech', so often described in the literature, is in fact heard only rarely by most birdwatchers. The bird actually produces a strangled, shrieking sound rather than a full-blooded screech, with more or less of a hissing quality, but it is still loud and unearthly enough to send a shiver down anyone's spine.

The softer, quieter, and more conversational noises from a nest site are heard more often. The strange, hissing, snoring calls of a family of young birds can carry over quite long distances. There is also a sharper, yelping flight call, which may be heard from hunting birds at night.

It would indeed be a sad thing if barn owls were to be reduced to real rarity in the countryside. As predators they will never be numerous in most parts, but most farms could support a pair if the conditions were right. That would be a healthy situation, rather than the current position in which some whole counties can only muster a handful of birds.

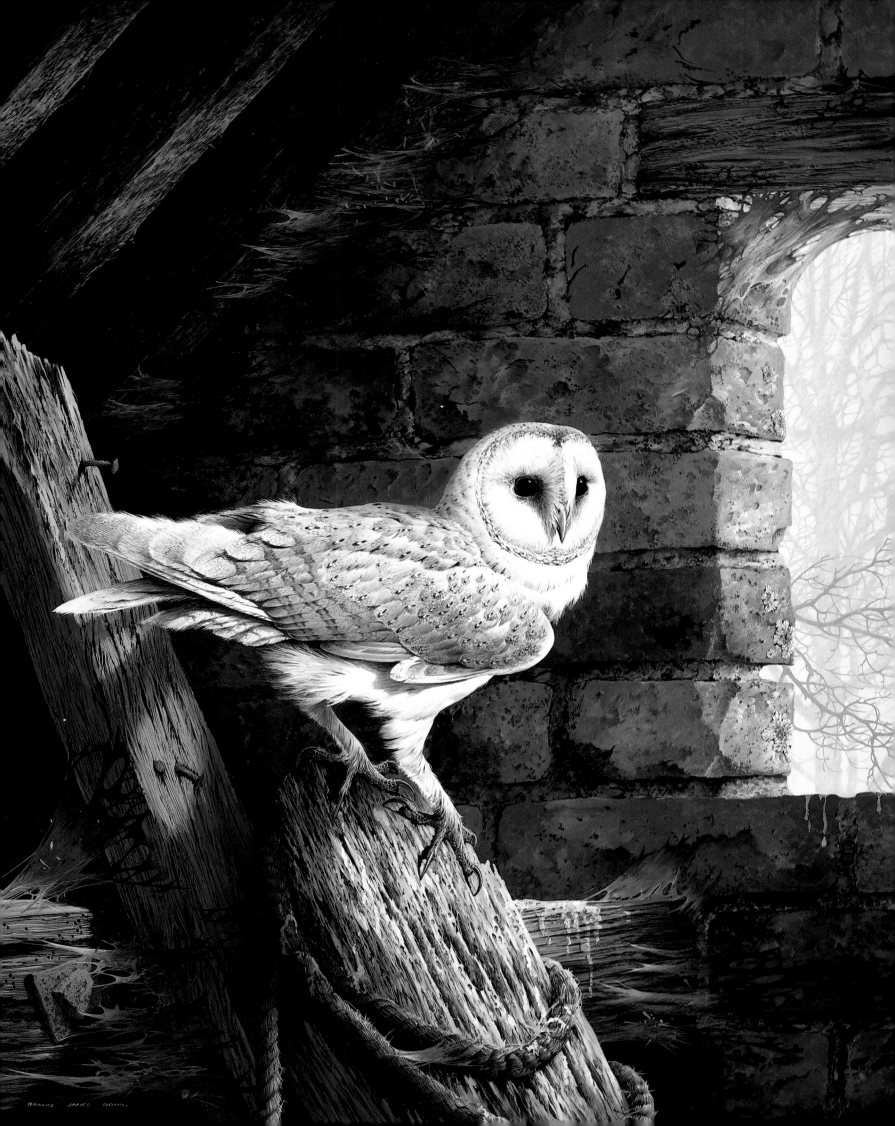

COMMON TERN

Sterna hirundo

It is very easy to become stereotyped in the illustration of a species and its surroundings, and I suppose, to a certain degree, that is what has happened with this particular bird!

Over the past twenty-five years or so I can recall painting this subject only five times, on average once every five years. Without exception those works portray the tern sitting amongst stones or pebbles. To an extent, then, these paintings, particularly the large set-pieces, have become a celebration of stones rather than the bird.

You can inject an incredible range of colour into a composition with a restricted design, or alternatively make it as monochromatic as you like. Compare the stones on these two common tern paintings with those in the background of the belted kingfisher (page 91) and you will see what I mean.

While Terry admits a long-term fascination with stones, the common tern does invite such a setting. Nowadays, much more than formerly, common terns in Great Britain nest inland, around flooded gravel pits in particular. In North America they have a surprisingly restricted range, perhaps partly as a result of past competition with Forster's terns. There they are largely coastal, and in much of Europe they still remain chiefly birds of the coast, although they are occasionally seen over reservoirs and lakes inland while on migration. In eastern Europe, even nesting common terns penetrate long distances along major river systems.

Whether beside a river, on a shingle bank, on a gravelly island in a gravel pit, or on the sea coast, the likeliest spot for a common tern to nest is on a stony or pebbly beach or ridge. Some choose bare rock, others crevices in rocks, which may be more or less filled with vegetation, such as scurvy grass or mallow, while other pairs choose sandier surroundings. The latter risk losing eggs and chicks to sandstorms, which can literally bury the nest without trace. Many nest so close to sea level that a high tide backed up by a strong wind may flood them out completely.

Most terns, however, face potential disaster from human interference or predators. People like visiting beaches, both sandy and shingly ones, and as a result many tern colonies have been deserted over the years through inadvertent disturbance by weekend visitors and holiday-makers. Few beaches escape such interference in a fine summer, and tern colonies mostly need wardening or fencing off these days to survive in a popular holiday spot. Others on more remote rocky islands do better.

Little terns are actually more vulnerable to disturbance, and to disaster from high tides or strong winds. They lay their eggs right by the high tideline on the most popular sandy or shingle beaches and walk a fragile tightrope in most parts of their breeding range. At least common terns are more adaptable and readily use specially provided artificial rafts, or take to derelict buildings and overgrown concrete on deserted islands where a lighthouse or military installation used to be sited. Such sites, made by man, whether deliberately or not provide alternative arrangements for the birds.

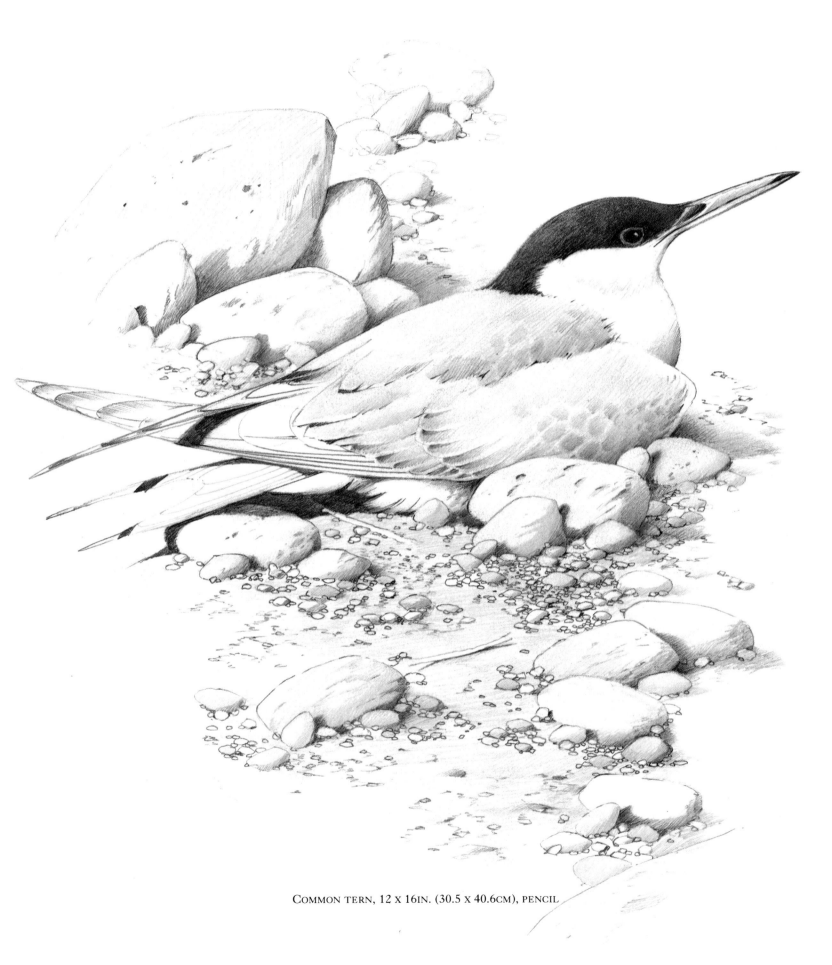

COMMON TERN, 12 X 16IN. (30.5 X 40.6CM), PENCIL

The common tern is a summer visitor to Europe and North America, arriving in April and leaving for West Africa and the coasts of South America respectively, in about September. A few European birds go right around the Cape of Good Hope and double back along the east coast of Africa, where those of more easterly Asian origin spend the winter. Sometimes, one or two may get caught in the roaring westerlies to the south, and drift east to Australia, but this is not nearly so regular an occurrence as it is with the very similar arctic tern.

In spring, they arrive back at the colony after their vast journey, and usually return to the very same bit of beach on which to nest, even sometimes using the same depression or crevice in a rock. The pair will probably have separated during the winter, but this may not always be so, as sometimes it seems that they have already reinforced the pair bond before arriving back at the breeding site. If they are separated, they will most likely meet up again at the nest. Whether the pair are actually faithful to each other, or to the nest site, is not clear, but it comes to the same thing.

Older pairs grab the best sites and are the most successful breeders. Young birds are inexperienced in the art of territorial defence and fishing for both themselves and a growing, hungry family. The variations between different ages have been thoroughly studied, with fascinating results.

One of the features of the courtship phase, before egg laying, is the frequent feeding of the female by her mate. He will present her with the best fish, while making do with small scraps for himself. This is vital, because it allows the female to stay near the nest site and defend it from other terns, while building up much-needed reserves to create the large eggs. Usually three eggs are laid. The last to be laid is often smaller, and may fail to hatch, or the chick from that egg may not survive. It seems that it serves as an 'insurance' policy; should, for example, a larger chick from one of the earlier eggs be taken by a predator, the last, small chick then still has a chance of survival.

COMMON TERN, 30 x 24IN. (76.2 x 61CM), ACRYLIC

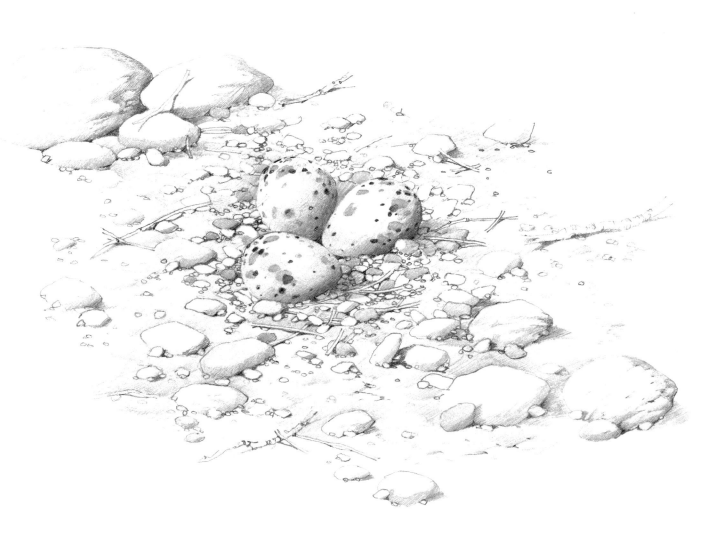

NEST AND EGGS (COMMON TERN), 12 X 16IN. (30.5 X 40.6CM), PENCIL

Approximately six years separate the two pictures of common terns (see pages 114 and 117). One is painted in gouache (a water-based, paste-like paint), the other in acrylic (a newer form of paint, based on synthetic acrylic acid, which has quite different qualities, including a certain transparency and a waterproof surface when dry). The comparison is interesting from an artist's point of view, but I doubt whether any reader confronted with the originals would be able to tell which is which. In structure and composition the two are similar, but each has that little additional device that creates secondary interest: one a discarded length of rope, the other a small pool of water.

It is interesting that Terry so frequently includes a piece of man-made hardware, or a scrap of discarded rope, a broken old fence or nest box, in his paintings. It is often the case with the common tern that the bird is seen in conjunction with something man-made and it does not lessen its appeal. It is, if one wishes to think of it that way, a bird of the wild parts of the world, the oceans and the beaches: but it also finds a home among the docks, on piers and buoys, on moored yachts and dinghies.

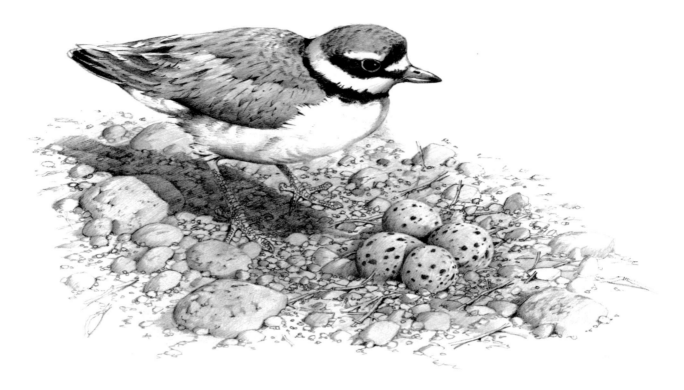

Common terns eat fish, which they catch after a headlong plunge from the air. They have long, forked tails, which act as rudders, the slender streamers providing the aerofoil that helps the bird twist and turn in its rapid descent, to strike its prey with pinpoint accuracy. As has been noted already, in spring one can often see male terns offering fish to their mates. This is vital as a pair-bonding activity: by accepting such an intimate action the female signals her willingness to co-operate with the male, and shows that he is an acceptable father for her offspring.

Back to the paintings, one can see the typically slender tern form, with long tail and wings, a pointed bill, and short legs that are of little use on land. The plumage is simply pale grey and white except for the black cap. The vivid vermilion or orange-red bill with a black tip helps to distinguish the adult common tern from the arctic tern, which has a bill of deeper, blood-red with no black in summer. In winter, the bill of the common tern will become almost black, the forehead clear white.

Common and arctic terns are so difficult to identify that they are often lumped together in birdwatchers' notebooks as 'commic terns'. This is all too often a needless defeatism, however, since with care the two can be told apart, given the right circumstances, and the challenge is an enjoyable one. The arctic tern looks a fraction greyer on the body but paler, more silvery, on the upperwing in flight, while the underwing is purer white with a finer black trailing edge. Compared with a common tern, a flying arctic also looks a touch lighter, more airy, with a longer tail, yet shorter, rounder head: subtle differences, it is true, but surprisingly obvious if one takes the trouble to look for them.

Common tern, 26 x 18in. (66 x 45.7cm), gouache ▷

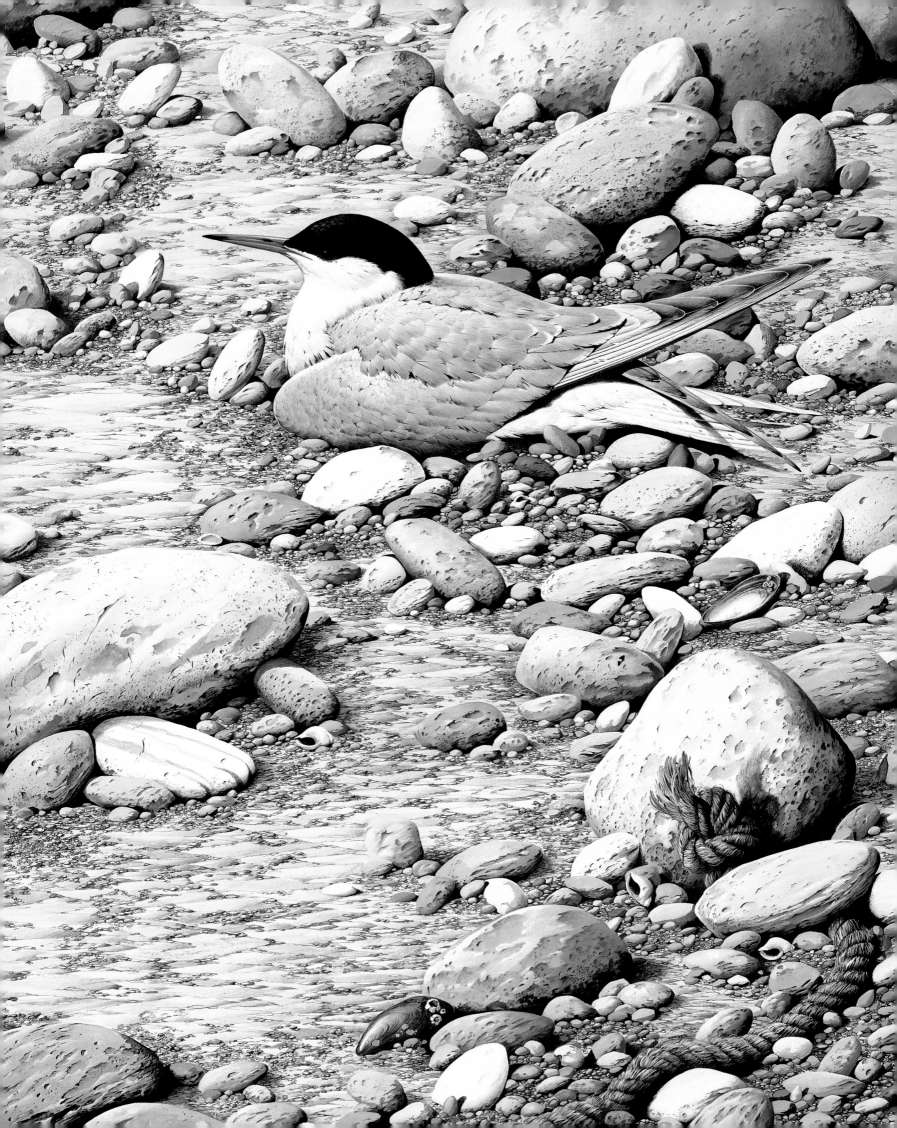

TEAL

Anas crecca

When commissioned by a client to paint some ducks – any species apparently, so long as they were ducks – I knew more or less right away that I would choose teal. One of Europe's prettiest and smallest wildfowl, the teal is always a pleasure to paint, particularly that lovely glossy green and ginger head.

Ducks are gregarious by nature, so I felt it would be appropriate to produce a picture that contained several birds. The painting on page 123 is the result. A characteristic, which is almost a trademark of my paintings, is the inclusion of a highly detailed habitat background. Often the setting has taken longer to paint than the bird. In this case, I chose to keep the background fairly uncomplicated. My reasons stemmed from the desire to place the ducks out of reach of the viewer, by not indicating how far they were from the water's edge. In addition, I felt that a busy composition of four birds, all with distinct and complex patterns, did not require additional embellishment in the background.

By including reflections, however, I have relaxed slightly, and I have hinted at the presence of trees and vegetation not too far from the birds. And, despite the relative simplicity, the water still took longer to paint than the ducks.

Teal are the smallest ducks regularly found in north-west Europe. The same species, with some small detail differences in appearance, is also found in North America. It is a lively, highly strung bird, hard to get close to except at some nature reserves, where the birds justifiably feel safe and secure. The drake in late autumn and winter is a superb creature, finely marked with grey and black, highlighted by a panel of cream beside the tail and a beautifully patterned head. At long range it looks all-dark except for a white line along the body. The larger wigeon tends to look paler, with a dark head and a contrastingly pale forehead. The female and male in eclipse – his dull, grey-brown plumage of summer – are more difficult, best distinguished by their size, grey bill and legs, the wing pattern (with a band of cream and white along the midwing) and a tapered streak of pale buff each side of the tail.

Of all the ducks, teal are the quickest to get airborne if disturbed: their light weight allows a near vertical take-off: they literally spring from the surface into full flight. In the same way, their return to water or to wet mud is also quick and unflurried. A small group in the air will twist and turn almost like a wisp of snipe or a party of golden plovers. That they are genuinely quick, and do not just give a misleading impression of speed because of their size, can be judged when they fly beside other, larger species and soon outstrip them.

Everyone knows that ducks quack, but in fact, the familiar, long, nasal quack at the town park lake comes only from the female mallards. Other species do quack, but the sound is much less loud and 'vulgar': female teals have quite a restrained vocabulary. The drakes produce a quite different sound, one of the most evocative of the saltmarshes and winter floods. It is a short, ringing, almost unbird-like note: 'crrik crrik'. The call has a strangely soothing, tranquil effect, especially as the sun sets at the end of a long, hard walk across a marsh or around a big reservoir, and frost begins to whiten the grass.

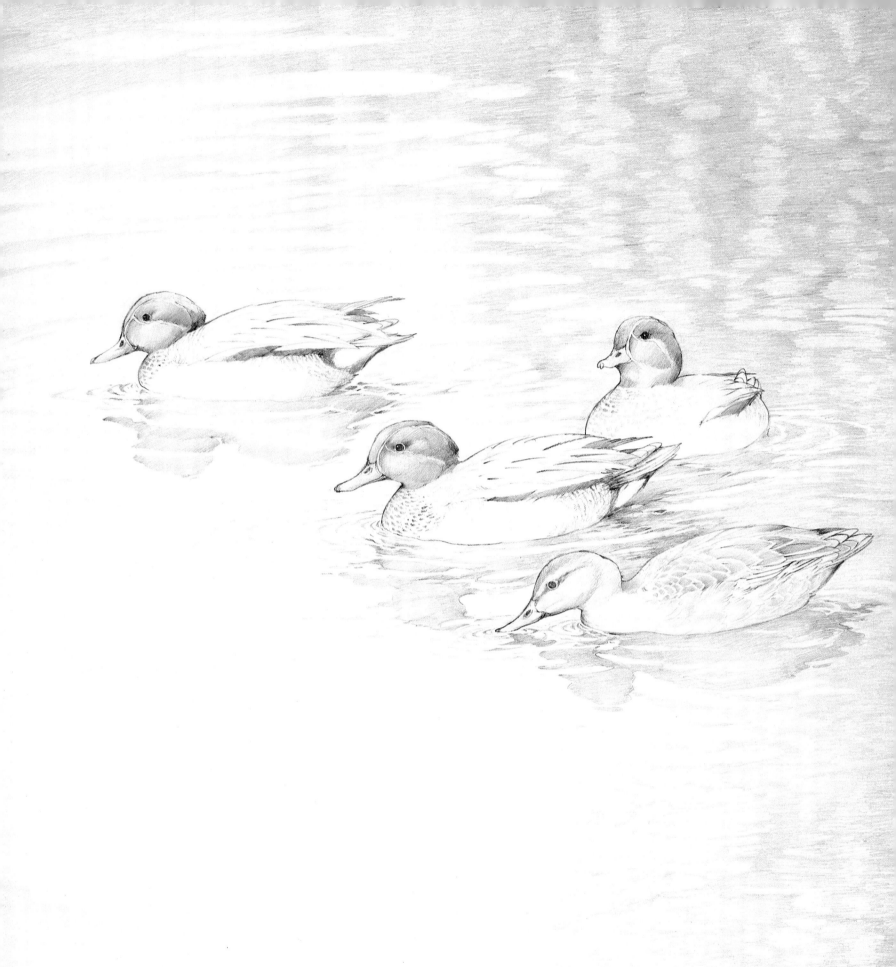

EUROPEAN TEAL, FINAL WORKING DRAWING (SEE PAGE 123), 36 X 27IN. (91.4 X 68.6CM), PENCIL

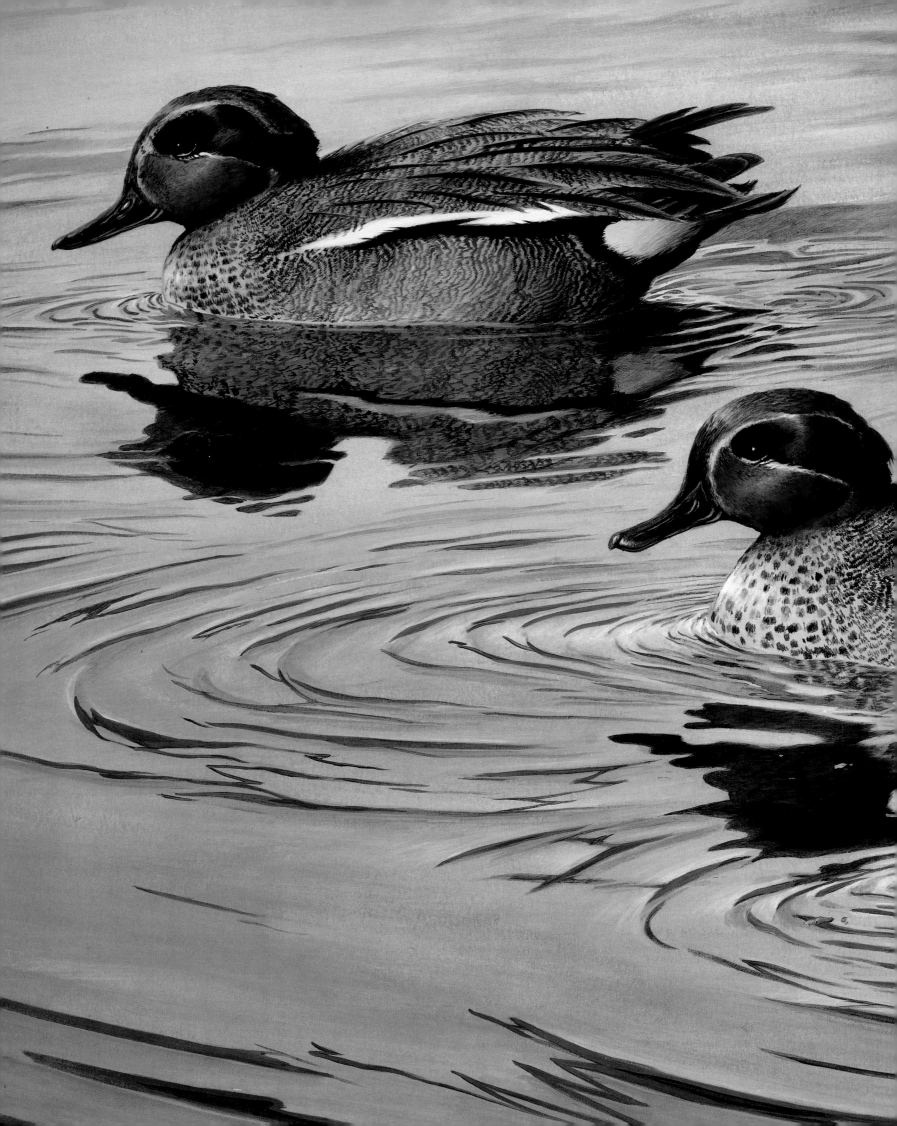

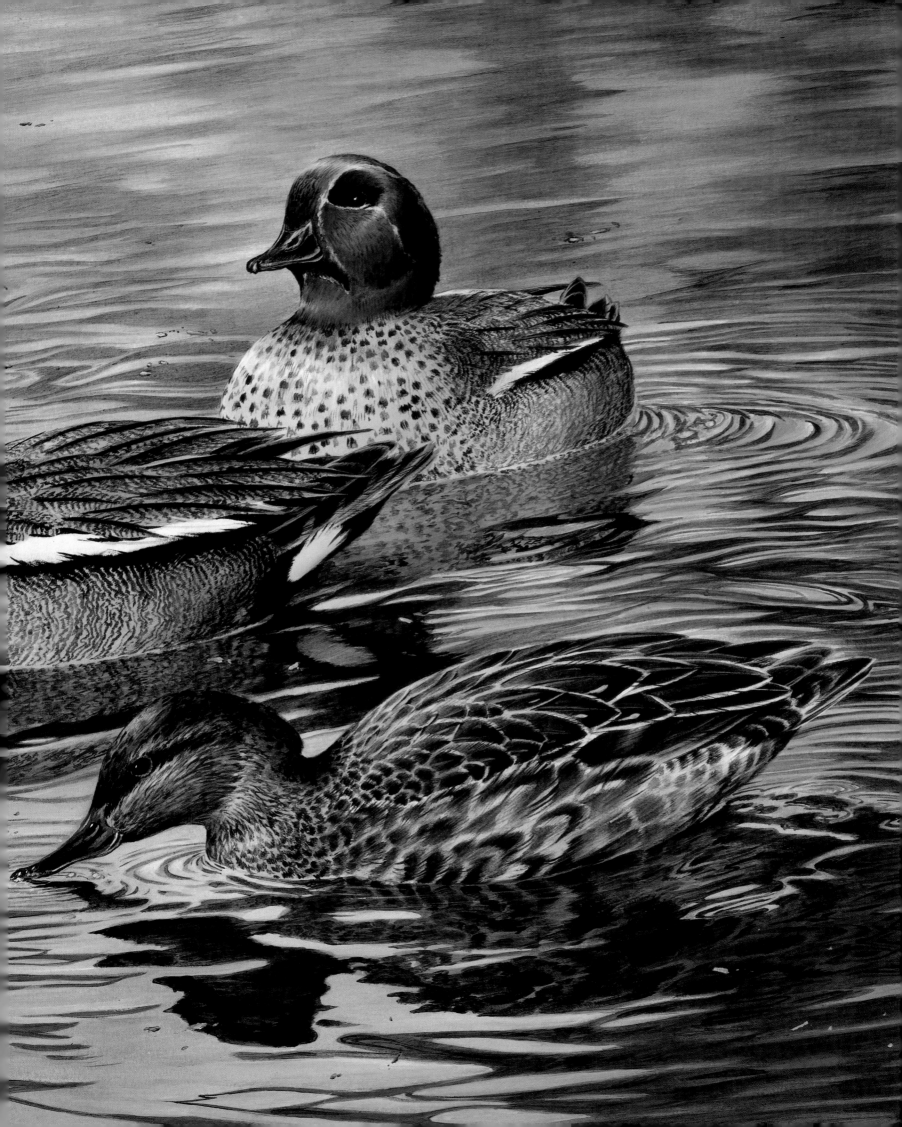

Teal are often active at dusk, when they may move either to the water's edge, to muddy ooze, or to stubble fields to feed. They are 'dabblers', not 'divers', filtering and sieving seeds and minute animal life from shallow water with their bills, or getting out on to dry land to graze, or feed on waste grain. They are not infrequently seen swimming about in flooded willows and other tall vegetation growing from water: they often fly in to a lake, settle just offshore, then swim quietly into the bankside growth out of sight. Consequently, there may often be many more teal around a lake than might be imagined at first sight.

As breeding birds, they are generally sparse in Great Britain, nesting in a highly disjointed range, beside saltmarshes, by a few large lakes and rivers, and on the wilder upland moors in the north and west. For most of us, to locate a pair of teal in summer, or to see a duck leading her ducklings across a pool, is a rare and memorable experience. They are far more familiar as visitors outside the breeding season, to almost any decent patch of fresh or salt water.

In spring another teal-sized duck appears on a few pools and marshes, especially in southern or eastern England. This is the garganey, sometimes called the garganey teal in older bird books. It is exceedingly like a female teal in autumn, when the birds are all in dowdy brown plumage (although the head is more striped than a female teal's), but in spring the males, at least, are quite distinct. They look rather pink and grey, with droopy feathers edged in white over their sides, and a broad, crescent-shaped line of white curving back over the eye. At all times of year, the male catches the eye in flight, having quite bright, pale-blue forewings.

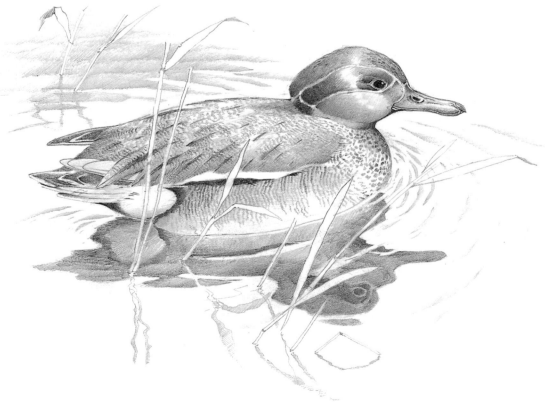

EUROPEAN TEAL, 12 X 16IN. (30.5 X 40.6CM), PENCIL

◁ EUROPEAN TEAL, DETAIL (SEE PAGE 123) EUROPEAN TEAL, 36 X 27IN. (91.4 X 68.6CM), ACRYLIC ▷

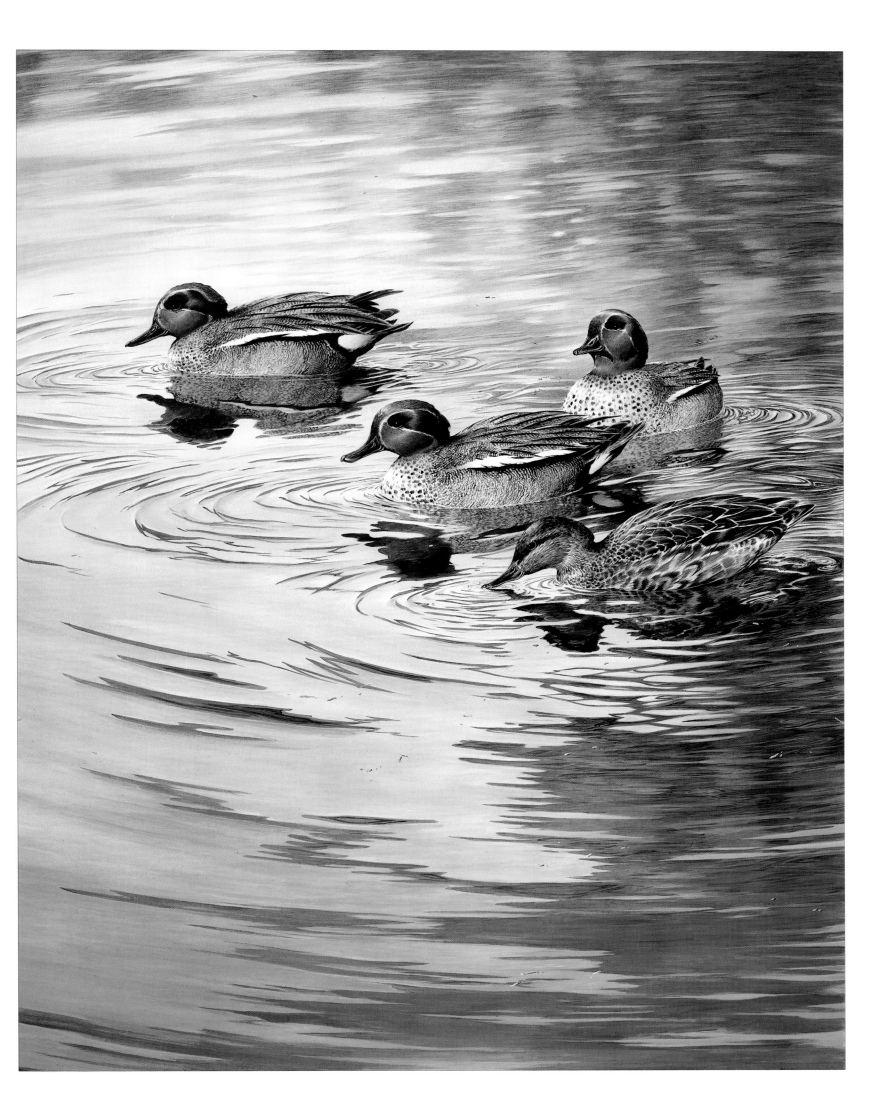

GREAT GREY OWL

Strix nebulosa

There are many beautiful and several truly magnificent species of owls in the world, but few can compare with the great grey owl in either respect.

Its size is awesome, while its plumage is so thick and soft, so delicately patterned, that it has that elusive combination of sheer power and exquisite good looks. Its head is very big, round and broad from the front, although it is remarkably like a small satellite dish in shape when seen from the side; there is surprisingly little depth to that great cowled head. It is, indeed, as a receiver dish that this facial disk performs, concentrating sound into a pair of highly sensitive ears.

It is a small-eyed owl and this confirms the great store that it places on its hearing when hunting. It can detect a scurrying mouse beneath eighteen inches (half a metre) of snow and dive down to catch it. In the open it may launch itself into a glide, ending with a headlong plunge some 300 feet (one hundred metres) away from where it originally heard its prey. Despite its smallish eyes, a great grey owl usually hunts in conditions of low light intensity: not during the hours of darkness, but in twilight, whether that be the middle of the dark, dreary days of winter, or the 'night' of the summer with the midnight sun.

The range of the great grey owl is a broad belt around the Arctic, occupying the great boreal forests south of the tundra. It breeds in northern Scandinavia, and eastwards right across to Sakhalin Island, and from western Alaska and the Rocky Mountains to the Great Lakes. These magical coniferous forests are wonderful places, but extremely challenging to a bird that lives there all year round. They are at their most difficult in the depths of winter, when the trees are shrouded in snow, and the ground buried deep in white drifts. Then the thickness of the owl's plumage creates an indispensable layer of insulation. Underneath, the bones and muscle of the body make up a relatively lightweight bird, yet it is still a powerful animal.

At the nest, the great grey owl is fearsomely aggressive to human intruders, and not to be treated lightly. It is capable of scoring a deep, painful wound across an exposed face, and could tear out an eye, or even fracture a cheekbone with its accurate swoop and frighteningly fast, silent strike.

As a hunter, it is not as ferocious as a snowy or eagle owl; it depends largely on relative small fry such as voles and shrews (while the eagle owl takes squirrels and capercaillies). It is this reliance on voles that makes great grey owls periodically move out from the vastnesses of the far north. Voles are notoriously fickle, with irregular cyclical variations in populations. In a poor year for voles, the owls have to go out and explore, and then a few may be found in unlikely places.

Here is the perfect painting of one of the world's great owls: upright, alert, yet relaxed and confident in its bearing. Look closely and you can just see one of the curved, needle-sharp claws designed to catch and hold struggling prey until the bill can be used to give the coup de grâce. In this frontal view the bill looks small, but it is actually a sizeable hook, buried deep in the soft facial feathers. The black triangular areas either side of the bill, overlain by the lower edge of the white crescents between the eyes, gives an idea of the width of the mouth, which can open up and swallow a filling meal in one great gulp! Note, too, the pale bars of grey-buff on the front edge of the closed wingtip, lying just above the tail. In flight, these pale bars create a striking buff patch between the wrist and the wingtip, a pattern repeated on many species of owls worldwide.

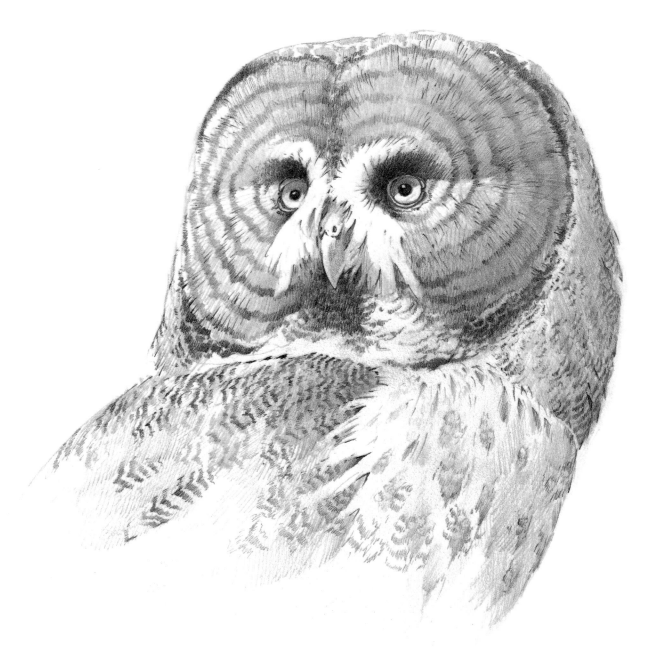

GREAT GREY OWL, 10 X 10IN. (25.4 X 25.4CM), PENCIL

Breeding great grey owls tend to settle into their territories early, with the males calling by mid February when the snow may still be thick. The song is a deep, booming 'hoo-hoo-hoo', with a gradual rise in pitch. The snapped-off trunk of an old pine may be used for nesting, but most pairs choose the old nest of a goshawk, buzzard, raven or magpie, or, in North America, perhaps the abandoned structure of a red-tailed or broad-winged hawk nest.

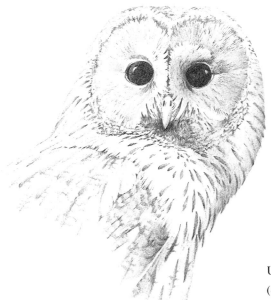

If ever there was a case of a bird's bark being worse than its bite the great grey owl is it. At close quarters this owl looks enormous: as big as any of the eagle owls. But it is largely bluff: most of what you see is dense feathering, concealing an average-sized owl underneath. It is, however, the feathers and their patterns, and particularly the incredible head, that make this my favourite owl.

The bird has enormous character: to some observers the face is comical, with large 'pop art' rings around tiny eyes. The eyes – cold, purposeful, deadly serious – it is a bird of prey, don't forget, and that aloof, superior stare belongs to an efficient killing machine. The understated efficiency appeals to me as much as the wonderful appearance. While on the subject of looks, this owl has the most beautiful wing feathers that I have ever had to paint.

It is a no-nonsense bird and pays little heed to man unless he is stupid enough to get too near a nest. Then the owl will leave no illusions about who is boss. The tenacity of the bird is also demonstrated when you consider that it lives in a hostile environment, snowbound for much of the year, and always on a knife-edge between success and failure. In the near future I must paint another of these owls just for myself.

Most of us would, I think, echo Terance's desire for a great grey owl picture to hang on a wall at home. It is, after all, the nearest most of us will get to seeing the real thing.

The Ural owl, shown in the pencil sketch above, is another large and impressive owl, but not quite such a giant as the great grey. It is a rather plain-faced bird, lacking the concentric rings that make the great grey so distinguished, and has solidly dark eyes, without the piercing yellow iris.

Ural owls are found in north European forests and in a few scattered localities in eastern and south-eastern Europe, in remote mountain forests. They prefer ancient woods with plentiful large dead or dying trees and broken stumps, usually nesting in the end of a decaying branch or stem. Such conditions are rapidly disappearing in Europe, as forests are tidied up, felled or disturbed, but there is some hope for the Ural owl. In a few parts of Scandinavia it has been attracted to nestbox schemes with considerable success.

GREAT GREY OWL, 36 X 27IN. (91.4 X 68.5CM), GOUACHE ▷

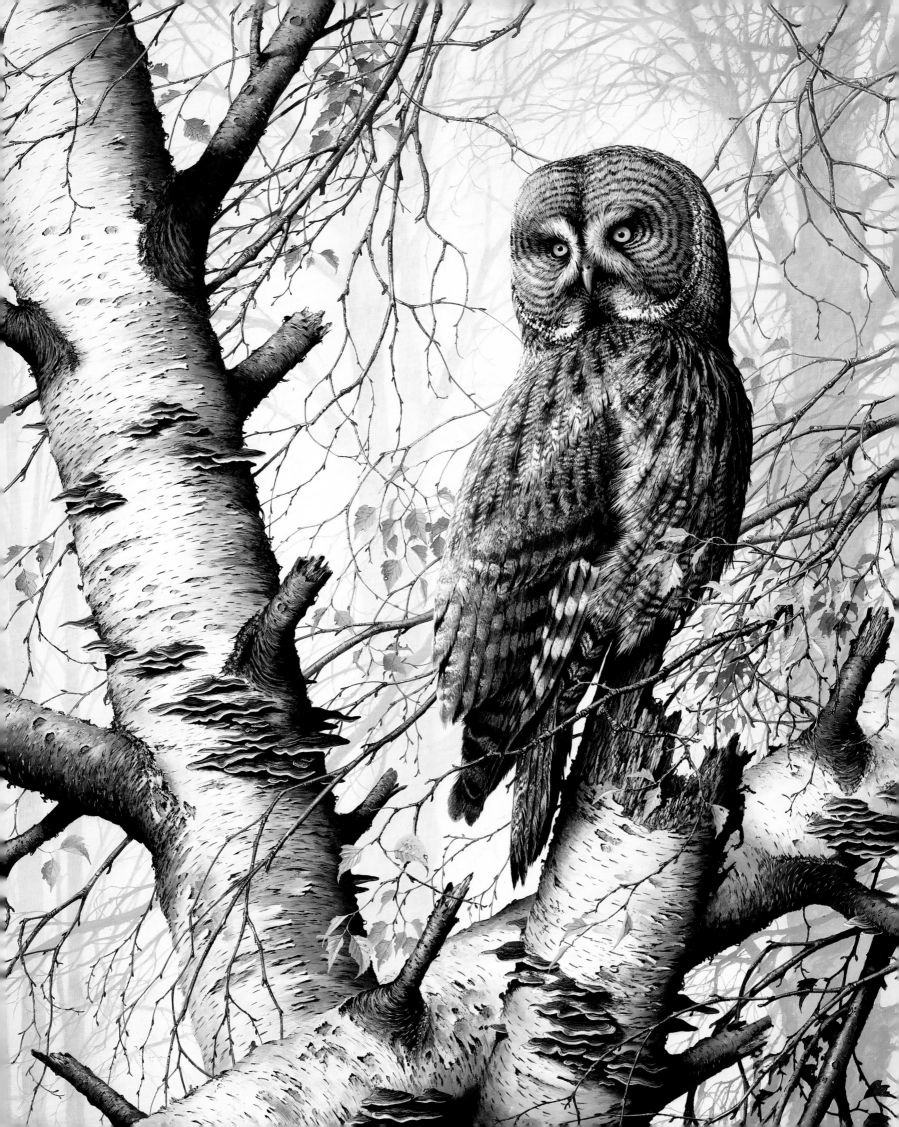

GREEN WOODPECKER
Picus viridis

It is surprising, perhaps, to see one's first woodpecker on an open heath, far from any decent-sized trees. It is, however, quite a likely spot for a green woodpecker, for it is by nature a ground-feeding bird and it loves ants above all else.

It needs trees, nevertheless, in which to forage, roost and nest, and to which it can fly when disturbed. It is always shy and difficult to approach in the open, and when it resorts to a large old tree for safety, it very often contrives to sit out of sight behind a thick bole.

In spring it calls incessantly, with a very loud, challenging cry. The call is rather like a devilish laugh, a fast repetition of a high, sharp, strident note. Variations on this call form most of the repertoire of a green woodpecker all year round: most often a somewhat less intense version is heard as a simple alarm note, for example when a green woodpecker is accidentally flushed from its favourite anthill.

The woodpecker bores a deep hole into the bole of a tree, sometimes quite low down, but usually at a height that would require a climb or a ladder to examine it. This is its nest, in which five, six or seven round white eggs are laid. The young remain inside for some three weeks after hatching and, by the time they are a couple of weeks old, are apt to give the game away by calling constantly to be fed. The cries of a hungry family are a babble of nasal, squeaky squeals and grating notes.

Like most of the owls and several other woodland species, woodpeckers are absent from Ireland. The green woodpecker is also rare in southern Scotland, and practically unknown farther north, although it is widespread in many parts of Wales.

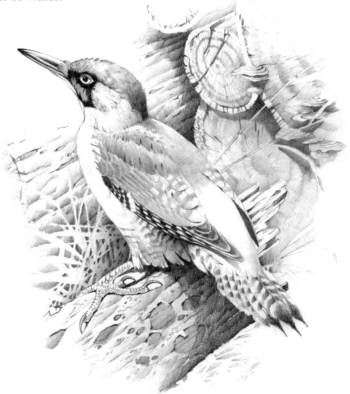

GREEN WOODPECKER, 16 X 12IN. (40.6 X 30.5CM), PENCIL

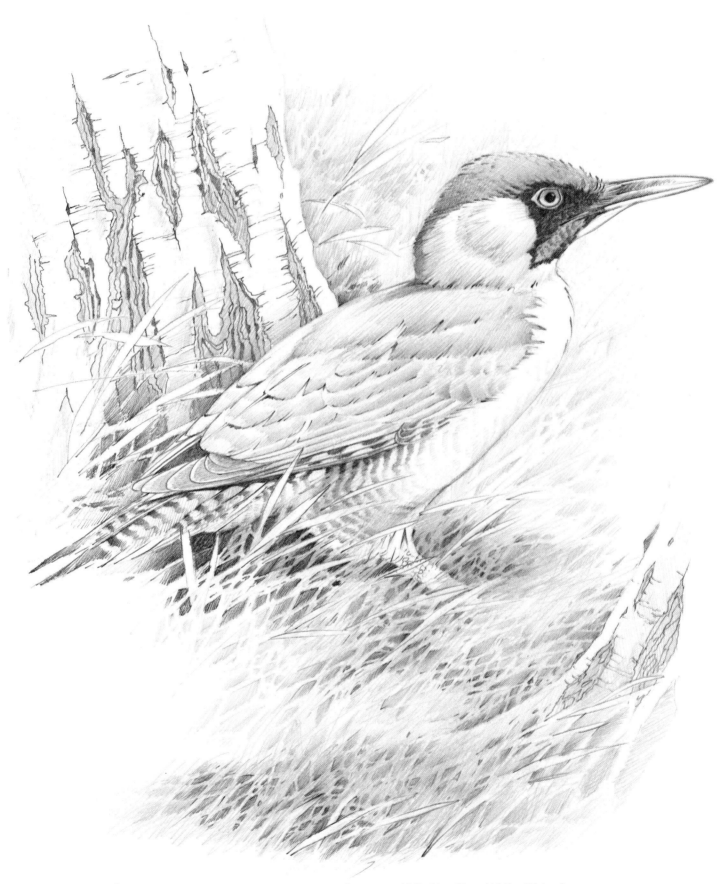

Green woodpecker, preliminary sketch (see page 171), 12 x 10in. (30.5 x 25.4cm), pencil

Green woodpeckers usually look rather dull in flight, except for their eyecatching yellow rump. In closer view, the complex head pattern can be seen well: a staring, white eye set in a black surround, a black moustache (with a central streak of red on the male) and a soft, crimson crown with more or less streaking of pale grey, which gives a strange, almost silvery or velvet effect, depending on the angle of light. Young ones are extraordinary birds, with the whole of the pale greenish-cream neck and underparts barred with 'V'-shapes of dark green, creating a unique parti-coloured pattern.

This bird, so taut and tight in its alert pose, is clearly a male, judging by the red-centred moustache. Its tail is slightly separated into two points by the pressure and weight of the bird; this is typical of the woodpeckers, which use their stiff tail feathers as props. This use of the tail gives them a stable 'tripod' base when they are perched upright against a branch.

The feet of woodpeckers, the green's included, are peculiar. Most birds have three toes facing forwards, one back; however, the outer toe of a woodpecker turns back, to give two forward, two back. It can also be swung sideways to give an extra wide grip around the curve of a branch. This is a particularly long toe on a green woodpecker, ideal for clinging on to broad, curved surfaces. The claw, also perfectly suited to the task, is long, arched and very sharp.

Despite its long, chisel bill, the green woodpecker does not have the strong beak of a great spotted woodpecker and is less of a chiseller into firm timber. It prefers soft, rotting wood and, still more, anthills. It roughs up the sides of the mounds where ants nest, digs deep into the earth and probes far into the open galleries using its long, sticky, barbed tongue. Green woodpeckers survive well in old parkland, where a mixture of trees and meadowland provide a perfect situation; however, where heaths and meadows have been converted into more productive farmland, the anthills disappear, and the green woodpeckers, unfortunately, go too.

It is all too easy to provide 'amenity' plantings and parks that are simply too tidy and unproductive for wildlife. Most tree plantings seen in England, at least, in the 1990s are well-meaning but devoid of imagination. Trees are restricted to angular plots and planted in regulation straight lines, and beneath them is mown grass where little survives. In the long term, these may develop, but the green woodpecker needs more than a few trees. It has to have somewhere to feed too; bare ground, irregular clearings, the edges of bramble patches and bits of scrub add essential elements to the woodland habitat that it requires.

Rather like kingfishers, woodpeckers are not easy to show to people. They may frequent a certain wood, or feed on a particular heath, but to go and look at one to order is rarely simple. They have a somewhat elusive quality. Even where they are common and should be found easily, time and persistence are required, as well as a bit of luck, to get anything like a really good view. The best way, so long as it can be accomplished from a safe distance or a hidden vantage point, is to watch the nest. This is not always as difficult as might be imagined, because in mid summer the young birds still in the nest often give away its location by making extraordinarily loud and varied screeching and hissing noises at the mouth of the hole. As Terry's paintings show, it is worth the effort to get to know the woodpecker better, as the green woodpecker is really one of the gems of European bird life.

GREEN WOODPECKER, 30 X 24IN. (76.2 X 61CM), GOUACHE ▷

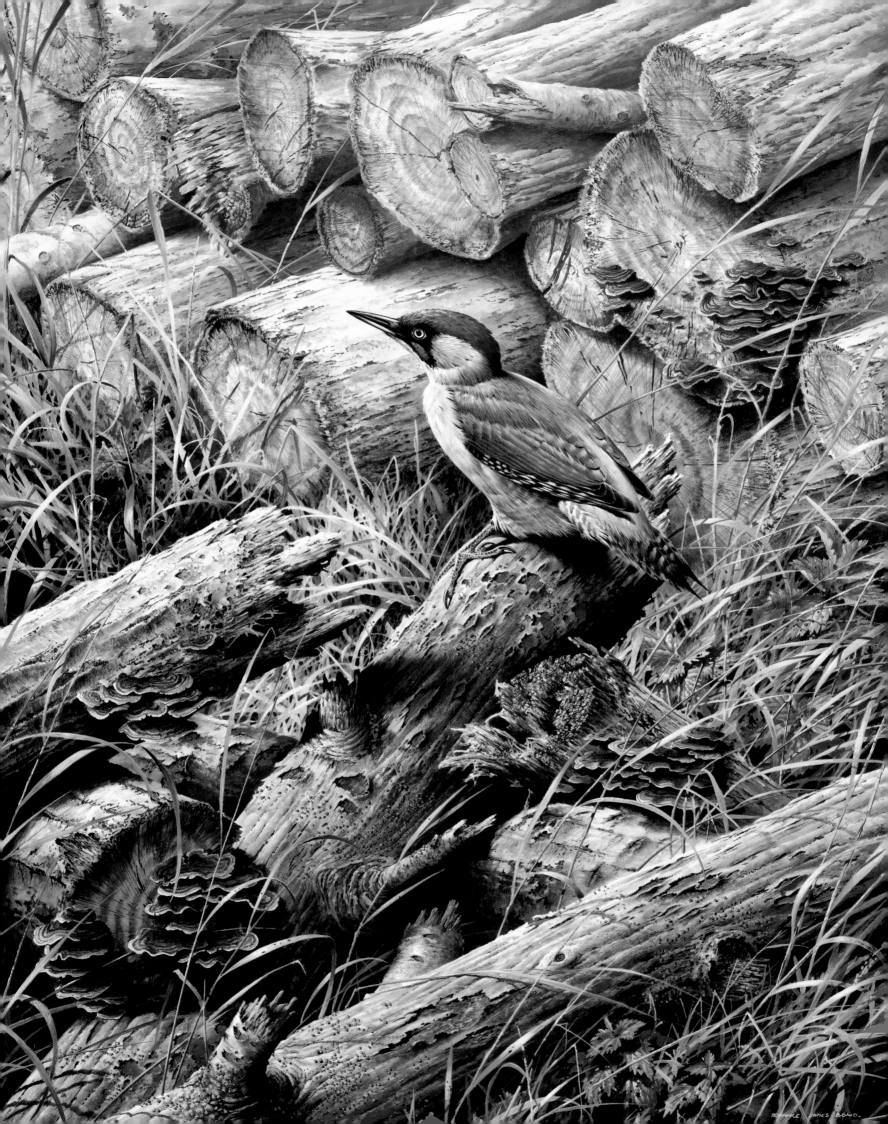

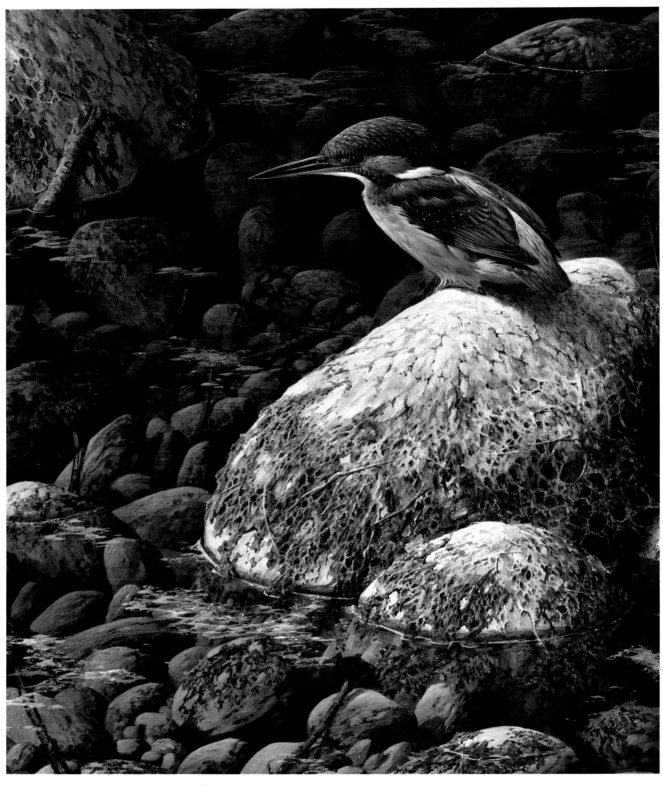

KINGFISHER, 20 x 16IN. (50.8 x 40.6CM), ACRYLIC

SMALL BIRDS AND SMALL DRAWINGS

The following short section includes an assortment of drawings and paintings depicting some of my favourite small birds. Little birds in small paintings are, in compositional terms, more demanding to paint than most people would believe: the less content in a painting, the more difficult it is to come up with a fresh interpretation of the subject. One great advantage with little birds, of course, is that the work takes less time to complete.

KINGFISHER

Alcedo atthis

A flying kingfisher throws a spark of brilliant electric blue across a lake, but even a monotone drawing can capture its character, because it has such a distinctive and peculiar shape.

A kingfisher is not a large bird; it has a short tail, a large head and a large bill, so its proportions make it quite difficult to compare with any common species. It is rather like a tailless starling in its chunky, rather heavy appearance. In flight, it sometimes seems tail-down, and can look as if it is about to drag across the surface of the water, despite its apparent speed.

Although the short neck gives the impression of a lack of mobility, a kingfisher can stretch itself into a tall, upright, slender creature if alarmed or curious, and can twist its head around almost as well as an owl. Yet it is often seen in quite the opposite posture, hunched, fat and dumpy. Indeed, it has a distinctive shape: but quite what this shape is depends on the mood of the kingfisher at the time!

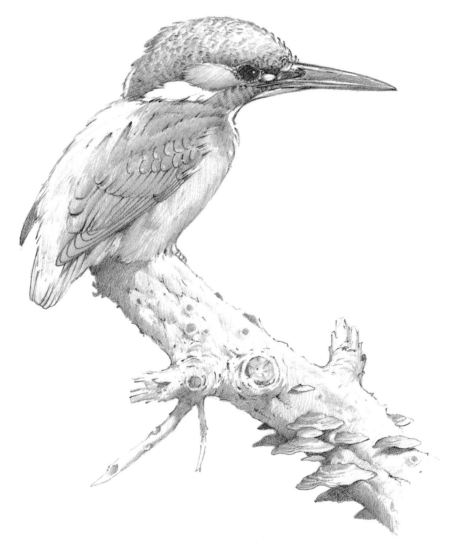

KINGFISHER, 16 X 12IN. (40.6 X 30.5CM), PENCIL

WHEATEAR
Oenanthe oenanthe

Of all the birds that return to Europe in spring, after a long winter in Africa, the wheatear is often the earliest to arrive. Birdwatchers in southern Great Britain may hope to see three or four summer visitors before March is out: little ringed plover, chiffchaff, sand martin and wheatear. However, often it is only the wheatear that fulfils its promise.

It will usually be seen on some grassy down, or a smooth green sward above a coastal cliff, or perhaps on a freshly ploughed field. In any situation it looks handsome and bright, especially the male. Against a glistening, dark field of newly turned earth, the wheatear is particularly vivid; the clean greys and creams are remarkably intense. It is like a first spring flower: a drop of light and optimism after a cold, dreary winter.

Once a wheatear flies it reveals its identity immediately, should there have been any lingering doubt. No other small ground bird has such a big, bold patch of purest white above the tail, while the tail tip and centre create a black, inverted 'T' shape.

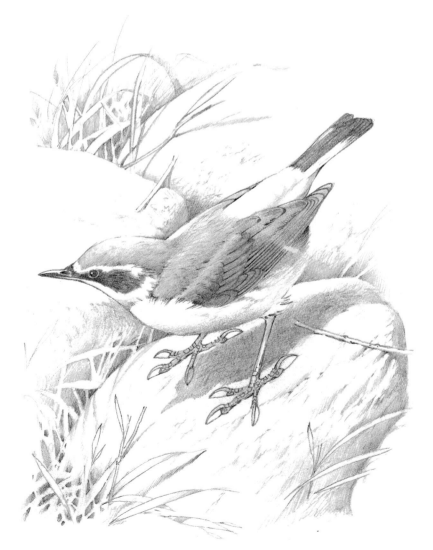

WHEATEAR, 12 X 8IN. (30.5 X 20.3CM), PENCIL

TREE SPARROW
Passer montanus

Compared with house sparrows, tree sparrows are generally neater, smoother birds, with a softer colour scheme. Unlike house sparrows, male and female are alike: both resemble the male house sparrow most closely. The colour painting on page 173 gives a more complete idea of the colour and pattern.

On the ground, tree sparrows have a tendency to hop about with tails cocked, their precise, jaunty actions quite distinct from the ruffian house sparrows with which they frequently mingle. They look smaller, rounder-headed, with the whole of the top of the head a warm milk-chocolate colour, the rump more buff, less grey, the face whiter except for a bold square or blob of black on each cheek, and the black bib much smaller.

Tree sparrows also have a distinctive call that, once learnt, often draws attention to a bird or two in a flock of finches, or one flying by across a meadow: a hard, sharp 'teck'. The song, however, is much like the rambling efforts of the house sparrow; if anything, it has a slightly richer quality to the abrupt, disjointed chirrups, which the bird produces with all the pride and passion of a master musician such as the nightingale, but with none of the brilliance or finesse.

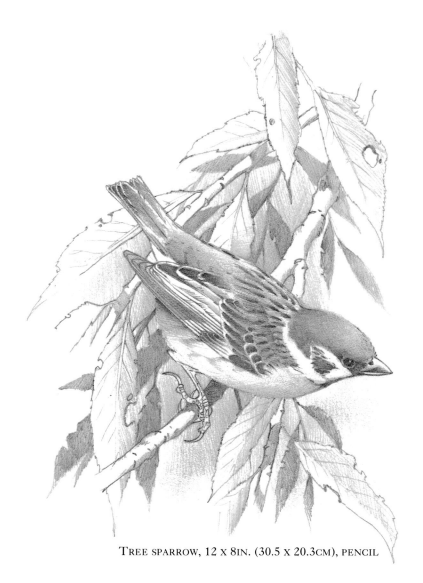

TREE SPARROW, 12 X 8IN. (30.5 X 20.3CM), PENCIL

CRESTED TITMOUSE
Parus cristatus

For the average British birdwatcher, the crested tit is a great rarity, not so much because of very small numbers, or through any irregularity of occurrence, but simply by virtue of its restricted distribution. It is found in only a small area of the Highlands of Scotland, where it survives largely in ancient forests of Scots pine, with smaller numbers in newer, artificial plantations. In Europe it is much more widespread, and any visitor to the Alps, or The Netherlands, or to the forests of France or Spain, can expect to find it.

Crested tits are, nevertheless, fairly easy to find in those Scottish forests where they occur: indeed, in winter they are not at all averse to taking advantage of peanuts at bird-tables in nearby villages. They are often seen quite high in the magnificent old pines of the remnant Caledonian forest, but can regularly be found much lower down, so giving much better views, in small sapling pines on the edge of the swampy forest clearings.

Crested tits are small, but instantly recognizable in a decent view by the unique head shape and pattern, reminiscent of the tufted titmouse of North America. In addition to the shape, the call is a good clue to the experienced ear: it is a deeper note than most tits' calls, with a stuttering trill that is so soft, that it is almost like a purring sound, although with a rather abrupt pattern: 'p't-trrrrp-p'.

With that amazing little crest on top of its head, this tiny bird looks as though it has just been dragged through a hedge backwards! That look of permanent surprise is part of the attraction of this little titmouse, together with the muted, understated colours of its plumage. It will have become apparent by now that the browns, umbers and natural earth pigments are my preferred colours. The crested tit is a wonderful example of restrained sartorial elegance – apart from the crest, that is!

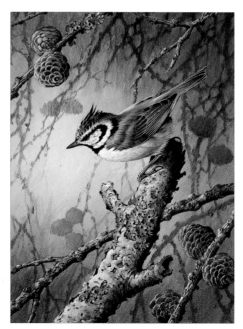

CRESTED TITMOUSE, 12 X 7IN. (30.5 X 17.8CM), ACRYLIC

COAL TITMOUSE

Parus ater

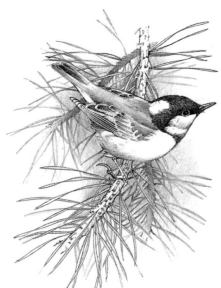

COAL TITMOUSE, 12 X 8IN.
(30.5 X 20.3CM), PENCIL

This stunning little chap is Great Britain's smallest titmouse and, in my opinion, probably the most attractive. The contrasting colours and patterns of the head are superficially similar to the bird's larger relative, the great titmouse, but this bird's plumage ranges through more subtle browns and greys.

For Terance, the subtleties and contrasts of the coal tit are better than the more immediate coloration of the great tit. It is, indeed, a bird of great appeal, but those with less of an eye for the subtleties of colour and tone tend to relegate the coal tit to a lower division in the garden-bird league. Continental coal tits are somewhat brighter than those of Great Britain, with more rusty or cinnamon underparts, but it is only the Irish coal tit that has any appreciable yellow on it: the cheeks are yellow, and quite unlike the dead white of the typical British bird. No coal tit has any trace of blue or pure green.

I cannot recall how many of these birds I have painted. Several, I imagine, and most of them against a dark-green background, usually a pine. This may seem to be artistically unimaginative, but occasionally I paint a picture just because the bird and a particular association work well and give me pleasure. At least, that's my excuse!

Terance is, of course, right to put the coal tit in a conifer, but it is not exclusively a bird of coniferous trees. It does like woods of Scots pine and even the less varied ranks of planted Sitka spruce and, in mixed woods, it often goes for spruce, larch or pine trees dotted about within the usual run of oaks and beech. It eats a great deal of beech mast, however, and has a broader habitat range than many people assume.

A frustrating thing about coal tits is their behaviour at a peanut basket. Blue and great tits provide endless entertainment; coal tits, however, are there for a moment, then gone almost before they can be appreciated. They do not like pecking at a nut and eating it bit by bit at the bird-table, where they are liable to lose out in the general mêlée. Instead, they extract a peanut whole, and fly off to deal with it where it is less likely to be stolen. Coal tits also have a habit of burying nuts, and hoarding food for harder times in the winter.

PIED WAGTAIL
Motacilla alba

Of the European wagtails, the pied is the most common and widespread, although the Continental form is somewhat different from the British birds. The latter have blacker backs and are more truly pied, while continental birds have pale-grey backs, browner wings, and far less sooty black on the flanks. Many books use the name 'white wagtail' for this race, which is a spring migrant through much of Great Britain.

Like other wagtails, pied wagtails love the vicinity of water, although they are not as restricted to fast, clear streams as are grey wagtails, nor do they necessarily like the oozy, wet watermeadows so favoured by yellow wagtails. Pied wagtails seem to be home almost anywhere: the gravelly edge of a flooded gravel pit, the muddy rim of a farm pond or riverbank, even the high-tide line along a beach will do.

These are birds of parks and large gardens, too, with a particular fondness for tarmac footpaths and roadsides, which most other birds avoid. The pied wagtails are probably looking for insects stranded on the bleak, hard surface, or knocked to the ground by traffic. Along the waterside they often have a regular circuit, so that they can repeatedly search the edge of the water for bits and pieces of food that have been washed up since the last visit.

Pied wagtails are easily identified by their long, black-and-white bobbing tails and black bibs, but in winter the face is much whiter, and juvenile birds are altogether duller, with some buff and brown around the face, and the bib limited to a simple bar of brownish-black across the chest.

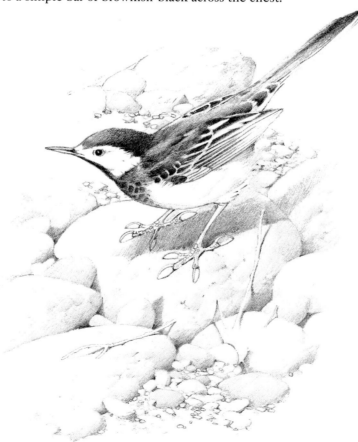

PIED WAGTAIL, 12 X 8IN. (30.5 X 20.3CM), PENCIL

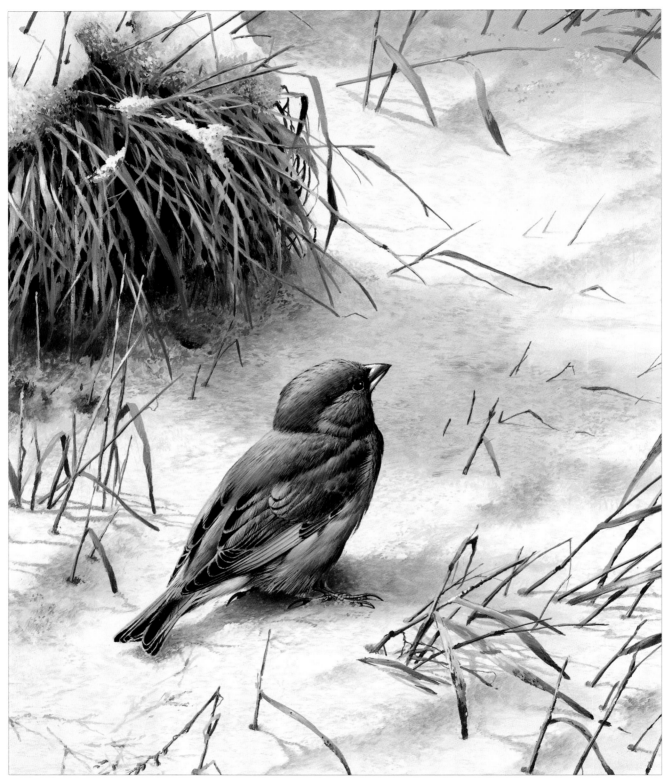

GREENFINCH, 14 x 10IN. (35.6 x 25.4CM), GOUACHE

COLLECTABLES

Since 1971 this particular format has become almost a standard, and I have painted a considerable number of these works for the majority of my clients. This convenient shape can accommodate most of the smaller species of song birds, and still leave room for background detail to be successfully incorporated. Another attraction, certainly from my point of view, is that patrons very often buy more than one, and usually add to their collection at regular intervals. The following selection of 'fourteen by tens' is representative of the genre.

HOUSE SPARROW
—— *Passer domesticus* ——

HOUSE SPARROW, PRELIMINARY SKETCH (SEE PAGE 175) 12 X 16IN. (30.5 X 40.6CM), PENCIL

In the same way that the paint kettle is more important than the sparrow in an earlier picture (see page 17), so the digestive biscuit is really the raison d'être for this little work. Just an excuse to paint another sparrow, I suppose!

Terance's preoccupation with common birds is not at all unusual, although not many people have quite so strong an attachment to the house sparrow! Nevertheless, magazine editors, authors and television producers all come across a similar problem: most serious conservation issues are in Third World countries; most of the really colourful and striking birds are in the tropics; yet most bird lovers in Great Britain prefer to see, read about, or watch films of British birds. It should be no surprise; people like to be able to relate to the subjects in books and films, and it is no less true when it comes to paintings.

The house sparrow is not quite universally distributed. There are some remote places that they just do not seem to have colonized, despite human presence. Villages or farmsteads surrounded by Dorset heaths, hamlets on the East Anglian fens, and villages in north Scottish straths are all places worth visiting if you wish to avoid a sparrow.

On the other hand, it is probably better to accept them and enjoy them. After all, house sparrows, rather like the feral pigeons of railway stations and industrial sites, add life and movement to drab surroundings and should be welcomed for that. The farmyard, though, is perhaps the place where the house sparrow seems most at home, and best fitted. Somehow, the bits of metalwork, cast-off lengths of wood, old bricks and rusty buckets, and the scraps of straw and grain spilled from sacks make the perfect environment for a sparrow or two, and it is this that Terance so often exploits when painting them.

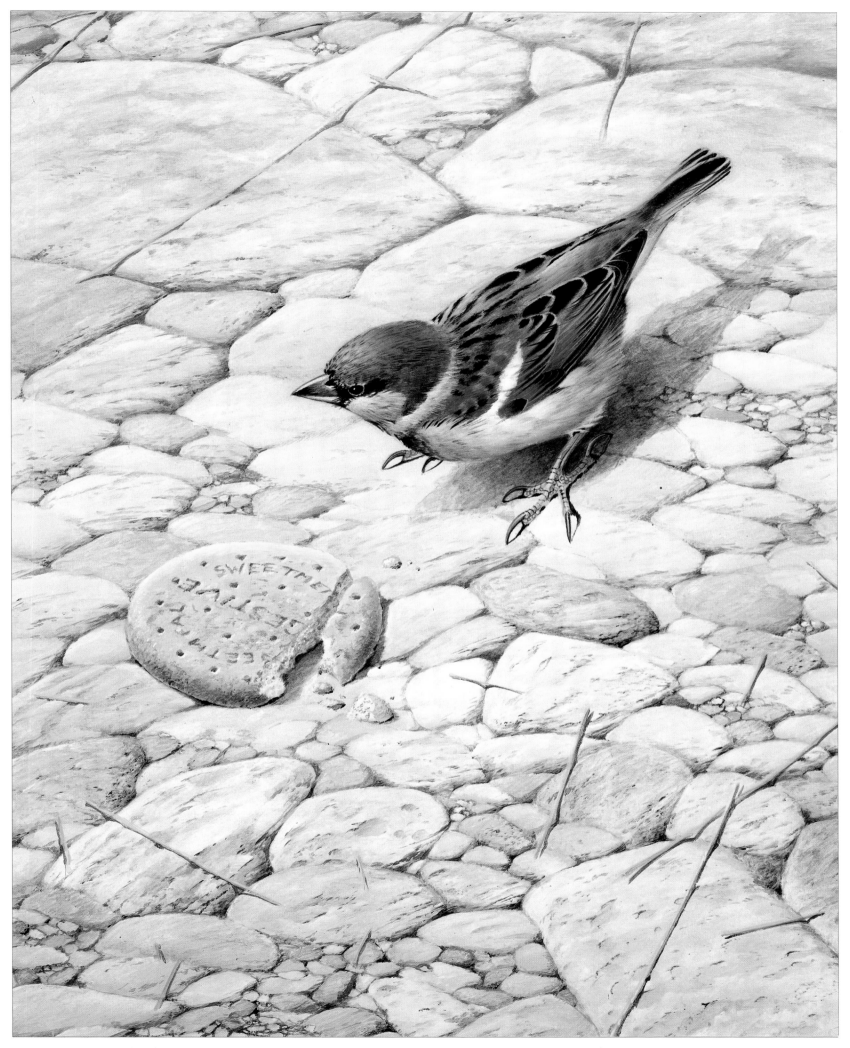

HOUSE SPARROW, 14 x 10IN. (35.6 x 25.4CM), ACRYLIC

CHAFFINCH
Fringilla coelebs

Once numbered amongst the commonest species in Great Britain, the chaffinch has lost ground in recent years, at least in the south and east. No longer are there unkempt, weedy stubbles all winter, and acres of fallow land through which mixed flocks of finches can forage. Neither are there so many big, old hedges with tall oaks and elms, from which male chaffinches can sing brightly in spring.

In much of Wales, the north of England, and Scotland, however, chaffinches remain numerous and also particularly tame. In many lay-bys and car parks they take on the role of the house sparrow, hopping about on cars and coming to take food from the hands of delighted visitors.

Chaffinches are easily recognized by two, broad, white bands across the wings and white sides to the tail. The upper wing bar is the broader of the two, as the painting shows, but it can be almost hidden by the overlying feathers of the upperparts if the bird is feeding quietly on the ground, and wishes to remain inconspicuous. When in a state of alarm the chaffinch exposes the white band, which acts as a warning signal to other chaffinches. The white band is also deliberately shown off to the full in courtship displays.

Males are beautifully clean, colourful birds in summer, but in autumn they have a fresh set of feathers tipped with buff and brown. These tiny, dull, feather edges all but cover the underlying colours, and make the winter male a more subdued-looking bird, although still subtly attractive. In spring by some means, which as yet is not fully understood, the feather tips become brittle and crumble away.

These lovely little birds were always a familiar sight around the buildings and woodlands of my parents' farm. The species conjures up particularly evocative memories and indelible associations with my early birdwatching days.

The pair of chaffinches shown here are typical of the chaffinches I paint: invariably on terra firma (I like painting small finch-type birds on the ground), feeding amongst leaf litter or spilt seed and grain. This is one of the very few really colourful birds that I treasure, and the picture here has been deliberately kept light and limited in contrast, to accentuate the birds' plumage.

It is a welcome sign of spring when the chaffinch begins to sing. It is not the most musical of songs, but it is such a bright and vivacious offering that it has to be ranked high among the favourite bird songs of many birdwatchers. It is a fresh, bubbly effort, beginning with a faltering rattle, but soon getting into a loud, fast flourish of cheery notes. Young chaffinches have the basis of a song instinctively within them, but it is learning from others that endows them with the full chaffinch song. By learning from and copying others, chaffinches perpetuate a local 'dialect'; regional differences between chaffinch songs are marked and long-lasting.

Chaffinches are gregarious in winter, but spread themselves apart, by defending territories, in the summer. They need to do so because, although the adults feed on seeds, they feed their chicks on insects, particularly caterpillars, and have to have a guaranteed supply. For that, they must exclude other chaffinches from their feeding territory. This dispersion allows each pair to rear its family, and generates the territorial disputes and courtship displays that become the basis of natural selection: the survival of the fittest.

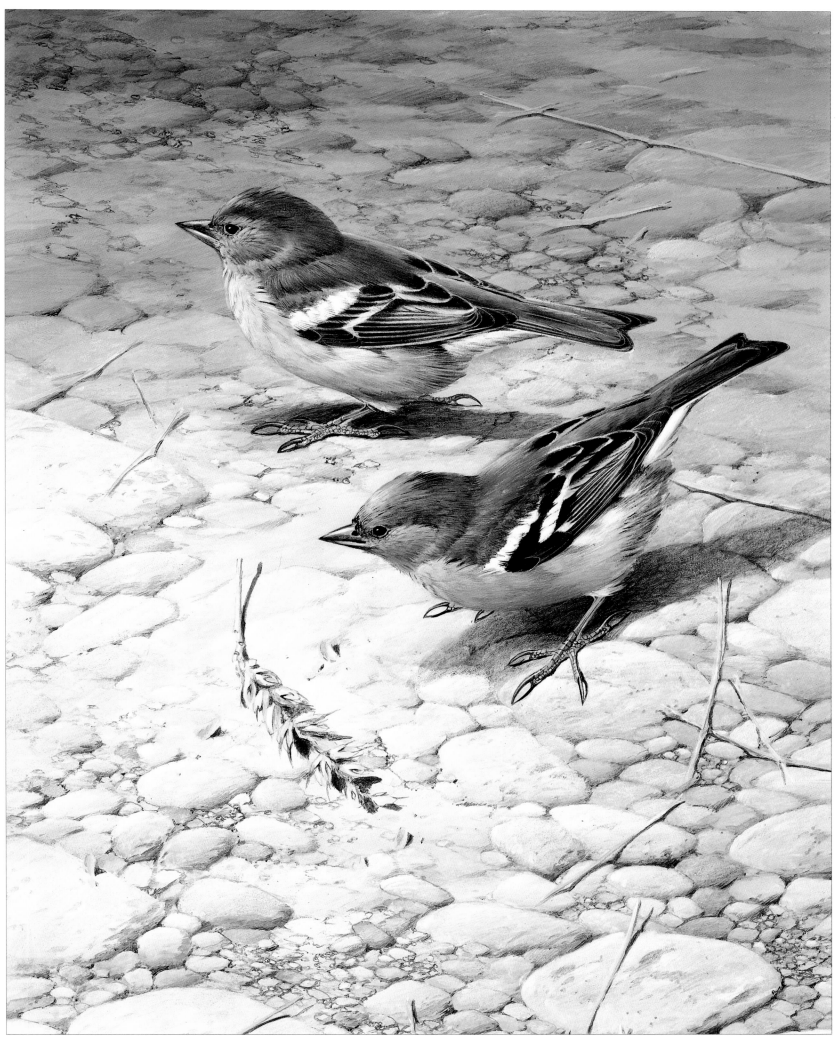

CHAFFINCHES, 14 x 10IN. (35.6 X 25.4CM), ACRYLIC

GREAT TITMOUSE

Parus major

GREAT TITMOUSE, 12 X 8IN. (30.5 X 20.3CM), PENCIL

Once again, Terance Bond has found a bird that suits his love for bold pattern and an association with trees. The great tit is the largest of its family in Europe (and indeed across much of Asia). It is also perhaps the most striking, although it is hard to beat a vivid blue tit in spring. The first thing one sees is the extraordinary, pure, cold-white cheek patches against a blue-black head. In the depths of a thick hedge, the black disappears, leaving only the white to be seen, like specks of sky showing through the blackness of the twigs. Then, the yellow underside shows up, and finally a good view reveals the full range of greens and greys.

Many a birdwatcher has said 'I've no idea what bird is making that sound – it is probably a great tit'. The great tit is, indeed, quite likely to be the source of any strange bird noise coming from a tree or bush, as it has a wide repertoire, and creates all kinds of scolding, squeaking and buzzing notes. It also taps loudly against a branch, especially if it has found a nut or seed, which it is hammering at with its bill.

Despite its comparatively small size, this painting of a great titmouse in an apple tree is about as colourful as one could get without going over the top. At first glance it would appear that literally dozens of shades have been used to achieve this multi-toned work. Surprisingly, the opposite is true. Apart from the inclusion of red and brown, the pigment range is drawn from the six colours used on the bird itself. In essence, it all comes down to how much there is of each colour, and how well placed it is.

Great tits are among the dominant birds at any garden feeder set up with bags of peanuts and suspended coconut halves. This is a world where might is right, a place for the survival of the fittest and strongest. It is not, sadly, one where equality of the sexes has much going for it. Look at the birds on the nuts and you will soon notice that the males, with their broader black breast stripes, are the dominant birds.

GREAT TITMOUSE, 14 x 10IN. (35.6 x 25.4CM), ACRYLIC

REDSTART
———— *Phoenicurus phoenicurus* ————

A neat, round head, with a bright eye and meek expression, a sober but exquisite plumage of buffs and browns, all set off by a tail of light, rusty-orange, which never ceases quivering, make the female redstart a delight. However, when she is approached by the male, and we see him in his glorious summer colours, the hen is instantly forgotten. Whether seen for the first time, or an acquaintance renewed year after year, the first, spring, male redstart is breathtaking.

His face is intensely black, the more so because the forehead is purest white. The closest of views is needed to see the eye, other than a speck of reflected light. Beneath the black bib is a body of richest orange-chestnut and the tail, despite the darker central feathers, which largely hide the outer ones when it is closed, is a splendid orange-red. Few birds of the woods can match that.

In autumn, after a complete moult, the feathers are all tipped with buff, the clarity of the colours subdued and blurred by innumerable, tiny pale crescents. They give the redstart a new, equally attractive, but different character, as he is turned into a bird of subtle hues and minute detail.

It is in autumn that many people see redstarts, when migrants turn up along many coasts and in coastal woods. Usually they are inconspicuous, one here, another there, but now and then conditions are such that some coastal sites are showered in migrating redstarts that have become lost in the fog, have drifted across the North Sea, and found themselves fetched up in some East Anglian wood, or in a thicket of willows and buckthorns on a remote stretch of dunes.

To those who live in the west, the redstart is a bird of spring and summer, and a bird of the woods and well-wooded lanes. Redstarts sometimes flit from hedge to hedge ahead of a car, or dart up into a roadside oak close to some winding, mountain road. Where a great oak stands in a field, away from the wood, a redstart may use it as a song post, perching at the very top, a mere dot, whose elusive voice floats out across the valley.

In spring they are easier to spot, before the leaves are fully out, yet the complex patterns and rich colours of bursting buds, lichen-covered twigs and branches, and light and shade make even such a handsome creature as the male tricky to see. His song is then a useful clue: a short, lovely warble that stops almost before it starts, a promise of more to come that is never quite fulfilled.

My first encounter with a redstart was at the RSPB nature reserve of Ynyshir in western Wales. Typical of that part of the country, it contains several contrasting habitats in a small area, from hillside oakwoods to reedbeds, and a saltwater estuary. My more vivid recollections of the redstart include birds perched against a background of dark and shadowy foliage. Through binoculars, one had that peculiar but attractive impression that the bird was isolated against an out-of-focus stage backcloth.

Highlighted by a low sun, the colour, in particular that lovely red tail, really stood out. It is the combination of sunshine and shade that I sought to reproduce here.

Although largely western in Great Britain, the redstart is quite widespread in broad-leaved forest with more or less clear spaces below, favouring oakwoods on slopes, with drystone walls and boulders breaking the adjacent ground. It also breeds in pinewoods, especially in Scotland, and in mixed woodland alongside turbulent streams, scrubby places beside heaths and moors, and in places where scattered trees and bushes peter out into slopes of scree.

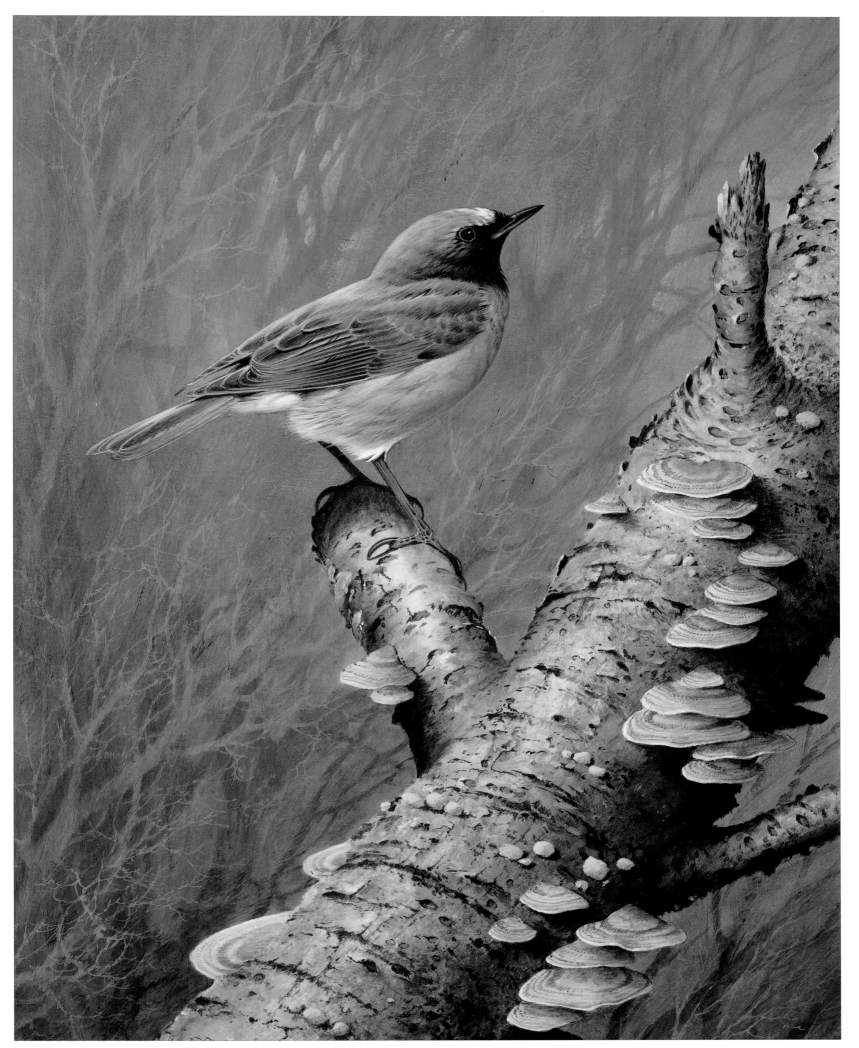

REDSTART, 14 x 10IN. (35.6 x 25.4CM), ACRYLIC

REED BUNTING
Emberiza schoeniclus

Birds with a descriptive name tend to be illustrated in a way that demonstrates the suggested link: hence the reedbed setting in this picture.

My first introduction to the species, however, could not have been more out of character. A pair would appear on the lawn just outside the patio doors, and spend a considerable time collecting the dog hairs shed by our two labradors. At least, the hen did so: the cock, looking very dapper in full breeding colours, perched on the patio step and adopted a purely supervisory role.

The red damselfly in this little painting, along with its blue relatives, is a resident of our ponds. Its inclusion is intended as a focal point on the bird's projected sightline.

Reed buntings in Great Britain have, in fact, shown a tendency in recent decades to move into drier areas and have even come into gardens in winter to feed around bird-tables. In part, this is perhaps a response to a necessary change in habitat, since so many wet areas have been drained. It does, however, illustrate the species' great adaptability.

Had it not been so adaptable, the reed bunting would now be rare and restricted to only a few places in most regions of Great Britain. It is still a marshland specialist, but content with a small area of waterside vegetation and a larger patch of rough ground with tall, rank growth. While the edge of a reedbed with a mixture of sedges and willows is ideal, the bank of a river running alongside some overgrown gravel pits, with willowherbs and nettlebeds, does just as well.

Reed buntings are small, quite bright rusty-brown birds; they have a distinctive black tail with broad, white sides. The back is more or less streaked with black and cream, and the underside is dull white with fine, dark streaks all over. In summer the male is strikingly obvious, with his black head and white collar, but in winter the whole head and neck pattern is blurred by extensive brown edges to the fresh feathers. The hen is superficially sparrow-like, but the tail and streaked underside are quite different and there is always much more patterning about the head, with stripes of cream and blackish-brown.

In a reedbed in spring, when last year's old stems are still standing proud of the fresh, green shoots of the new season's growth, reed buntings select the tallest perches as song posts. They sing with an admirable determination, repeating a little song phrase over and over again all day long. Sadly, perhaps, the song itself is no great shakes: a short, simple series of jingly notes in a tuneless, slightly halting, monotonous phrase: 'chi chi chi chikit'.

The nest is a neat, substantial cup of dry grass and sedges with a lining of finer grass and a little animal hair. It is on or just above the ground, often in a tussock of sedge or on an overgrown stump, perhaps raised just enough to prevent flooding should the weather turn wet. The eggs, usually four or five in a clutch, are buff with a complex pattern of dark streaks and spots. Should an intruder stumble upon the nest, the hen bird will sit very tight, but if she is flushed will feign injury to draw attention away from her eggs or young.

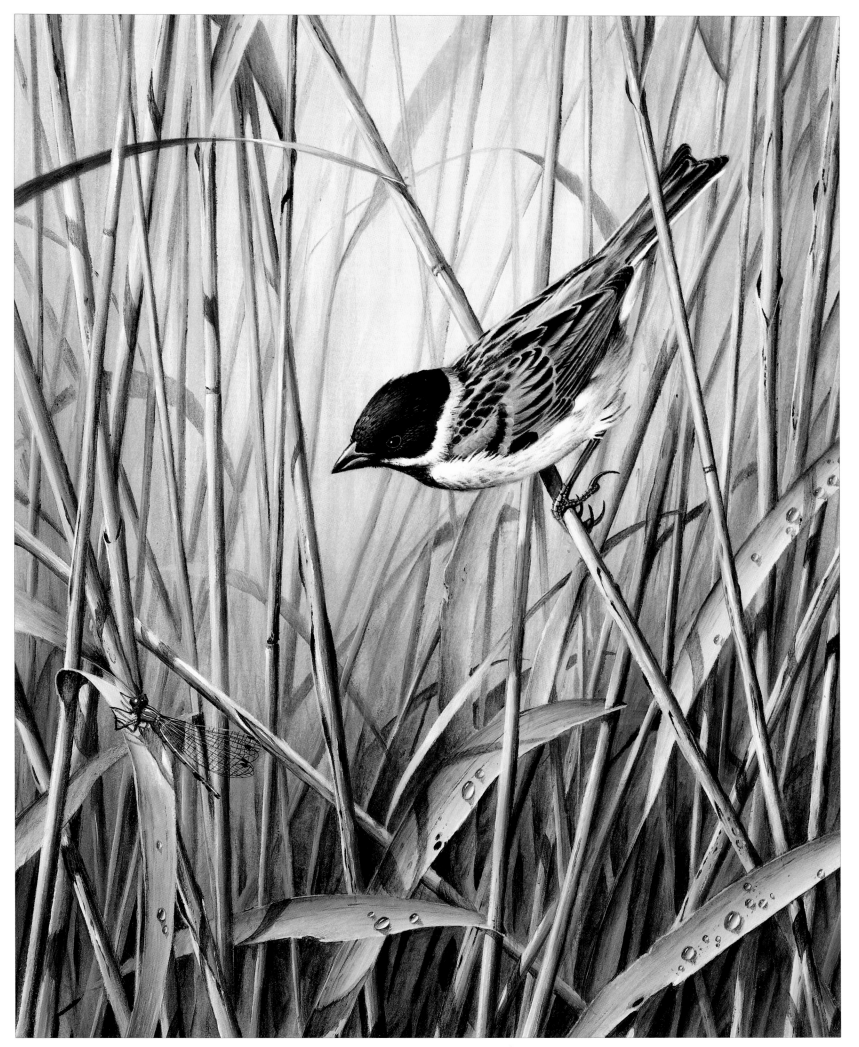

Reed bunting, 14 x 10in. (35.6 x 25.4cm), acrylic

BULLFINCH

Pyrrhula pyrrhula

BULLFINCH, 12 X 8IN.
(30.5 X 20.3CM), PENCIL

Y*ou either like the colour of the cock bullfinch or you don't; it's as simple as that. From my point of view, as a painter, the best way to succeed with this incredible colour is to illustrate the bird against a very neutral background. Once again, this formula works best: lots of detail and interest, but little competing colour. The wonderful thing really is that the shocking pink of the cock bird works so well with its associated areas of grey and white.*

If Terance has problems making the colours work well in paint, then photographers face greater difficulties, or so it would seem. There are few colour photographs of a male bullfinch that capture its lovely delicacy and freshness; most colour film simply loses the pink and substitutes a more orange hue. The least hint of flash light and the whole bird takes on a gaudy, brash appearance, quite unlike the real thing. Its beauty seems too fragile, too ethereal, and beyond the camera's reach.

Colour is not, of course, the only thing that is held against the bullfinch. It is, by nature, a bud eater. It does take seeds, and a pair can work its way through thousands of hanging ash keys, but that thick, rounded bill is best used unravelling the soft outer layers of rich fruit and flower buds. This nutritious food is the bird's undoing where fruit orchards are important to the local farming economy.

For the average gardener and birdwatcher, however, there is no harm in a bullfinch, at least none that cannot be forgiven for a glimpse of that glorious colour. Nor should the female be overlooked: her softer, browner appearance is none the less attractive, and she also has the black cap and bib. Both sexes, and even the young birds (which lack the cap), share one most eye-catching feature, shown best if they are accidentally disturbed: a broad, square, white rump.

Usually bullfinches feed quietly and surprisingly inconspicuously, low down in a hedge or bramble brake. The only clue may be an occasional call: a unique, soft and low, yet penetrating fluty note: 'poo' or 'piew'. Hearing the call, one may look for the bird, but only get a glimpse of the square of white, disappearing through the depths of the thicket. It is always a slight disappointment, as you realize what a wonderful view you might have had, had you seen the bird before it saw you!

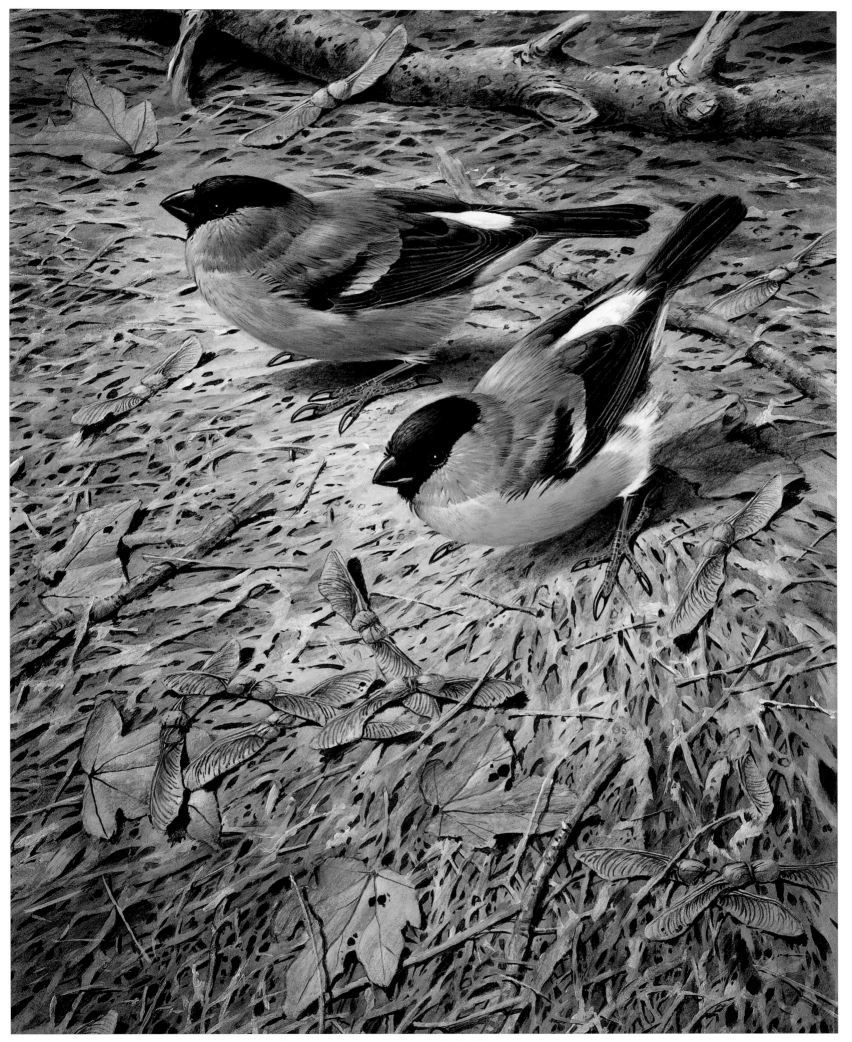

BULLFINCHES, 14 x 10IN. (35.6 x 25.4CM), ACRYLIC

WHEATEAR

Oenanthe oenanthe

This is one of the few paintings in the book in which I have used an area of light blue; it is a colour I use sparingly. Jill and I, while walking over the hills in North Wales on a brilliantly sunny day in June, were aware of large numbers of wheatears calling from the tops of walls and boulders, as we walked around a large reservoir. The clear blue sky is a means of holding on to the memory of that day. Each time I look at the transparency I made of the painting, I can recall everything about that special afternoon.

The best way to appreciate the distribution and remarkable movements of the wheatear is to look at a globe, rather than a map in an atlas. Wheatears nest over an enormous range, in a great variety of environments. Some nest in the extreme north of Africa; others in the Middle East and Asia Minor. The bulk of the population breeds from southern Spain, north to the extreme north of Scandinavia, and east to the farthest point of Siberia. Alaska is also occupied by breeding wheatears, and others nest in a thin, largely coastal, strip along northern Canada, around almost the whole of Greenland, and throughout Iceland. That the same bird should nest in an African desert, on a Scottish moor, in the Russian tundra, and on an Antarctic coast in North America is remarkable enough. That all the wheatears, from throughout this vast and diverse range, should fly to Africa for the winter is even more so.

The globe helps to explain it. The journey from the Arctic Circle to Africa is not quite so illogical if you look down on the North Pole and follow the shortest route. Nevertheless, two flights a year from Alaska to beyond the Sahara Desert is pretty extraordinary, and a tribute to the stamina and persistence of such a tiny scrap of life.

In winter, wheatears are on all kinds of bare earth, from rocky slopes to high African plains, where they will be neighbours of lions and elephants, ostriches and marabou storks. In spring, they move across the desert, and pause along hot, bare Mediterranean shores, before pressing on to the cool, green countryside of rural northern Europe. In Great Britain they appear early, often at the beginning of March on the south coast, and like areas of short grass at the top of cliffs or beside lakes and reservoirs, and sandy or bare ground, whether dunes, sandy tracks, or ploughed fields.

They reach their breeding grounds quickly. In much of Great Britain they nest on upland slopes, where the ground is grazed by sheep, which keep a short sward, on which the wheatears can hop about in search of food, and broken by boulders and scree. Failing that, drystone walls over the dales will suffice: crevices in rocks or under stones are needed for nesting. A few breed on sandy landscapes inland, where rabbits graze the turf and provide holes that serve as nest sites.

A typical view of a wheatear is of the bird flitting away, quite fast, suddenly spreading its wings to land on the ground or swoop upwards to perch on a wall or fence post. A feeding bird hops along the ground, sometimes breaking into a short run, then pauses momentarily, frequently on a small mound or a rock. It stretches up, chest out, flicking its wings, then leans forward and hops on again. Its character is always alert, inquisitive and confident, yet it may be shy and easily disturbed; it is always ready to fly off and dive out of sight beyond a pile of boulders or into the depths of a ditch.

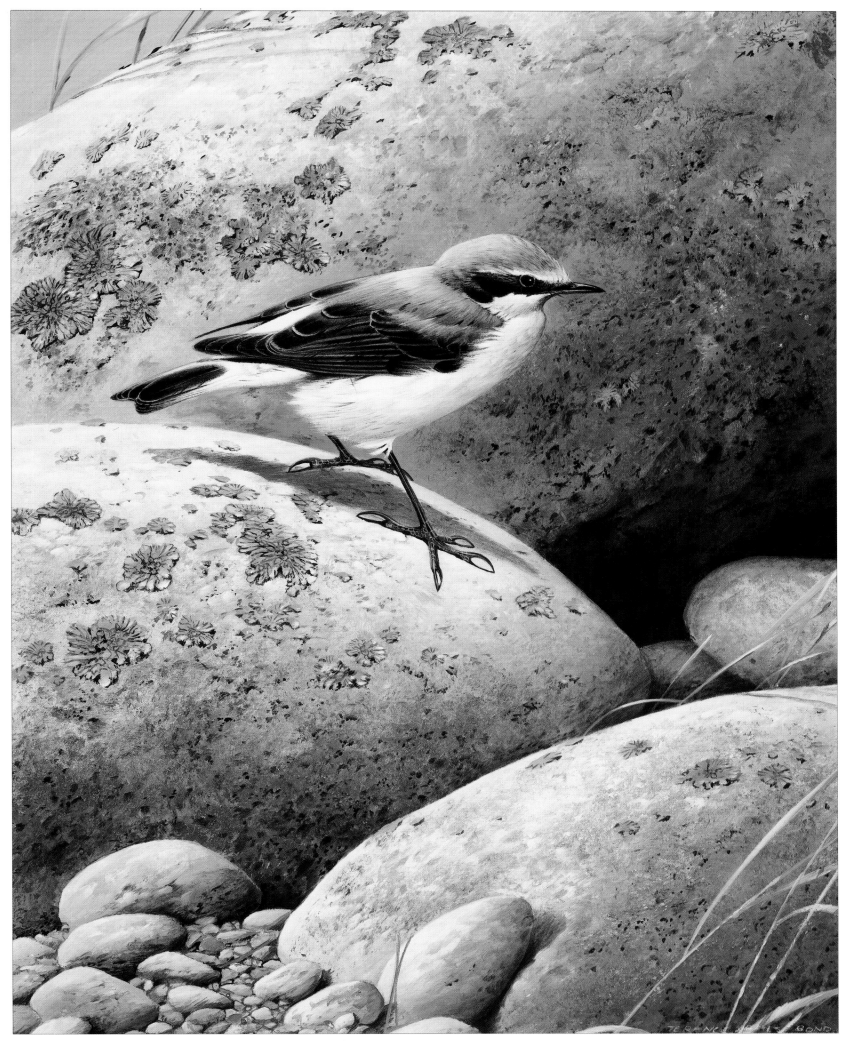

WHEATEAR, 14 X 10IN. (35.6 X 25.4CM), ACRYLIC

BLACKCAP
Sylvia atricapilla

Blackcaps are almost entirely European in their breeding distribution, although the range does extend a little eastwards into central Asia. They are found from the lower, gentler parts of Scandinavia, south to Spain, with a very small extension into the northernmost parts of Africa, and east to the Black Sea, again with a very slight eastwards spread along the north coast of Turkey to the Caspian Sea.

The habitat varies, but is always based around the presence of trees, often mature forest with a good, but not too dense, layer of shrubby undergrowth. The understorey seems to be necessary for nesting, although the birds also feed within it quite a lot, particularly in autumn, when berries of elder and honeysuckle are eagerly sought. Coniferous woods are generally avoided in Great Britain and so too is scrubby, bushy growth without taller trees, although the closely related garden warbler readily occupies such areas.

In spring, the male sings frequently, often from near the tops of the mature trees. His voice is often so like the garden warbler's that it may be impossible to distinguish with certainty. Even experienced birdwatchers, making detailed censuses of breeding birds, prefer to see the blackcaps they hear, before making a confident entry in the notebook.

In full form, it is a distinct enough song, with a low beginning that grows louder and clearer in a fast, fluty warble, ending with a flourish of great volume and clarity. It is a song that comes close to a nightingale's in quality, although it is almost always a short phrase, separated by a lengthy break from the next episode. Later in the summer, it is often less emphatic, more even in tempo and volume, and closer to the garden warbler's in form. Nevertheless, it has a richness and brilliance of delivery, which makes a 'good' blackcap a particular joy. Another characteristic note is a hard, abrupt, low 'tack', like a rap on dry wood. In autumn, it is a good clue to the presence of migrant blackcaps feeding in a dense thicket.

Few warblers are found in Great Britain and Ireland in winter: indeed, only the Dartford warbler and the recent colonist, Cetti's warbler, are true residents. But some blackcaps are spending the winter in Europe with greater regularity than used to be the case. Most, however, move south to Africa, to spend the winter in West African mangroves and acacia savannah, or the mountain forests of the Sudan. British-breeding blackcaps mostly move south-east in autumn initially, but then change tack to fly south-west across France to northern Spain. From there they head on south of the Sahara to Senegal and Guinea.

The birds that are seen in England in winter are from eastern Europe. It is odd that a breeding population should move away completely, to be replaced by a scattering of birds from so far afield, especially as they then become largely dependent upon artificial feeding at bird-tables if the weather turns cold and snowy.

Unusually, this little painting is of a female blackcap. Most clients commissioning a painting want a male, whatever the species. I do not think there is anything chauvinistic about this trend: it is presumably just because the males do, generally, show more colour in their plumage. One of these days I will paint a hen pheasant: whether anyone would buy it in preference to a cock bird I don't know!

Presumably, I could be accused of reinforcing the chauvinism by illustrating this hen blackcap undertaking the most female of duties, incubating her eggs. That aside, it proved to be a popular picture, as it was sold within days of being finished.

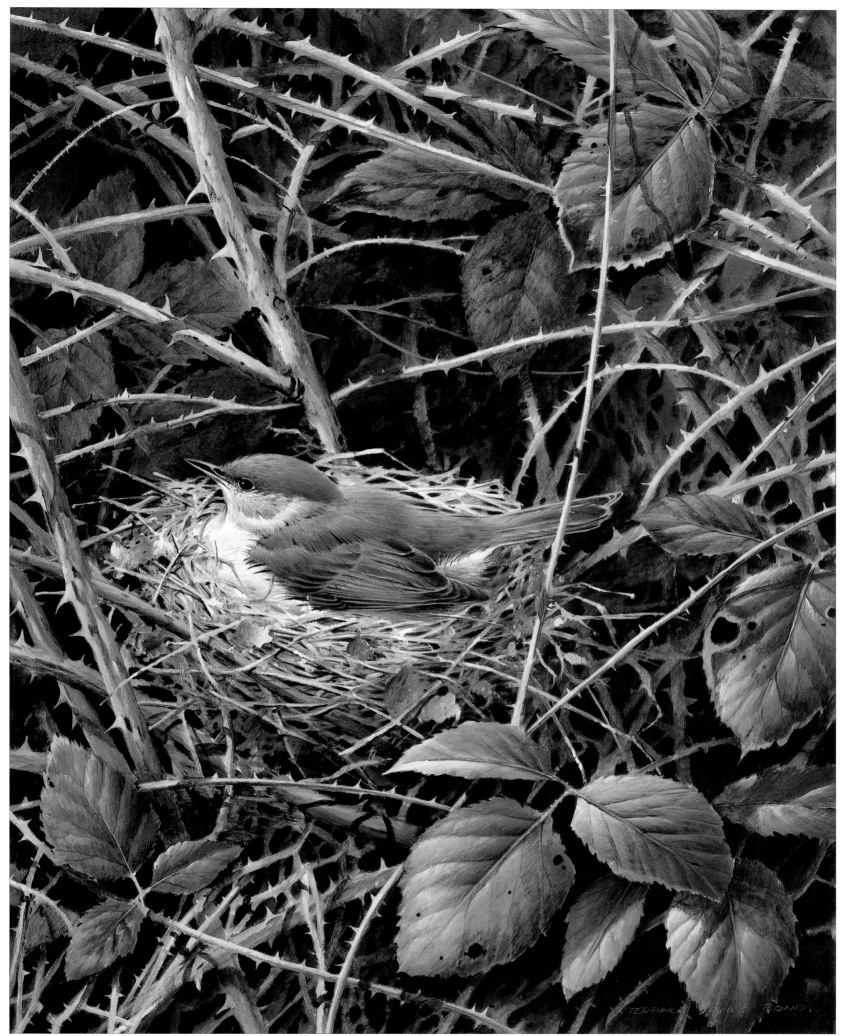

Blackcap (female), 14 x 10in. (35.6 x 25.4cm), acrylic

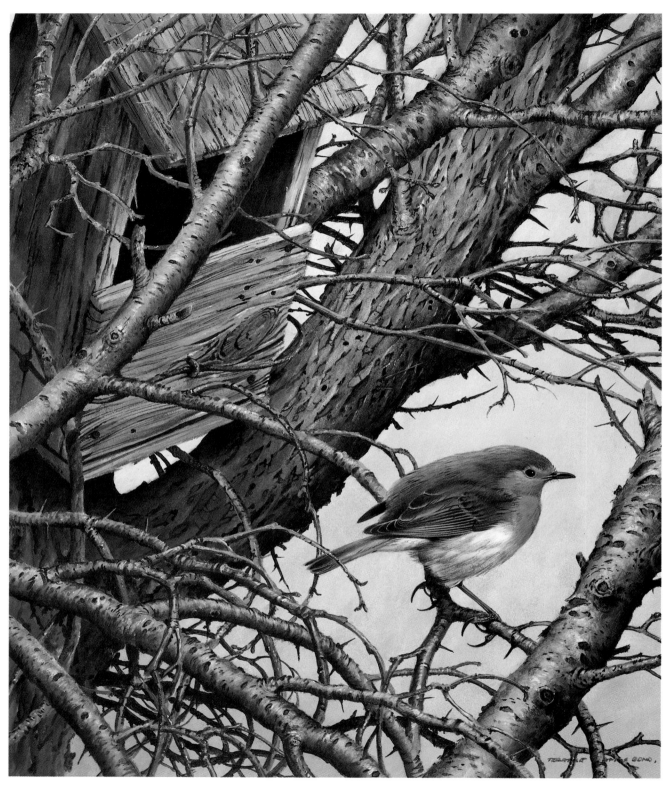

ROBIN, 16 x 12IN. (40.6 x 30.5CM), ACRYLIC

ASSOCIATED SUBJECTS

Backgrounds to the paintings have, in recent years, become so complex and diverse that they can almost take over from the subject as the focal point. During the execution of a particular work, I often include an element that adds character or feeling to the composition. Invariably I enjoy painting this as much as painting the bird itself.

MAPLE LEAVES

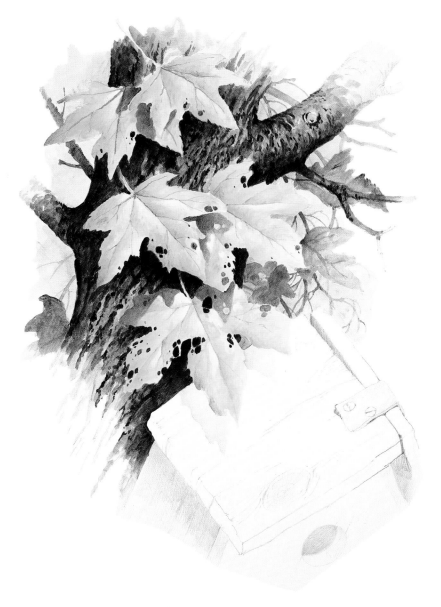

NORWAY MAPLE, PRELIMINARY LAYOUT (SEE PAGE 31), 16 x 12IN. (40.6 x 30.5CM), ACRYLIC & PENCIL

Of all the trees that figure in the paintings, probably the maple in its various forms and the willow are my favourites. Walking around the fields after harvest, and watching the colours change, I am always pleased and slightly surprised by the beauty of the common hedge maple. Perhaps its widespread distribution renders the species too common for particular mention, but as a contributor to the autumn spectacle, I do not think it can be beaten. The lovely five-lobed shape of a leaf is very attractive to casual observer and artist alike, and very little persuasion is needed for me to include this particular tree in a painting.

APPLES

WINDFALL APPLES, PRELIMINARY LAYOUT (SEE PAGE 97), 16 X 12IN. (40.6 X 30.5CM), ACRYLIC

If I have done my arithmetic correctly, then there are five paintings in this collection that feature apples, either as an incidental, or as a key component in the composition. Apples are lovely to paint, and I feel that it really does not matter too much whether or not the particular variety of the fruit is patently obvious. As long as the basic characteristics are present, the fruit will look right. The colour range within apples is enormous, and whether it is a 'cooker' or an 'eater', it is never a problem to find the correct shape and colour to suit the painting. One of the more difficult things to impart is the feeling of heaviness, and to help accentuate this I generally use fairly strong shadows. The best part of the whole operation is painting in the holes and the spots.

NESTBOXES

Nestboxes are, of course, familiar to most people, and for that reason they are illustrated in several of my paintings. Including something as commonplace as a nestbox is an attractive idea, and many people do seem to have a similar construction to the one painted here. This conveniently brings about a link between the viewer and the painting, and generally prompts a remark such as 'We've got an old nestbox just like that'.

I find the simple shape and geometric construction of these little wooden houses so very pleasing to paint that I am tempted to do too many. Whilst the general construction seems to fall into two main types, with either a pitched or a sloping roof, the effect that can be achieved with light and shade on the wooden surfaces is endless, and it is a certainty that I will paint another one before too long.

Nestboxes are not necessarily all simple, small boxes intended for blue tits. There are many and various types, with all kinds of birds in mind. The boxes used in Great Britain and Europe rarely match the extravagance of the fantastic purple martin houses found in North America, which are literally castles in the air, with room for 100 or 150 pairs in a tower built on top of a sturdy pylon.

American nestbox schemes have also led to the recovery, in places, of the beautiful eastern bluebirds, which faced problems partly through a lack of natural nest sites. In Great Britain, pied flycatchers have been encouraged to breed in woods where they otherwise were rarely seen: in some, as many as a hundred pairs have been attracted to stay each summer.

More ambitious boxes include long, slender ones filled with expanded polystyrene, which woodpeckers hack out. Loose slivers of bark tied against a tree trunk attract tree creepers. Bigger boxes made from tea-chests have some success with barn owls when placed in suitable trees or outbuildings. Little owls, on the other hand, need long, narrow, tube-like or tunnel boxes, placed on fence posts or even dug into banks. There have even been boxes provided, with some success, for breeding shearwaters and petrels on remote islands!

WOODCOCK NEST, STUDY, 14 x 10IN. (35.6 x 25.4CM), ACRYLIC

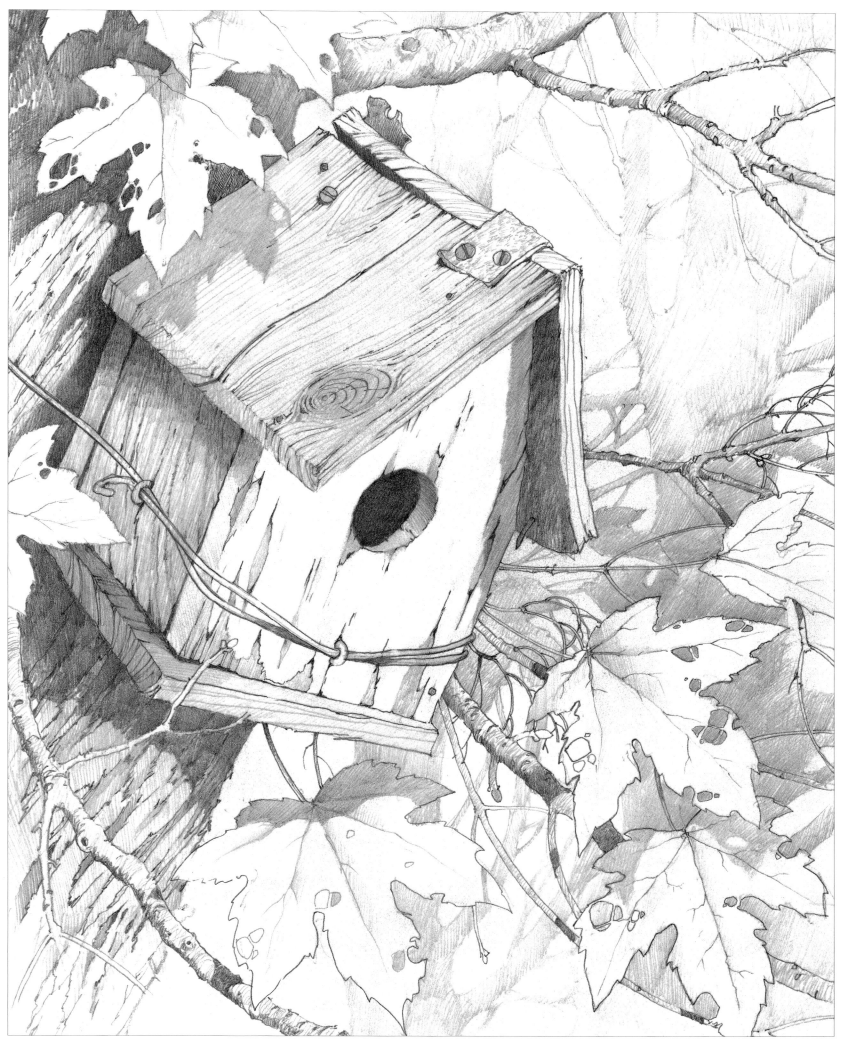

Nestbox with maple, 16 x 12in. (40.6 x 30.5cm), pencil

FUNGUS/FEATHER

TOADSTOOLS (FLY AGARIC), 16 X 12IN. (40.6 X 30.5CM), ACRYLIC

Among all the receptacles for pencils, brushes, and the general artist's paraphernalia standing on my desk, is a jar full of feathers, collected at different times while walking around the local countryside. Seeing a freshly discarded feather from an owl or some such bird is always a delight, and I cannot resist the urge to pick it up, straighten the barbs and stick it in my pocket. It does seem such a waste of a beautiful thing just to leave it lying there.

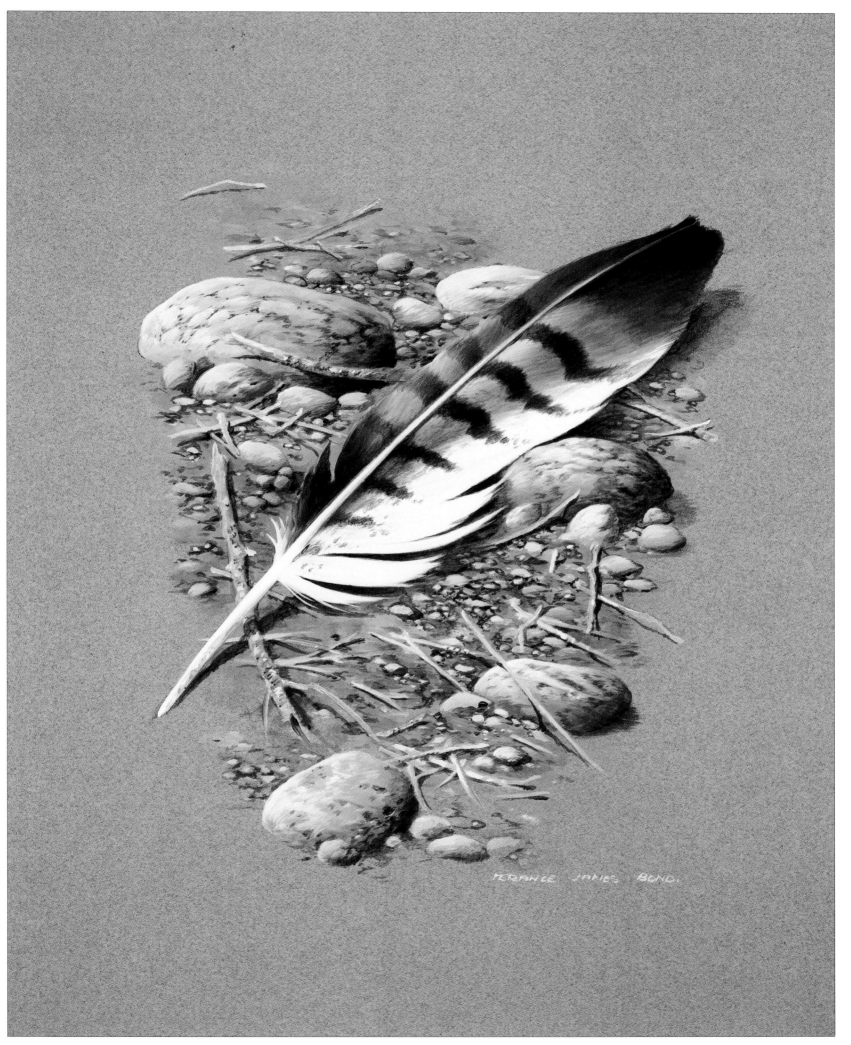

WING FEATHER (COMMON BUZZARD), 14 X 10IN. (35.6 X 25.4CM), ACRYLIC

PINE CONES

PINE CONES (MONTEREY PINE), 12 X 16IN. (30.5 X 40.6CM), PENCIL

T*hese particular cones have formed part of the composition for two paintings in this book (see pages 33 and 67). No doubt they will be used again for works in the future. Collected along with a sizeable branch, to which they were still attached, they were transported from the arboretum to my car and then from the car park back to my studio, a journey of about 250 miles (400 kilometres). However, as a species, they have travelled far greater distances than that. This is the Monterey pine, a tree native to the west coast of America and California in particular, that was planted in large numbers in both private and public collections throughout Europe during the last 150 years.*

As a tree it does well in the European climate, and grows in stature to a degree not seen in its native country. I was particularly fascinated by the way the groups of cones adhere to the branch for anything up to thirty years before releasing their seeds and, as the branch thickens over that period of time, the cones spread out and adopt their characteristic assymetric appearance.

Much of the joy of Terance James Bond's paintings comes from the detail and character of the settings in which his birds are placed. His technique is particularly well suited to his favourite subjects – trees, old bark, lichens, peeling paint – and pine cones are among the most confidently painted objects.

Terance has a collection of bits and pieces that add to the interest of his pictures, and these include cones. As for the great horned owl, it is a bird that often prefers the darkness and shelter of a mature pine, and the hard, angular cones make an ideal foil for the soft, delicate patterns and feathering of the bird. Little wonder, then, that a combination of owl, pine tree and cones comes together so often in a successful TJB picture.

PINE CONES (MONTEREY PINE), DETAIL (SEE PAGE 67), ACRYLIC ▷

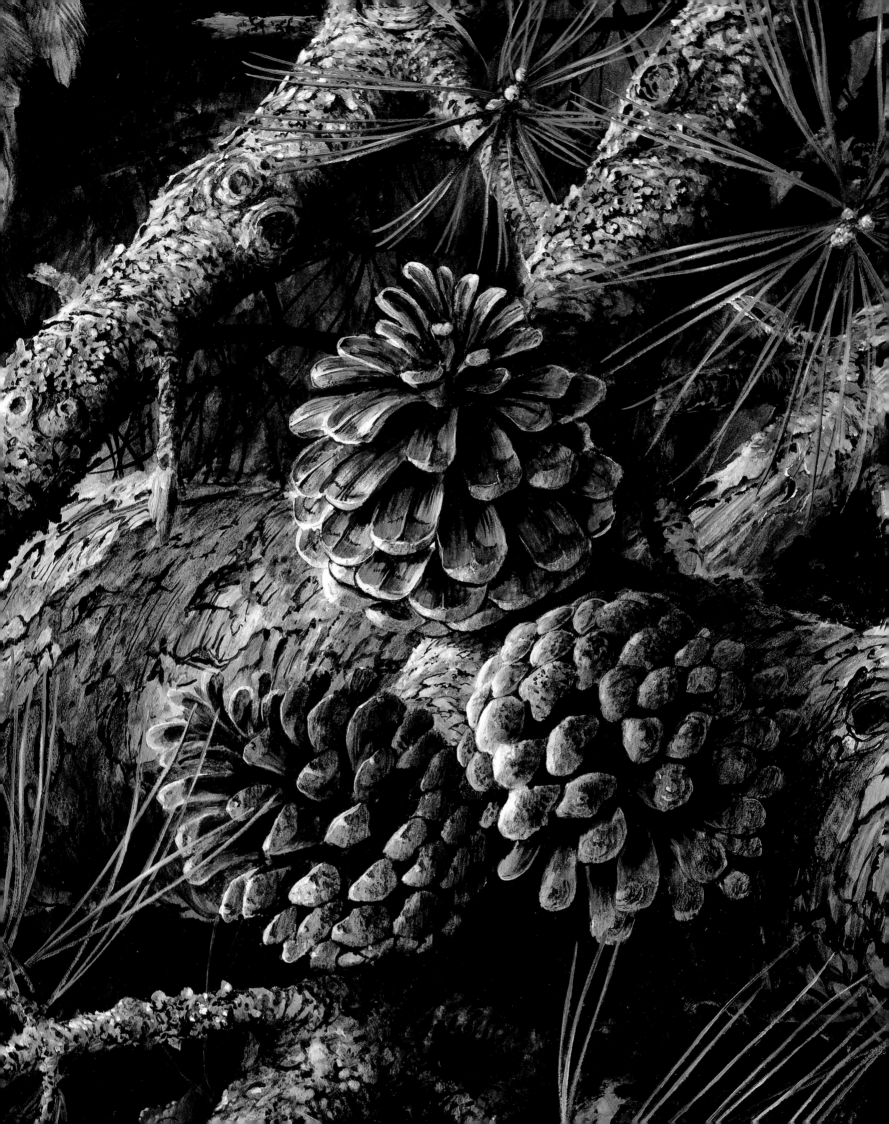

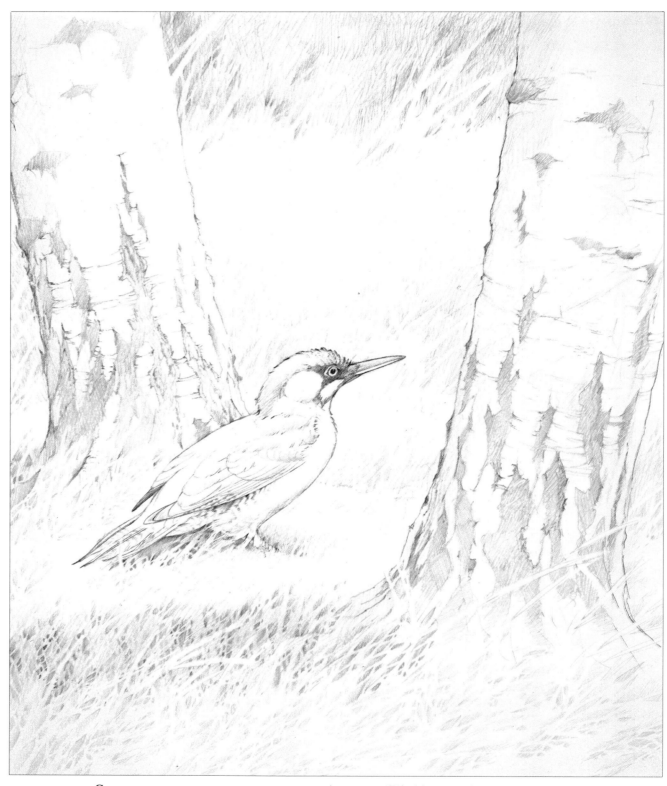

GREEN WOODPECKER, PRELIMINARY LAYOUT (SEE PAGE 171), 24 x 20IN. (61 x 50.8CM), PENCIL

SOURCES
OF INSPIRATION

A number of paintings in this book contain many ingredients, but for the majority it was the secondary subject that provided the initial inspiration, as opposed to the choice of bird. These are often some of my more successful works and, although this chapter is devoted to that particular idea, the theme has been incorporated in many paintings throughout the book.

GREEN WOODPECKER

—————— *Picus viridis* ——————

It may or may not be coincidental that both paintings of green woodpeckers in this book show the bird on the ground, or at least very near ground level. Our local pair spends the majority of the day jumping about all over our lawns and log piles, so I suppose it is predictable that I should illustrate the bird like this.

The two silver birch trunks in the smaller painting grow just outside my studio. Planted in 1978, they are now maturing into a lovely pair of trees. I have a particular preference for silver birch, and I have planted hundreds of them over my meadows. I'm surprised that I had not included these two specimens in a painting before now.

The silver birches crop up in several other pages in this book. I offer no excuses: I just love them. It's as simple as that.

While talking through some ideas in preparation for this book in Terance's studio, I saw plenty of action on the two birch trees he has painted: but on that particular day, mostly from tree creepers and a great spotted woodpecker, rather than the green woodpecker. Green woodpeckers spend a great deal of time on the ground, as Terance mentioned: in fact, they feed very largely on ants.

The tongue of the woodpecker is remarkable: a long, slender, pink object that coils back up and over the skull, but can be thrust forwards into an anthill to catch ants on its rough, sticky tip. Green woodpeckers have large, stout beaks, but they are not made for hacking into solid tree trunks like great spotted woodpeckers' bills. They are not so strong: usually, they are used instead to dig into the ground and into softer, rotten wood, so the bird can get at grubs and its beloved ants and their larvae.

Nor does the green woodpecker make the remarkable, abrupt, resonant drum against a branch, that is so distinctive of the great spotted woodpecker. It may drum, occasionally, but the performance is neither so frequent nor so dramatic.

Instead, it is a much more vocal bird. Its old country name (although I wonder how many people actually use it nowadays) is the 'yaffle', and this refers to its loud, laughing, ringing calls. One is a quite musical and pleasant sound, another much more strident and almost uncomfortable, a sudden rattle of alarm.

Green woodpeckers are found in England and Wales and in southern parts of Scotland, but not at all in Ireland. They prefer deciduous or mixed woods, avoiding stands of pure conifers, but are most frequent in places where a scattering of pines, birches, oaks and hawthorns are found over a rough heath or grassy parkland. Here, they can feed on the ground, poking about in the clumps of heather and grass tussocks, and investigating fallen branches or decaying logs. If they are disturbed, they make off fast and low towards the nearest trees, flashing bright yellow above the tail as they go. As often as not the bird will settle on the side of a tree, and quickly sidle round out of sight, perhaps leaving just the top of its head visible as it peers round to make sure the coast is clear before returning to resume its interrupted meal.

GREEN WOODPECKER, 24 x 20IN. (61 x 50.8CM), ACRYLIC ▷

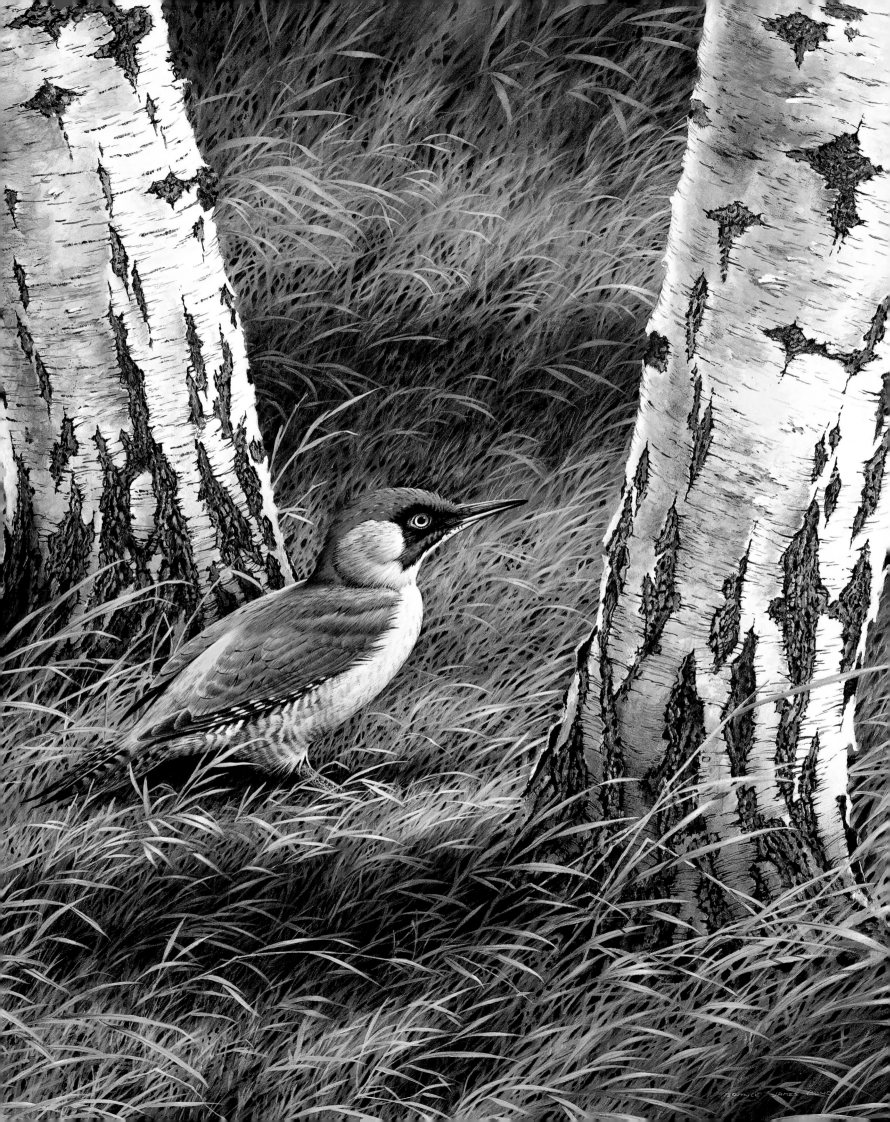

TREE SPARROW
Passer montanus

Tree sparrows have a broad range across most of Europe and much of Asia. In places they are quite at home on the outskirts of villages, even around the ancient defensive walls of hilltop towns in Spain, where they nest in cavities within the structure of the walls or nearby buildings. On remote Irish coasts they breed in similar holes in the walls of ancient towers and castles. However, in Great Britain, they are – generally speaking – much more rural birds than house sparrows, more typical of a well-wooded park, or at best a village garden, than a town square or a suburban bird-table.

Old woods, with plenty of clearings where trees have fallen, and an abundance of dead timber and natural cavities in trunks and branches, and parkland with scattered, venerable oaks and limes make ideal tree sparrow habitat. They nest in holes, and like to be in trees, but require open spaces in which to feed: the proximity of farmland, especially stubbles and fallow ground, is important to them.

Given this relatively wide choice of habitat, it is odd, indeed almost inexplicable, that the tree sparrow undergoes periodic changes in fortune over large areas of the country. In the 1980s and early 1990s, it was at a low ebb over much of England, in parts almost absent from districts where not long before it had been common. Part of the reason must be the changes in farming practices, as spilled grain, weed seeds and, in summer, an abundance of insects, have become things of the past.

It is a pity that the species has apparently fallen on hard times in so many areas, but it may be that a natural cycle will see a recovery again in due course. This is not the adaptable, successful vagabond that the house sparrow so evidently is. It is a much shyer, more aloof, more attractive bird, too little known by most people, who rarely see it, or fail to recognize it as a garden visitor.

This year I had the good fortune to have these handsome little birds adopt one of my nesting boxes. Watching them squeeze in and out of a hole designed to let in blue and great tits and to keep out the larger house sparrows, was intriguing. Several times I thought that I would have to get the ladder and rescue one of the pair, which gave every impression of getting stuck halfway in (or out)!

They were very successful in raising a brood, but when the time came for the young sparrows to vacate the box, things proved a little awkward. Some fledglings tend to weigh more than their parents when they leave the nest. Whether this is true of tree sparrows I don't know: but, try as they might, the four chicks could not get out! Finally, I had to remove the metal plate on the front of the box, with its blue tit-sized hole, and enlarge the hole in the wood behind with a file. I'm not sure if the inmates took kindly to being covered in sawdust, but, that slight inconvenience notwithstanding, all four left the box by the end of the day. There is no metal plate on the front of the box in this picture, so hopefully this pair will have no problems.

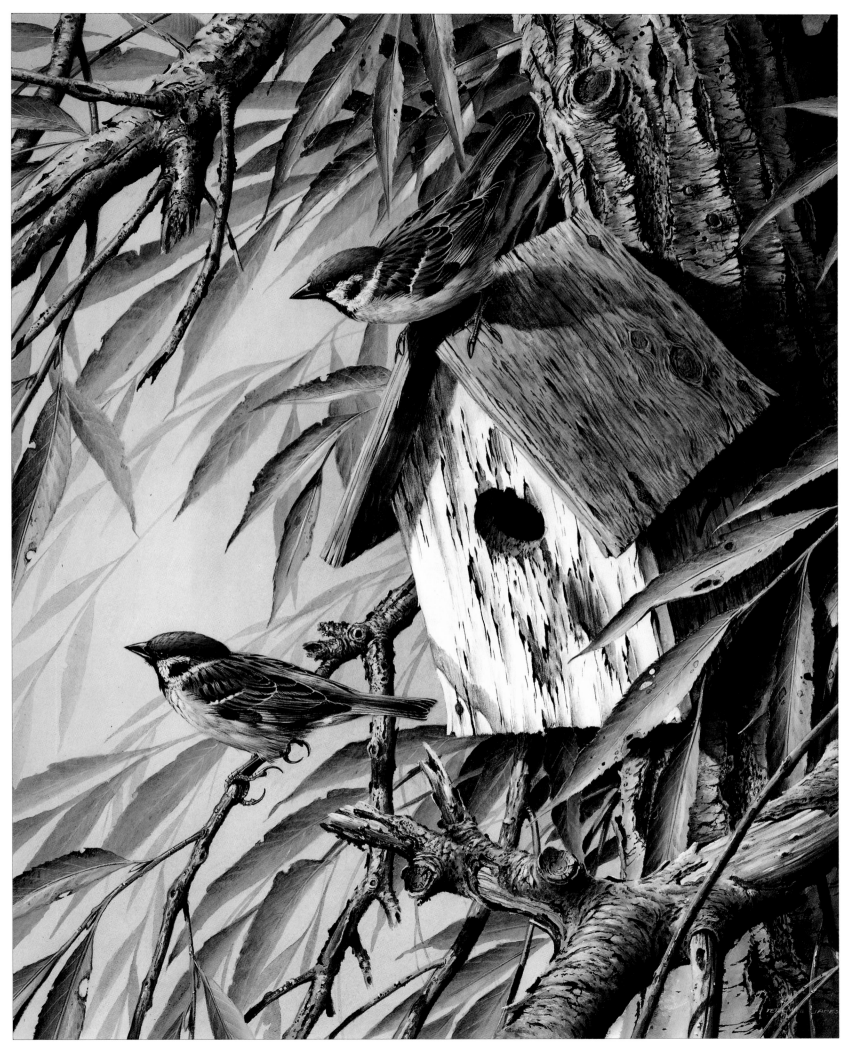

TREE SPARROWS, 20 x 16IN. (50.8 x 40.6CM), ACRYLIC

HOUSE SPARROW

Passer domesticus

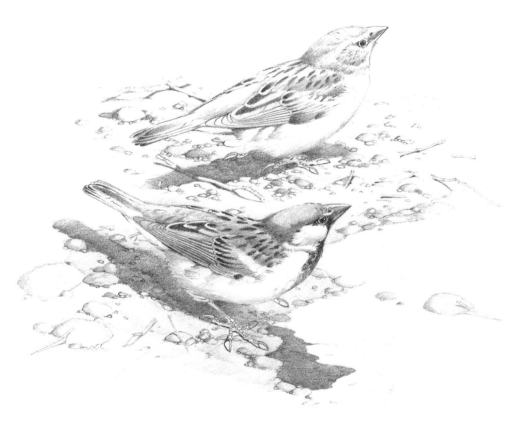

HOUSE SPARROWS, 10 X 12IN. (25.4 X 30.5CM), PENCIL

Walking around old, derelict farm buildings always gives me great inspiration. Ideas for paintings come so thick and fast that I have to make a conscious effort not to get carried away with the artistic possibilities.

After the terrific storm of 1987, several local farm buildings, including those adjacent to our house, were damaged and de-roofed. Major repairs had to be undertaken. The sight of this old rainwater pipe lying discarded, after remedial work had replaced it with modern plastic, prompted this idea.

Using the old piece of pipe was no problem. The sparrow was the obvious foil to the composition. The idea of the bird investigating a dry rainwater pipe was a response to a succession of drought-stricken summers in my home county of Suffolk.

Weather conditions undoubtedly have temporary effects, at least, on bird populations. The storms to which Terance refers felled many old trees, reducing nest sites for barn and tawny owls, and destroying much habitat for woodland birds such as woodpeckers. On the other hand, some broken-off branches did open up holes that were accessible to kestrels and owls, offsetting to some extent the loss of traditional nest sites.

The droughts had quite different effects on some unexpected birds. One was the house martin, which found wet mud so hard to come by in some areas that few new nests were built and numbers were reduced as a consequence.

HOUSE SPARROW, 20 X 16IN. (50.8 X 40.6CM), ACRYLIC ▷

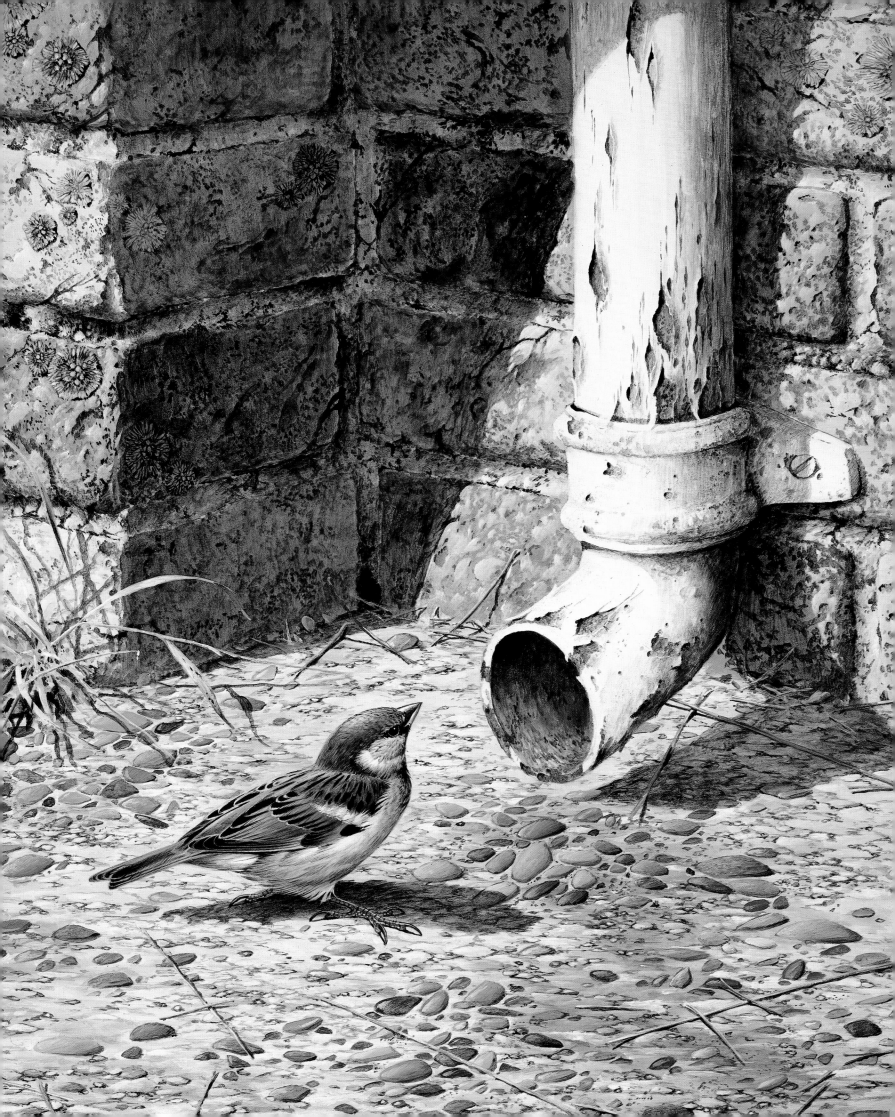

PUFFIN

—— *Fratercula arctica* ——

Are puffins beautiful or merely comical? Fascinating or simply ornamental, or a bit of a joke? Most people who see them properly, perhaps on the green slopes above a red sandstone cliff on some Scottish isle, or off the west coast of Ireland where they breed above the crashing Atlantic waves, tend towards the more respectful, even reverential, view.

These are birds that spend the whole winter at sea, far out on the open ocean, sitting on the waves, with a viewpoint only a couple of centimetres above the salty, freezing spindrift, in a world that extends barely beyond the surrounding wavetops. They feed on tiny fish and plankton, caught in long, deep dives, during which they use their wings to 'fly' underwater.

In spring, by a means still beyond our understanding, the puffin, which can see no further than a few metres (unless it flies up from its saltwater home and looks across to a more distant horizon), returns across the open Atlantic to its home colony. It may be a mainland cliff, shrouded in fog, or a tiny island, little more than a dot in the ocean. Yet the puffin unerringly returns each year: how does it find its way over the trackless sea?

Once there, it becomes the incurably nosy busybody, loved by all those who know it well. Puffins are constantly gregarious and the behaviour of a pair instantly sets off other pairs in the vicinity. Should two puffins begin to rub bills and nibble each other's feathers, as they often do, then the nearby pairs have to set to billing and preening, too. If a pair courts and mates, others rush across to see what is going on, trying to join in, and eventually courting and mating as well. When a puffin turns to go into its burrow, there is bound to be another one close behind, trying to pry into its next-door neighbour's business.

Such actions all have a vital role in synchronizing the breeding activities within a colony, so that all the pairs achieve the maximum benefit from the security and defence provided by the crowded birds. Some colonies are vast: tens of thousands of pairs peppering scree slopes, broken cliffs and grassy hillsides on remote islands. Most of us would have to make quite an expedition to see them.

The young puffin remains in its burrow for many weeks before it is eventually left to fend for itself. It may come to the burrow entrance for several days before plucking up the courage to leave for good: it must then fly to sea, getting away from the predatory gulls as quickly as it can. It stays alone, fending for itself for a few years, until it decides that the time is right to return to the colony, by that minor miracle of bird navigation.

This is the only large study reproduced in the book. It represents a style of picture that dominated the first ten years of my painting career. I still paint a few pictures of this type, but over the last few years it seems that clients and publishers alike prefer paintings with fully finished backgrounds.

Birds such as these two puffins, bold and contrasting in appearance, suit this type of work very well. In this form the birds themselves are the key element in the composition. The background takes second place. Naturally these paintings, for their size, take less time to complete, and for that reason I will often follow a large and complicated work with a small study, almost as a form of relaxation and a change of mood. The finished result always gives me great satisfaction.

PUFFINS, 26 x 18IN. (66 x 45.7CM), ACRYLIC ▷

ROBIN

Erithacus rubecula

Paint me a robin and include some of your peeling paint!' were the instructions from a client who commissioned this painting for his young daughter. Despite this painting looking very pretty, it contains only five colours. The bird itself is typical of my robins: round, plump, looking very contented, and illustrated in a rural setting. That is always my preferred backdrop for the species.

Robins were presumably originally birds of woodland edges and clearings, and followed large animals that might disturb suitable food. In particular, wild boars and, later, domestic pigs left to forage in woods, would have been ideal for robins, which could pick up the worms and grubs revealed as the animals turned over the topsoil. This preference for sunny edges and open spaces within forests easily translated to the suburban garden, and the pigs were simply replaced by the typical gardener. Hence the familiar image of a robin, waiting on the spade handle, hoping for a juicy worm.

Apart from their fearless behaviour, and ability to adopt a family of people, rather than the other way round – robins often make the first move and enter a house, or tap on the window – robins have another great advantage when it comes to getting in with the householders (and being forgiven for their faults); they sing beautifully. In autumn, robins sing a softer, more wistful song than their full performance in spring. It has a melancholy air, exactly matched to romantic, human ideas of autumn and the passing of another year, only too well suited to anthropomorphism. Spring song is a strong and dynamic delivery, with a succession of short phrases and short pauses, strung along in a varied and always pleasing piece of music.

Unlike the song thrush, the robin does not repeat its phrases immediately, and may have a few hundred variations to choose from. Even close neighbours, which might be expected to learn and copy from each other, very rarely share even a short phrase. Yet, despite this undoubted variety, a robin always sounds like a robin (except when some faster, longer spells of song can take on much the same quality as a garden warbler). What makes it so? Well, perhaps it is the robin's wistfulness, and tendency to finish each burst with a long, fading note, that gives it away.

The sad fact so little appreciated by robin lovers is that, as with all small birds, most young robins can look forward to only a very brief career. It is, of course, obvious that with so many young reared, nearly all will die before the following year, or we would be knee-deep in robins. In Great Britain, on average, 62 per cent of adults and 72 per cent of young birds die each year. The best outlook is for one- and two-year olds – once they reach that stage of life, their chances are better. But, come three or four and they are running out of time.

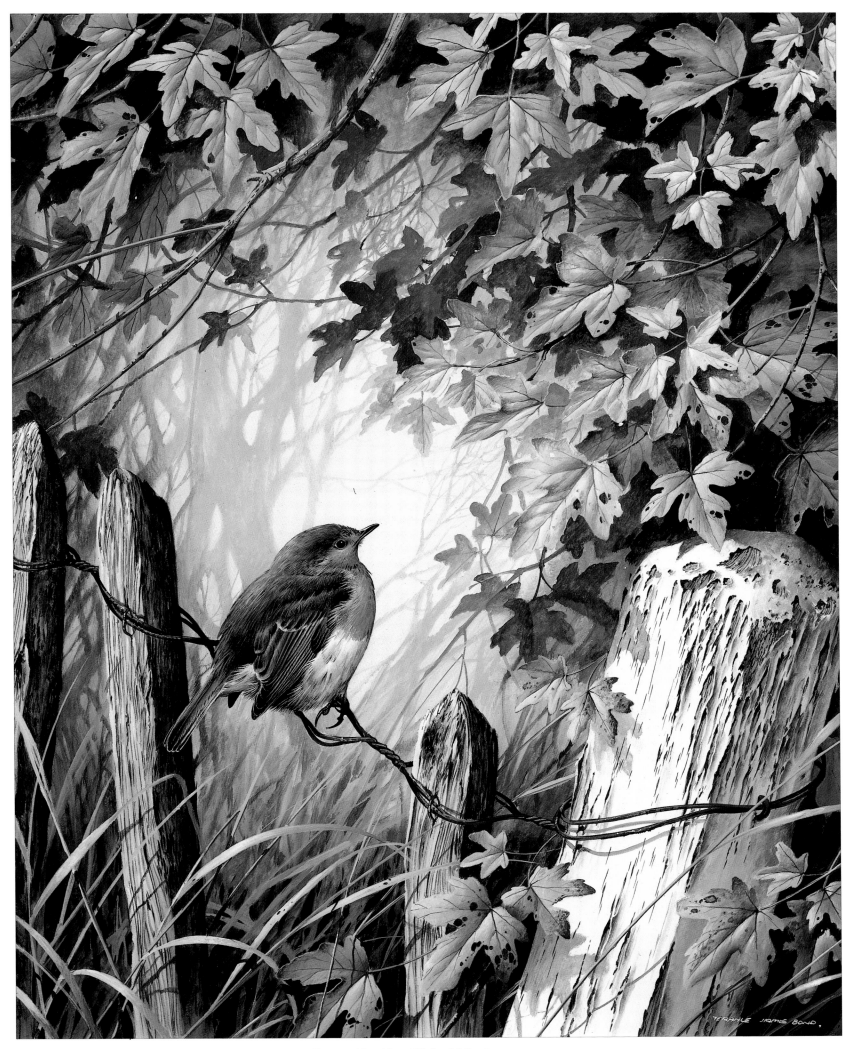

ROBIN, 16 x 12in. (40.6 x 30.5cm), GOUACHE

BLUE JAY

Cyanocitta cristata

BLUE JAYS, 25 X 17IN. (63.5 X 43.2CM), GOUACHE

Seeing these birds for the first time in New York State, I found it difficult to comprehend and accept that they were wild; somehow they seemed more like exotic birds that had escaped from somebody's private collection.

If their colours alone were insufficient to render them conspicuous, the blue jays' inquisitive temperament and raucous voices would certainly do so. They are also widespread and fairly common through much of North America, so, all in all, they are difficult to overlook.

Silver, grey and white are colours that really work well in conjunction with the striking colours of the blue jay's plumage. During the blending and mixing of pigments while painting this picture, it suddenly occurred to me that some of the more brilliant blue feathers were exactly the same colour as the primary coverts of our European jay.

Jays are widespread in the northern hemisphere, but North America has the best variety of species. The blue jay is essentially an eastern bird, getting part-way through Texas, but not to the Rockies or beyond. The west has others, however: there are scrub jays, grey-breasted jays, Pinyon jays, Steller's jays, and grey jays. Most of them have a large element of blue in their plumage, while the European bird is basically a beautiful, soft-pinkish colour. All share that particular jaunty, bouncy air and springy step that makes jays so attractive, wherever and whatever they may be.

BLUE JAYS, DETAIL (SEE PAGE 180) ▷

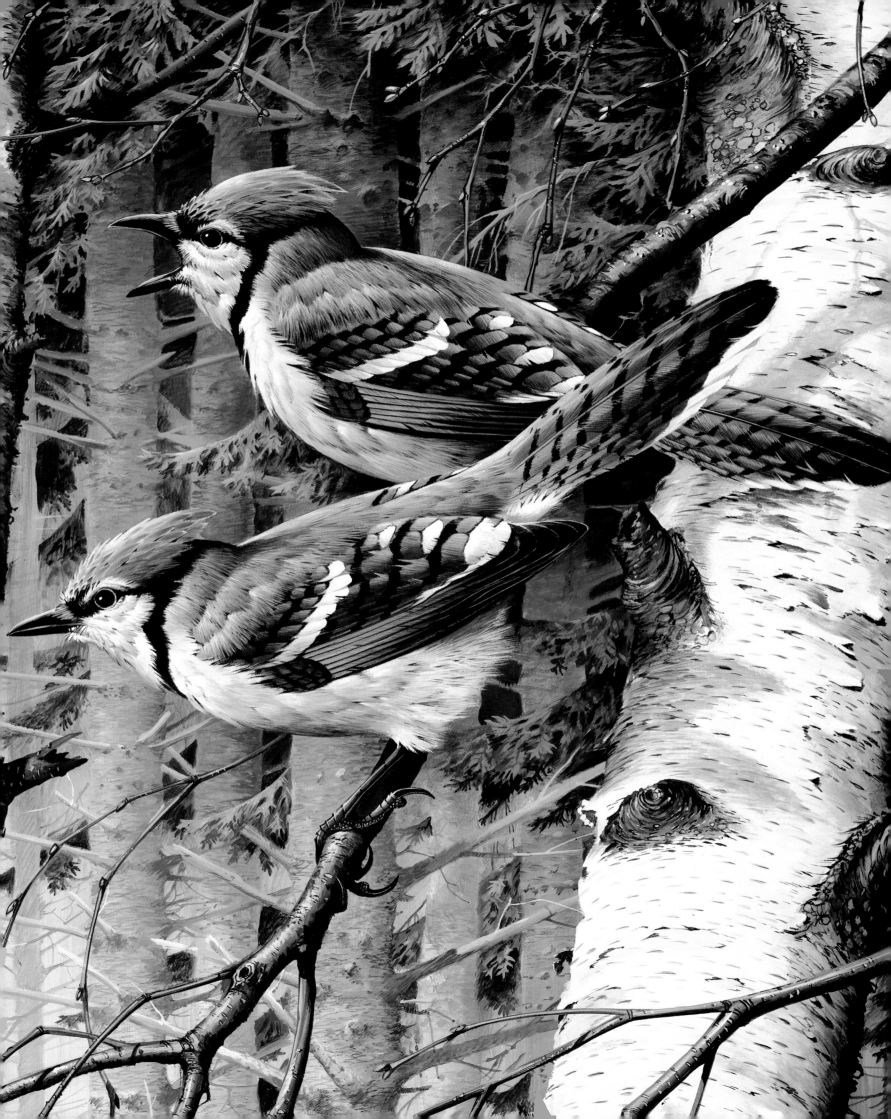

KINGFISHER

Alcedo atthis

When I visited Terry Bond's house one November, he told me 'the kingfisher' had just left the lake near the front door, but it would soon be back. I did not see it, as it happened. Kingfishers are like that – unreliable. If you find a place where kingfishers are 'certain to be', you can be sure that they will be absent when you take a friend. They seem unwilling to co-operate.

Most people, when they do succeed in seeing a kingfisher for the first time, are surprised at the size of the bird: it is barely as big as a starling, yet many people expect it to be more the size of a pigeon, at least! Add to that the fact that kingfishers are very much harder to see than might be expected from a picture of a bird with such colours, and it might be thought that here is a disappointment. Not a bit of it.

Kingfishers genuinely are bright and jewel-like, but a good view is needed for the full effect to be properly appreciated. The light should be clear, preferably bright, although the richness of the royal blue and electric turquoise sometimes shines out splendidly on a dull day, if the bird is against a dark background. Sunshine, however, adds an extra touch of brilliance, and as the bird turns and tilts, so the upperparts are shot with deep and bright blues and emerald green.

A kingfisher squatting on a cross branch can look round and dumpy. On a swaying, upright twig, it takes on an altogether more upright, taut appearance, using its ridiculously short stub of a tail to balance. It can stretch up its head, or bob in an almost owl-like way to fix the position of a fish. If it is lucky, and performs its task well, the kingfisher will fly back to its perch, after a rather undignified belly flop, carrying a silvery, wriggling fish in its beak. Then it whacks it, unceremoniously, head first against the branch, subduing its struggles before finally juggling it round to swallow it, head first.

More often than not, however, all the luckless birdwatcher sees of it is a flash of blue as it flies away, low over the water, straight as an arrow, calling a high, sharp 'chik-keeee' or 'keeee', often the first indication that a kingfisher is there at all. Kingfishers are just made to be elusive, brightly coloured or not. If they stay put, they are no easier: the contrasts of blue, white, green, black, and rich orange simply melt into the light and shade of drooping willow twigs and swaying leaves above the dark ripples of a stream or pond.

If asked to compile a list of the ten most 'wanted' birds, as far as my clients are concerned, the kingfisher would have to be included. It is not a resident bird in our 'patch', but a single kingfisher often adopts both our ponds in winter, and proceeds to eliminate as many of my wife's goldfish as possible before departing in spring.

The largest of the two ponds is about three-quarters of an acre (0.3 hectares) and contains a large and varied selection of fish, including rudd, carp, tench, goldfish, and golden orfe. All of them breed most years, providing plenty of fry on which the beautiful kingfisher can survive.

Presumably, somewhere, there exist 'private fishing' signs similar to the one depicted in the painting. Its inclusion in the composition is simply an excuse to give the bird something to sit on. Our bird actually has the luxury of numerous steel posts at regular intervals, through which are threaded wires to deter the grey heron from killing the larger fish. Watching the kingfisher fishing from these posts is a bonus, but somehow the idea of including a length of angle iron in the painting did not have the same appeal!

'EXEMPT', KINGFISHER, 16 X 12IN. (40.6 X 30.5CM), ACRYLIC

TURTLE DOVE
Streptopelia turtur

My intention in this painting was to give the illusion of a hot summer's afternoon, somewhere in a farm building complex. The doves themselves display warm, sunny colours. Placing them in a relaxed, almost intimate setting, side by side and out of reach of the viewer, has helped to reinforce the tranquil atmosphere.

I had planned that the image should remain as uncomplicated as possible from the outset. Originally, I proposed to leave the painted brickwork untainted, as a plain white area of reflected sunshine. For some reason, it did not quite achieve the desired effect. Some time later, during a sunny afternoon, as I walked around the outside of my bungalow, it became obvious that what was needed was strong shadow. Shadows, of course, emphasize sunlight. It is funny how the 'obvious' is not always so! As soon as the shaded area was painted in, the picture came alive. At the same time, I darkened the window opening, adding even more contrast to the white wall. It has since become one of my favourite paintings.

It is natural for turtle doves to be so strongly associated with sunshine and warmth. They are very much birds of the summer: at least in Great Britain and northern Europe. In winter, they are in the warmth and sunshine of West Africa. In Great Britain they are birds of farmland, and delight in thick, ancient hedgerows, with big, overhanging hawthorns and blackthorn thickets. Such hedges are fewer and harder to find than they once were, and turtle doves also have to run the gauntlet of spring shooting – although entirely illegal – in some Mediterranean countries (particularly southern France), so they have suffered a long and deep decline.

Long, lazy summer days are certainly enhanced by the crooning, purring calls of turtle doves from their selected thickets. The birds themselves may be heard but not seen; to many people, they are little known. Yet they are still not so hard to find, especially if there is a stubble field with spilled, waste grain in the late summer, perhaps with a few overhead wires above or beside it where pigeons and doves can perch if disturbed from their feeding. Then turtle doves may mix with much bigger woodpigeons and collared doves, from which they are distinguished by their lighter build, brighter colours, and a tail that shows a broad white 'V' at the tip when fanned as the bird is about to settle.

Turtle doves have a curious relationship with a small, pink-flowered and rather insignificant plant, fumitory. Its distribution mirrors that of the dove, and its seeds form 30 to 50 per cent of a dove's food in late summer. It seems unlikely that turtle doves would depend on the plant, but certainly there does seem to be a strong link between the two.

◁ TURTLE DOVES, DETAIL

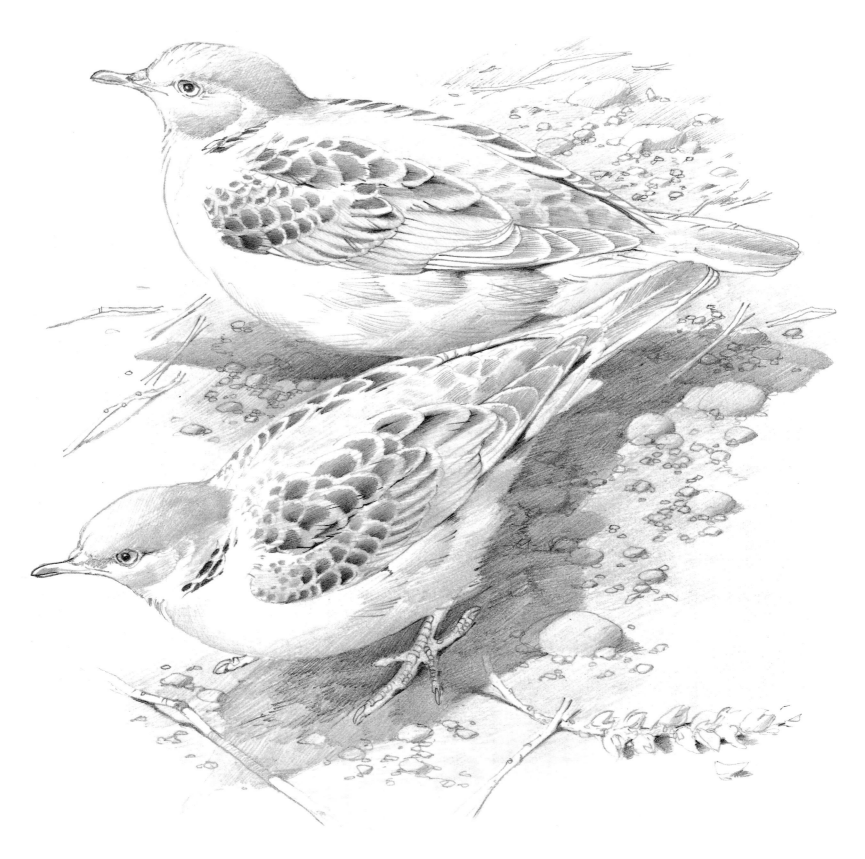

Turtle doves, 16 x 12in. (40.6 x 30.5cm), pencil

LAPWING
Vanellus vanellus

The spirit of a painting can be achieved in various ways. One can use the related positions of the subject and its surroundings, or simply illustrate a species that has such a powerful personality that the feeling emanating from the work is unmistakable. A more subtle approach to setting a mood can be achieved by lighting and colour.

This lapwing painting has proved as popular as anything I have ever done, despite the image being simple and straightforward. The key to its success lies in the effect given by the impression of looking across the water surface against the light. Heavy shadows, prominent highlights, and a reflective liquid surface combine to produce this twilight atmosphere.

The details are important, and the focal point of the work is the ring of tiny ripples radiating from the bird's feet. They reinforce the quiet, gentle nature of the subject.

Lapwings are surely among the most beautiful of British birds. At a distance, especially in flight, they look black and white; the broad wings and the rolling action in the air, which presents first the dark upperside, then the pure white underside, produce a flickering effect that is highly characteristic, even a couple of kilometres away. Closer views on a dull day allow the birds to melt away, almost unseen, against the dark grey-brown of a ploughed field.

At closer range and in better light, the lapwing may be revealed for what it really is: a veritable jewel. The back is iridescent, flashing magnificent yellow-greens, blue-greens, violet and copper. From some angles, momentarily, a lapwing may be glossed with pure lilac.

Breeding lapwings resort to damp pastures and meadows. They need the moisture to bring up worms and let them poke into soft soil, and must have short grass on which to feed. Long grass or cereal crops prevent them from seeing approaching predators, make feeding more difficult, and create problems for the short legs of newly-hatched chicks. Farming methods and drainage, afforestation of upland moors, and the loss of many a rough, moist common or marsh have caused a remarkable reduction in lapwing numbers in much of England and Wales, although breeding numbers are holding up well in much of Scotland.

In spring, the male lapwing performs one of the most remarkable display flights of any British bird. He flies up high on broadly-fanned wings, then tumbles down in a series of crazy, out of control, spirited twists, turns and plunges, rising again just as he seems about to dash himself into the ground, all the time producing a 'song' of ecstatic, wheezy, creaking sounds, as well as a loud rush of air through the separated feathers of his wingtips. He is defending a territory, just like the blackbird singing from the roof, or the robin warbling from the cherry tree.

In the early summer the lapwings form flocks again; by this time most lapwings will have already reared their chicks, or some may have failed and have given up for the season. Lapwings are irresistibly gregarious, sociable creatures and flock again as soon as their nesting duties are done with. They are quickly on the move, and small flocks can be seen flying over as early as late May, when the birds gather beside lakes and reservoirs where the fall in water level in late summer creates a muddy shore.

By late autumn, flocks on fields may number thousands. Lapwings are widespread all over England in winter, but a spell of very cold weather will see vast flocks heading south and west to escape the grip of the freeze.

LAPWING, 22 x 18IN. (55.9 x 45.7CM), GOUACHE

INDEX

House sparrow, 10 x 7in. (25.4 x 17.8cm), acrylic